About the Author

Steven Dickens lives in Flixton, near Manchester and is married to Sarah. They have three sons and three daughters. He is a retired Charge Nurse and College Lecturer and has written journal and magazine articles relating to history and genealogy, as well as several 'Through Time' volumes. His interests include rugby (Union), football and athletics. He recently completed the Great Manchester Run.

Special thanks are due to Simon Flavin at Mirrorpix Photo Archives for his help and advice in the compilation of this book.

Acknowledgements

British Newspaper Archive (www.britishnewspaperarchive.co.uk).

Manchester Evening News Archive (1868 – 2013), Manchester Archives and Local Studies, Central Library, St. Peter's Square, Manchester.

Mirrorpix Photo Archives, 22nd Floor, One Canada Square, Canary Wharf, London (www.mirrorpix.com).

Introduction

Manchester in the Headlines uses the newspaper reports of the *Manchester Evening News*, with a contemporary photograph of the news event, on each page. Many of the events recorded here I have included because they are nationally recognisable and notorious incidents in the news history of Manchester. For example, the Moors murders and Harold Shipman cases are immediately notable. I have also included many stories relating to wartime, particularly the Manchester Blitz of December 1940, when the city centre was completely decimated by Luftwaffe air raids. The centenary of the First World War has meant that I have included several news events of historical importance to that period of time, such as the use of 'tanks,' in the Battle of Arras, Zeppelin raids on Manchester and munitions workers in Old Trafford, as well as the sinking of Manchester Liners in the Irish Sea.

Manchester is steeped in social history and has strong links to both the Suffragette movement, with Emmeline Pankhurst born in the city and the development and growth of socialist politics, with MP J. R. Clynes prominent in the Labour governments of the 1920s. Mancunian recreational activities are represented by the famous Belle Vue Zoological Gardens and Queen's Park Museum, whilst the city's place as a notable cultural and artistic centre over the last century is well represented. Inevitably sport is widely covered, especially football, with the world renowned football clubs of Manchester City and United, dominating sport locally and nationally. Whilst City can claim to be the more dominant Mancunian team of the late Victorian and Edwardian eras, it is United, especially post-Munich Air Disaster and as England's first winners of the European Cup, who carried the mantle of Manchester football through the latter part of the twentieth century. Today both clubs, as recent Premiership Champions and European competitors, make Manchester the undoubted capital of English football.

Manchester has also had its fair share of fires – most notably the Woolworth's store fire of 1979, which led to changes in the regulations regarding the use of fire retardant materials in furniture; the British Airtours flight of 1985, which led to changes in the use of materials within the fuselage of airliners and improved fire safety regulations on board; and the firestorm which was the Manchester Blitz of December 1940. This led to the destruction of many historical buildings across the city centre and also led to the post-war reconstruction which was seen in Manchester, as well as many other cities across the United Kingdom.

Manchester's international airport (formerly Ringway) means that I have chosen three important and well-reported air disasters for this selection, taking place in 1957, at Shadow Moss Road; 1967, at Stockport, and 1985, on the runway at Manchester Airport. Royal visits also feature, with HRH Queen Elizabeth II opening the Metrolink system in 1992 and Commonwealth Games in 2002 and Princess Diana visiting Manchester in

MANCHESTER
IN THE HEADLINES

Steven Dickens

AMBERLEY

First published 2015

Amberley Publishing
The Hill, Stroud
Gloucestershire, GL5 4EP

www.amberley-books.com

British Library Cataloguing in Publication Data.
A catalogue record for this book is available from the British Library.

ISBN 978 1 4456 4802 6 (print)
ISBN 978 1 4456 4803 3 (ebook)

Typesetting and Origination by Amberley Publishing.
Printed in the UK.

the aftermath of the 1985 air disaster. Other notable events include the opening of the Manchester Ship Canal in 1894, which was a very important event for the economic survival and growth of the city at the time. The Strangeways Prison riots of 1990 and the IRA bomb of 1996 are also included, with both events having far reaching consequences. The former raising many questions regarding the future administration of the prison service and the latter leading to the redevelopment of the city centre and the economic rebirth of Manchester, in the early twenty first century.

The selection I have presented in this book concentrates on some of the major historical and social events reported in Manchester's news over the last 140 years. I have also attempted to balance the news events presented here, in relation to chronology and subject matter, and hope that the resulting book will be enjoyed by the reader and reflect the amazing diversity of life to be found in the city of Manchester!

1) Manchester Cathedral's New Organ, 1870

During the Victorian era the parish church of Manchester underwent many alterations and changes, becoming a cathedral in 1847 to serve a rapidly growing population. The organ proposed for the cathedral in 1870 was installed in 1871 by Hill & Son, with the main part of it standing on the screen in a new case by Sir George Gilbert Scott. This organ was rebuilt by the same firm in 1910 and in 1918 it was restored by Harrison & Harrison. The organ has been repaired since, particularly after Second World War bomb damage, with a new instrument recently commissioned to replace it.

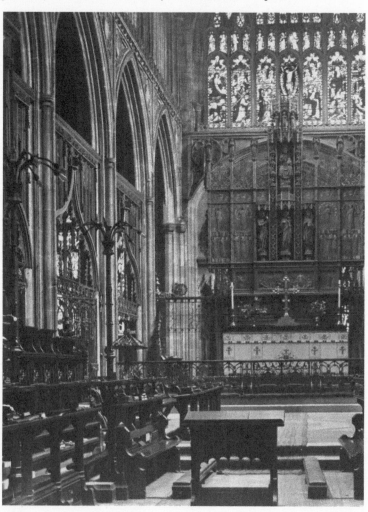

Manchester Evening News. Thursday, June 2nd 1870.

The Proposed New Organ for Manchester Cathedral.

This forenoon a meeting of ratepayers was held in the Cathedral for the purpose of considering an offer made by Mr. Wm. Henry Houldsworth to restore and replace the old Rood Screen in the centre arch in the Cathedral and to place a new organ therein. The Rev. H. C. Smith took the chair. There was a very small attendance. – Mr. Lings, comptroller, read a letter from Mr. Houldsworth, in which he stated that although he had at last received the consent of the chapter for the proposed alterations, he found that there were strong objections by some to the scheme, and he therefore wished the parishioners to meet and consider the matter, and appoint a committee to superintend the execution of the work, if the offer was accepted. – Mr. Charles Sever moved the following resolution:- "That this meeting, on behalf of the parishioners, accepts with pleasure the offer made by William Henry Houldsworth, retiring senior warden, to restore the rood screen in the Cathedral and Parish Church of Manchester, and to erect thereon a suitable organ for the musical services of the Cathedral, and begs to tender its grateful acknowledgements for his magnificent offer; and that the following gentlemen, viz, W. H. Houldsworth, Henry Wilson, Charles Sever, D. O. Evans, and R. Murray, Esqrs, be appointed a committee to carry out the same." Mr. D. O. Evans seconded the motion, and it was unanimously agreed to. – The proceedings terminated with a vote of thanks to the chairman.

2) Belle Vue on an August Bank Holiday

By the time of this newspaper article of 1870 Belle Vue Zoological Gardens provided a wide range of entertainments. It was inaugurated in 1819, with John Jennison taking out a ninety-nine-year lease on the land in 1836 and extending the existing gardens in 1843. In 1851 scenic artist George Danson came to work at Belle Vue, designing backdrops for the popular firework displays advertised in the article. Later a railway station, ballroom and lake were added, before John Jennison died on 20 September 1869. In 1870 the Italian Gardens, Indian Grotto and the New Maze were built, reflecting Belle Vue's continuing popularity.

Manchester Evening News. Friday, June 3rd 1870.

Zoological Gardens, Belle Vue.

Among the new attractions at Belle Vue, the great fireworks scene, both on account of its size and artistic excellence, first claims attention. The subject selected for representation on this occasion is the fall of Quebec, and it has afforded ample scope for the ready imagination and skilful brush of Messrs. Danson and son, of London, who have now for the 17th time produced the pyrotechnic display annually exhibited at these gardens. The town of Quebec, which has been termed the Gibraltar of America, is represented as it stood at the time of the decisive action which took place on September 13th 1759. It is situated on the banks of the St. Lawrence, and is irregularly built upon a very high and rocky table land. At the left of the picture the citadel is observed towering up on a

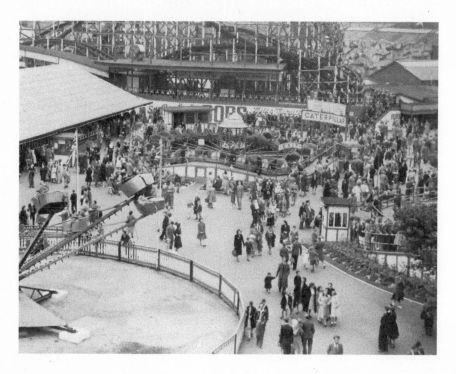

rock rising almost perpendicular to the height of 250 feet, and further to the right the castle of St. Louis is represented. A square – towered cathedral, several churches and public buildings, are distinguishable among the other erections as the eye passes along the picture. At the right there is a view of Orleans point, with the British fleet lying at anchor in the river. In the distance there is a range of mountains, while between the bottom of the rocky land on which the town is built and the river there is a space covered with trees and rocks which are brought out in a most effective manner. The first scene in the representation is a congregation of the medicine men of the powerful and warlike tribe of Irroquois Indians who are consulting regarding affairs of great importance to the tribe. They are staunch allies of the French, who are in possession of the town. While thus engaged, a boat from the British fleet approaches, and the Indians immediately make for the trees and rocks, where they effectually screen themselves from observation. A young officer lands from the boat, and, brandishing his sword, expresses supreme contempt for the whole race of redskins. He seats himself upon a rock and proceeds to take observations. The Indians suddenly emerge from their retreat and make a prisoner of the officer, and he is ultimately speared, scalped, and thrown into the river. The medicine – men engage in a war dance, and fire ships are sent down the river with a view to destroy the fleet. The British troops then debark in boats, form in front of the citadel, and the siege of the town is commenced. The besieging forces, covered by an effective fire from the fleet, proceed to storm the citadel by climbing the rock, and despite the exertions of the besieged – who by the use of hand grenades attempt to prevent them from ascending – they ultimately take the citadel, and the white flag of Orleans on its top gives place to the Union Jack. The scene terminates with a metaphorical representation. A transparency, which is sixty feet in length, by sixteen feet in height, exhibits General Wolfe, the hero of the siege, with Victory holding a

laurel wreath over his head, while round the top of the picture the words "Wolfe in the arms of Victory" are formed by an illumination with gas. The piece has been admirably conceived, and the effect produced is most pleasing. The different scenes have been boldly worked out, the distant mountain range and the judicious intermingling of trees, rocks, land and water in the foreground being particularly effective. Danson and son cannot be too highly complimented for the ability they have shown in the production of the picture. The same brush which has so ably depicted the different scenes in the fall of Quebec has completely altered the appearance of the large tearoom. The roof and walls have been elaborately decorated with a series of splendidly executed Chinese pictures. On the wall on the south side there are three large paintings, representing the Great Wall of China, the City of Nankin, and the Western Gate of Pekin, surrounded by a very effective border of Chinese fretwork, and these are surrounded by smaller pictures depicting Chinese manners and customs. On the west side a representation of the "Dragon," the national ensign of China, and a number of other pictures, have made a room which was comparatively unattractive into quite a picture gallery. A new apparatus, termed a "polycycle ring," has been introduced in the gardens and is likely to be well patronised. It has forty saddles, two abreast, and between each pair there is a seat for ladies. The wheels run round in grooved rails, the motion being imparted by the occupants of the saddles by treading as if they were on a bicycle. A considerable addition has been made to the flotilla of boats on the boat lake. With the view of more effectively supplying the wants of the inner man, the lemonade and ginger beer manufactory has been removed from its former location, and a handsome new building, 84ft., by 42ft., has been erected at the Hyde-road side of the gardens, where five tubs a day can be manufactured. The plants in the hothouses are in very fine condition. At the west side of the gardens a beautiful drinking fountain, of Grecian design, surmounted by a gas lamp, has been erected; and a new maze, of oval shape, 160 ft., by 120ft., is in course of formation. Extensive additions have been made to the hothouses, and several thousands of plants have been laid out in beds formerly occupied by the kitchen garden, which is now outside the grounds. A croquet lawn has been formed near the Longsight entrance, and several new rustic arbours have been erected. The zoological collection has been increased by the birth of three young lions, which were cubbed in the gardens about six months ago. We have no doubt the efforts of the Messrs. Jennison, as old caterers for the amusement of the public, will be abundantly rewarded by a large number of visitors during the Whitsuntide holidays.

3) Queen's Park Museum, Harpurhey

Queen's Park Museum and Art Gallery, Harpurhey, shown in 1992, was constructed in 1884. The park was purchased by Manchester Corporation in 1846. In 1870 the impending Whit Week holidays and associated attractions available to the residents of Manchester were front-page headline news. In the days when travel was limited, dependant on your social status and what you could afford to pay, parks and gardens were a very cost-effective way to enjoy a day out. They were also important to the health and well-being of the inhabitants of Manchester, acting as the city's 'lungs' in a polluted and smoky metropolis.

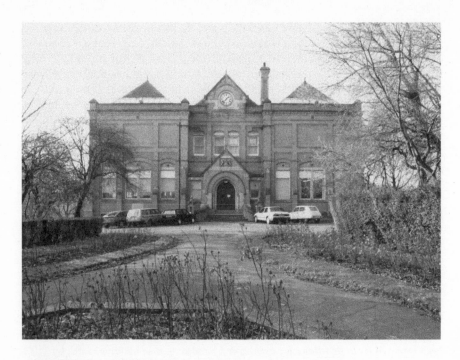

Manchester Evening News. Friday, June 3rd 1870.

Manchester will next week be to a great extent a deserted city. Its toiling masses will pour forth in thousands in search of recreation and enjoyment. While many will avail themselves of the facilities of railway travelling to fly from the smoke and dust, a much larger portion will be unable to seek any other retreat that can be found in the places of public resort, which are easily accessible. The city is highly favoured with outlets of this description, which are constantly being enlarged or improved to meet the requirements of a growing population. We supply a few particulars relating to the parks and some other places of recreation and amusement, which will not be without interest at this season.

QUEEN'S PARK MUSEUM.

There have been no alterations or improvements at this park during the past year which call for any lengthened comment. The walks in some parts have been re-asphalted, but otherwise the attention of Mr. Wilson, the head gardener, has been confined to keeping the grounds and shrub and flower beds in proper order. It is needless to say that in this he has been highly successful, and that the park presents a very fresh appearance. Hundreds of hothouse plants have been laid out in beautiful order in the flower beds, and the lawns have been newly mowed and dressed in anticipation of Whit Week. The park has attractions for young and old. The rising generations can enjoy themselves in the spacious playgrounds, which are well supplied with the best modern appliances for athletic and gymnastic exercises, while the contemplation of the scenery, and the manner in which the grounds are laid out, cannot fail to interest and please the visitors of more mature years. To those of an antiquarian and scientific turn of mind, a visit to the museum will afford considerable pleasure. Since last year, among other additions, a case showing the different elements of which the human body is composed, has been added to the extensive collection formerly exhibited

4) Manchester Racecourse

Many are not aware that the region once boasted a fine racecourse, with a long and proud history, although in 1870 the Jockey Club appeared to be doing their best to end this tradition! The *Manchester Evening News* is clearly supportive of the new venture and critical of the Jockey Club's proposals. From 1867–1902 racing was at New Barns, Weaste, Salford and Castle Irwell, Salford, for a second time, from 1902. The last race, the Goodbye Consolation Plate, was won by Royal Fury, which was ridden by Lester Piggott, on Saturday 9 November 1963. The site is now part of Salford University.

Manchester Evening News. Tuesday, June 7th 1870.

If the Jockey Club is to be guided by the advice of its committee, suburban meetings will very soon be placed without the pale of its laws. It has been decided by the committee that all race meetings at which money is charged for the admission of pedestrians shall be illegal; that the official "Calendar" shall not take any notice of them; that horses running at them shall not be allowed to start where the laws of the club are in force; that the trainers of these horses shall also be disqualified, and that jockeys engaged at these meetings shall be prohibited from riding elsewhere. This is a severe and vigorous course of action, which has very properly been proposed for the suppression of the many minor meetings that have sprung up within the last two or three years, especially in the neighbourhood of London. The objections to such gatherings are very strong, and are known to everybody having the slightest acquaintance with sporting matters. These meetings are simply got up for swindling purposes – that is from a racing point of view – the stakes being for particular individuals; they draw together the dregs and offscourings of the sporting world, and afford opportunities for practising all manner of vice and rascality. In short they are thoroughly disreputable. So far the decisive steps recommended for their suppression by the committee of the Jockey Club will be approved by every respectable member of the sporting community – by all who desire to redeem or maintain the respectability

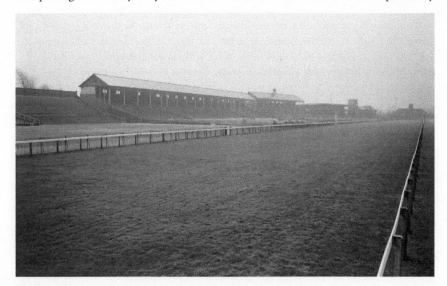

of the turf. But the purposes of this much-needed and excellent reform, in their virtuous indignation, have committed the mistake of making their measures far too wide and sweeping. Their recommendations embrace *all* meetings at which tolls are charged. Now some of these meetings are honourably conducted, and highly respectable, and therefore the new ruling, as regards such meetings, is clearly indefensible on any ground either of reason or justice. The question, indeed, thus becomes one of local importance, and it is on this account that we now refer to it. Manchester is a famous sporting as well as a famous commercial city. It is the only city besides London whose betting transactions are regularly quoted. It has a splendid new suburban course, second to none in the Kingdom, owned by a highly respectable company, and so admirably conducted that not one of the objections to which we have referred is applicable to it. Special care, in fact, has been taken to guard against every one of them. The prime object of the proprietors, indeed, has not been gain, but to afford a proper and easily accessible meeting place where the people of Manchester, at a very small expenditure of time and money, may at stated seasons enjoy the great national sport of horse racing. With this view the company chose a central position, and purchased the ground at a high price per acre, at double the amount for which suitable space could have been obtained six or eight miles out, at Ashton Moss or Newton. The site alone cost £20,000, and we believe that a sum of about £8,000 has been expended in draining, laying out, and fencing the land for racing purposes, besides something like £19,000 in the erection of stands and other accommodation. The company also give a very large amount of money (above £2,000) for first class stakes, all of which goes to the winners when the races are run. Of course toll is taken for admission, but so far from this being offensive, it increases the respectability of the meetings, owing to the excellent way in which the course has been enclosed. Now, if the suggestions of the Jockey Club's Committee are carried out, they will destroy the character of the races on this course, the attractions of which, during the next few days, will draw so many thousands away on pleasant holiday from the counters, the desks, and the factories in this busy city. But this is not all. It would be perpetrating a gross injustice in a pecuniary point of view to enforce them on the Racecourse Company, who have not the site on lease, but have purchased the freehold of it, and have a large amount of capital at stake. In view of such circumstances as these the Jockey Club should well consider the proposed measures before proceeding to put them in force. Let its utmost severity be directed by all means against the iniquitous suburban meetings which are fostered by dishonesty and for private purposes, but the vials of its wrath might surely, with as much propriety and justice, be directed against Epsom itself as against a course like that at Manchester.

5) Death of Charles Dickens, 1870

The death of Charles Dickens (1812–70), on Thursday 9 June 1870, led to mourning on a national scale. The Bishop of Manchester preached on Sunday 12 June 1870, a special evening service at Westminster Abbey commemorating the author's death, aged fifty-eight. He was buried in Poet's Corner, contrary to his wish to be buried at Rochester Cathedral, in an unostentatious and private manner. The *Evening News* also states that 'The flags at various public buildings in Manchester, and also that at the American Consulate, were hoisted half-mast high on Friday and Saturday as a token of respect to the memory of the late Charles Dickens.'

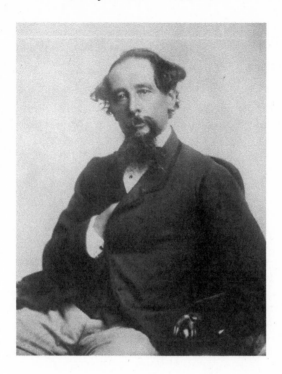

Manchester Evening News. Monday, June 13th 1870.

THE BISHOP OF MANCHESTER ON CHARLES DICKENS.

The Bishop of Manchester preached last night, at the special evening service at Westminster Abbey, from the words "Great is the mystery of godliness." The sermon has a plea for the toleration of differences of opinion where the foundations of religious truth were accepted. If the hope of a reunited Christendom were nothing better than a soothing dream, let us not, said his lordship, disturb it needlessly by misrepresentations and jealousies; there might be unity of purpose beneath wide divergence of thought and in spite of apparent differences of aim. In conclusion the Bishop said: It will not be out of harmony with the line of thought we have been pursuing – certainly it will be in keeping with the associations of this place, dear to English-men, not only as one of the proudest Christian temples, but as containing the memorials of so many who by their genius in arts, or arms, or statesmanship, or literature have made England what she is – if in the simplest and briefest words I allude to that sad and unexpected death which has robbed English literature of one of its highest living ornaments, and the news of which, two mornings ago, must have made every household in England feel as though they had lost a personal friend. He has been called in one notice an apostle of the people. I suppose it is meant that he had a mission, but in a style and fashion of his own; a gospel, a cheery, joyous, gladsome message, which the people understood, and by which they could hardly help being bettered; it was the gospel of kindliness, of brotherly love, of sympathy in the widest sense of the word. I am sure I have felt in myself the beautiful spirit of his teaching. Possibly we might not have been able to subscribe to the same creed in relation to God, but I think we should have subscribed in the same creed in relation to man –

he who has taught us our duty to our fellow man better than we knew it before, who knew so well to weep with those who weep, and to rejoice with them that rejoiced, who has shown with all his knowledge of the dark corners of the earth, how much sunshine may rest upon the lowliest lot, who had such evident sympathy with suffering, such natural instinct of purity, that there is scarcely a page of the thousands he has written which might not be put into the hands of a little child, may be regarded by those who recognise the diversity of the gifts of the Spirit as a teacher sent from God would have been welcomed as a fellow labourer in the common interests of humanity by Him who has asked the question, "If a man love not his brother whom he hath seen, how can he love God whom he hath not seen?"

6) Greengate, *c.* 1875

In 1870 traffic on Greengate (shown with the Bull's Head public house, at Salford Cross, in 1875), presented a not inconsiderable hazard to the pedestrian. By 1915, we can see that despite a change to motor transport, the situation regarding road safety had not changed. Greengate was originally a part of the historic centre of Salford and at the time of these newspaper reports was exceptionally busy, leading to Victoria Bridge across the River Irwell. Close to Manchester Cathedral, it is now part of the Cathedral Conservation Area. Today Salford Cross and the Bull's Head are demolished but were once part of Salford and Manchester's market centres and the site of the former Exchange railway station.

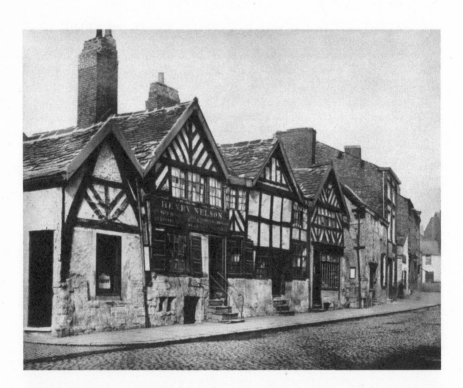

Manchester Evening News. Tuesday, July 5th 1870.

At the Salford Town Hall, yesterday, a man named Dennis Gilbody, who said he was a farmer, was charged with furiously driving a horse and cart along Greengate, and knocking down a man, named John Coope, breaking his leg and otherwise injuring him. The prisoner was remanded to Monday, and admitted to bail, himself in £40 and two sureties in £20 each.

Manchester Evening News. Wednesday, January 27th 1915.

MOTOR ACCIDENTS IN SALFORD. A Boy Killed.

A doctor was driving his motor-car along Greengate, Salford, yesterday, when a boy ran from behind a lorry, right in front of the car. He was knocked down, and promptly conveyed to the Salford Hospital. The boy, who was subsequently identified as Bernard Kerridge (4), of Boundary-street, died later from a fracture of the skull.

At the corner of Broad-street and Cross Lane, last evening, a motor-car and a tramcar came into collision, but fortunately nobody was seriously hurt. Alderman W.J. Smith, of Leigh, along with three ladies, was proceeding home in a motor, when in passing in front of the tram it was struck and jammed between the tramcar and an electric standard. The front wheels of the tramcar were lifted from the metals, and the motor-car was badly damaged.

Manchester Evening News. Friday, January 29th 1915.

Greengate Motor Fatality.

A verdict of accidental death was returned at an inquest at Pendleton, this afternoon, on Bernard Kerridge (4), of Boundary-street, Strangeways, who was knocked down by a motor-car in Greengate, Salford, on Tuesday.

Evidence showed that the boy ran from behind a lorry into the front of the motor-car.

A lorry driver said the accident was unavoidable.

STREET DANGERS. Another Fatal Accident in Manchester.

The jury at the City Coroner's Court this afternoon thought that a lorry driver named John Hooper, of Wellington-street, Bradford, was seriously to blame for the death of John Berry (36), a fishmonger, of Grey-street, Stalybridge.

Berry was crossing Thomas-street, at Salmon-street, Shudehill, in the early morning of December 8, when he was knocked down by a horse and lorry in charge of Hooper. Berry was badly injured about the leg, and died at the Royal Infirmary on Wednesday last from blood-poisoning.

The injured man before his death stated that the lorry came round the corner on its wrong side and the shaft struck him. The driver denied that he crossed on his wrong side, but witnesses of the accident declared that he "cut" the corner.

7) Gas Explosion, 1870

In 1807 gas lighting was introduced to Manchester, and a gas station at St George's Road, later known as the Rochdale Road Station, was opened in 1824. In 1844 control of the gas undertaking passed to the corporation. Rochdale Road Gas Station stood on over 9 acres and in 1894 could produce up to 8,500,000 cubic feet of gas. Gas making began in new premises on the same site on 16 December 1884 and 11 November 1892, in order to satisfy an increased demand from domestic and commercial gas consumers. It employed between 350–650 workers. In 1893 the length of mains pipes in the Manchester area totalled 975 miles.

Manchester Evening News. Thursday, December 1st 1870.
SERIOUS EXPLOSION AT THE ROCHDALE-ROAD GASWORKS.
ONE MAN KILLED AND ONE SERIOUSLY INJURED.

As briefly stated in our first edition, a serious explosion occurred at the Rochdale-road Gasworks shortly before 12 o'clock to-day, by which one man named Mark Clark, was killed, and another, named Frank Conway, received very serious injuries, which it is feared will prove fatal. A third man also received several injuries, but they were not such as necessitated his removal to the Infirmary. There are conflicting rumours with respect to how the explosion was brought about, but the real facts we believe to be these:- The Gas Committee have recently, at a cost of several hundred pounds, caused to be erected a new gas exhauster, which was broken and gas escaping from it worked its way into the exhaust house, where the three men were working, and coming into contact with a naked light a frightful explosion was the result. The engine room was set on fire, and the flames swept with considerable fury against the side of one of the gasometers. The fire brigade, under the command of Chief-engineer Leah, were immediately on the spot, and in about two hours the fire was subdued. The damage done to the exhauster is roughly stated at £100. Captain Palin and several members of the Gas Committee were present at the works shortly after the explosion.

8) Queen Victoria at the Official Opening of the Manchester Ship Canal, 1894

The Manchester Ship Canal opened on New Year's Day, 1894, before Queen Victoria's official 21 May visit (shown opposite page). At ten o'clock a procession of vessels, led by Samuel Platt's steam yacht *Norseman*, carrying the company directors, set out along the canal from Latchford. Thousands of cheering onlookers, steam whistles and sirens added to the celebration. *Norseman* was followed by *Snowdrop*, carrying representatives of Manchester City Council and *Crocus*, containing ladies and directors friends. A steamer owned by the Co–operative Wholesale Society, the *Pioneer*, unloaded its cargo of sugar from Rouen, becoming the first merchant vessel to be registered in the Port of Manchester.

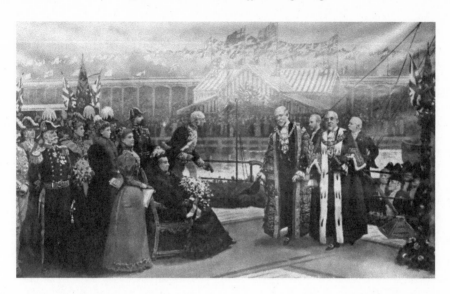

Manchester Evening News. Monday, January 1st 1894.

AT THE SALFORD DOCKS.

The scene at the Salford docks was one of much gaiety. There were sections of the canal, of course, which possessed much more interest from the technical point of view, but to the inhabitant of Manchester or Salford who claims the undertaking as his own the centre of attraction was his own doorstep. It is doing Manchester and Salford bare justice to say that they stood on their doorstep to-day with considerable pride. There was jubilation in the air. There was no very great display of bunting, it is true, and very little outward demonstration of any kind, but there was only one subject of conversation. Everybody discussed the Ship Canal, and every other person one met was either bound direct for Old Trafford or was running down to the office to open letters and getting there as quickly as he could. Trains and buses catered well for the town population and Old Trafford was in a state of much activity from a very early hour. The police took possession of the roadways shortly after eight o'clock. From the Old Trafford station, near the Northumberland Arms, to the Trafford Road Bridge constables were stationed about every fifty yards, and at the entrance to the road, and again at the extemporised turnstiles leading to the wharf on the Stretford side of the canal, there were batches of twenty or thirty. Trafford Road was completely closed to ordinary traffic. The bridge was not swung until eight o'clock, but rough barriers had been erected overnight at the Stretford Road end and except to those who had tickets there was no access. Notices had been issued, of course, to this effect, but the two or three drivers who attempted to run the blockade shortly after eight o'clock may be forgiven for not having seen them. The official notices announced that the road would be closed to ordinary traffic from eight o'clock to four. As early as eight o'clock the scene was fairly alive. Ticketless persons were sternly refused admission, but there was a constant stream of sightseers. Everybody nearly carried a basket or parcel and everybody seemed bent on seeing the thing through at any price. The favoured shareholders for whom the Trafford Wharf was reserved had probably the best view of the day's proceedings. There is no point from which the vastness of the canal can be seen to such advantage. The view from Mode Wheel is fine as a perspective, but to realise the extent of

the canal it is necessary to take up a position on the Trafford or timber wharf, immediately opposite the entrances to the Salford Docks. What is elsewhere a channel broadens out here into a magnificent sheet of open water – not too pure perhaps, but still magnificent. From a mere plan, such as we furnish elsewhere, it is impossible to realise the enormous extent of the docks. The bare statement that the water space amounts to 71 acres, and the area of the quays to 129 acres, is not likely to convey a proper idea. Few of us know what an acre means, especially when it is mixed up with seventy others. It will appeal more directly to the man who knows that four roods made an acre, but who is doubtful as to what constitutes a rood, to state that a walk round the quays means nearly four miles. Those who selected the Trafford Wharf as their standpoint were therefore fortunate. They not only commanded a full view of the canal up to Mode Wheel, but had the three large Salford docks immediately before them, fortunately there was ample space. If the company had been so disposed, in fact, they could have accommodated almost all their local visitors here. As it was there was more than room. There were long hours of waiting in the early morning, but there was no lack of incident. Two men in a boat were engaged between eight and nine o'clock in picking up the scattered bits of lumber, and in safely stacking them out of the way. Towards nine o'clock a tugboat came snorting from the Manchester docks in charge of a heavily-laden barge, and almost simultaneously another tug advanced from Mode Wheel with two or three in her train. The tugs, in fact, were puffing and panting about docks continually, affording much interest to the patient spectators, and giving many of them probably their first conception of a tugboat's services. There was no hope, of course, that the procession would arrive at Salford before one o'clock at the earliest, but the spectators were evidently prepared for the long wait. On the centre quay were a number of tents, erected apparently for the reception of the distinguished passengers. There were two or three flags scattered about. There was no great display. There was much enthusiasm of a quiet sort, but cheers were reserved for the arrival of the vessels, which for the first time brought their merchandise to our doorstep.

THE SCENE AT CENTRAL STATION.
The Central Station this morning, shortly before the eight o'clock express to Liverpool was due to depart, was exceptionally busy. All the platforms were crowded with people en route to Latchford Locks and the Prince's landing stage. The ordinary train was quite unequal to the task of accommodating half the passengers and several specials were put on. Among the passengers were members of the Arts Club and the Manchester Conservative Club bound for Liverpool, where they will join the boats which they have engaged to carry them in the procession to Manchester docks. The City police band, in their smart uniforms, were conspicuous among the throng, and informed inquirers that they had been engaged to enliven the journey of the members of the Arts Club by selections of music. From the windows of the train occasional glimpses were caught of the canal, and the most interesting points were duly pointed out. Several vessels were seen in the waterway, some of them were gaily decorated with bright-coloured streamers and flags.

9) Manchester United, FA Cup Winners, 1909

Bristol City versus Manchester United was played at the Crystal Palace, London, but did not live up to expectations. United were 1–0 winners, the goal scored by Sandy Turnbull in the twenty-second minute. Turnbull had previously played for the victorious Manchester City cup winning team in 1904. His team mate, Billy Meredith, had also

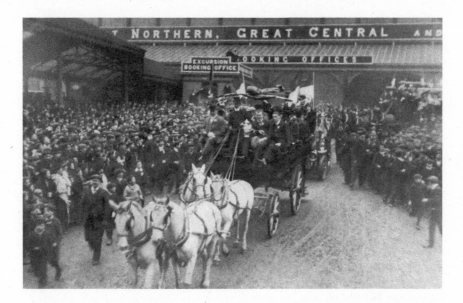

featured in the same Manchester City line-up. Both teams usually played in red, so changed their strips. Bristol City wore royal blue shirts and white shorts. United wore all white with red trimmings, and a red chevron, including red rose design, on their shirts.

Manchester Evening News. Tuesday, April 27th 1909.

UNITED'S HOME-COMING.

Scenes at the Departure from London.
WILD ENTHUSIASM AT MANCHESTER.

Our London correspondent telegraphs:- The last I saw of the Association Football Cup was as it was waved in the air by its proud possessor, Mr. Mangnall, the Secretary of the Manchester United Football Club as the 0600 train sped out of St. Pancras station en route for Manchester.

The team had had a most pleasant experience this week-end. Yesterday afternoon the players and those who have been playing with them had a drive out to Hampstead Heath. " 'Appy 'Ampstead" as Londoners delight to call it.

It was with real regret that many of the party returned to the North…..The players left the hotel shortly after eleven o'clock. Charlie Roberts and Duckworth walked to St. Pancras but the bulk of the party travelled to the station in buses belonging to the Imperial Hotel. A small crowd gathered round the players as they departed, and raised a cheer and a cry of "Good old Manchester."

THE SCENES AT ST PANCRAS.
On the platform there was a scene of bustle, some photographs which had been taken during the later stages of the training at Chingford were distributed by the photographers who had developed them. It was as much as the porters could do to get the players and their friends into the train and the ticket collector was at his wits' end to get the small bits of paper board which entitled them to travel on the train.

At last the signal for departure was given by the station-master and the train began to move. The crowd which had gathered round the carriages gave voice to their feelings, and cheers and cries of "Good old Manchester" were heard all round. Mr. Mangnall was carrying the cup in his hand, and waved it at the crowd as it was rapidly being carried away on its journey to its resting place for the next twelve months.

GREAT CROWDS AT CENTRAL STATION.

An hour before the time the train was due to arrive at Central Station large crowds of people assembled outside the station, and behind the barricades of the approach leading to the platform at which the London train usually comes in. The great majority wore the United colours and an ice-cream merchant attracted considerable attention with his huge red and white umbrella and his similarly coloured barrow. ...merchants who did a good business with memory cards of Bristol City came in for a good deal of good humoured badinage, while the United favours attached to a cardboard representation of the English Cup sold like hot cakes.

SCENES OUTSIDE THE TOWN HALL.

Long before the time for the tram to arrive at the Town Hall, Albert Square was occupied with people, and when they did arrive there were several thousands anxiously awaiting to see the victorious players. The police had great difficulty in keeping the crowd in order and barricades had been erected right round the square. Great enthusiasm prevailed even before the party from the station put in an appearance.

THE ARRIVAL.
Wild Scenes of Enthusiasm.

The greatest pressure was just outside the station, where a strong body of police had considerable difficulty in keeping back the crowd. Five waggonettes, gaily decorated with red and white bannerettes and ribbon, were in waiting, two entertaining members of the St. Joseph's Industrial School Band. The arrival of Rocca's Brigade, gaudily dressed in the colours of the United club, was the signal for an outburst of cheering. At first they were not more fortunate than many who made impertinent demands for admission to the platform, but eventually, amidst much pushing, the waggonette was allowed to pass through.

They had not been there many minutes when the London train hove in sight, and amid a scene of wild enthusiasm Mr. Mangnall emerged carrying the cup on high, followed by the players, their wives and other people who had travelled from the Metropolis.

A GREAT SCRAMBLE.

The band struck up "See the Conquering Hero Comes," and there was a great scramble by the crowd, which had been permitted to enter the platform to reach the players.

Some were carried shoulder high and ultimately they were comfortably seated in the third waggonette. To the accompaniment of enlivening strains of music by the boys of St. Joseph's school, the procession moved out of the station, and its appearance was signalled by a tremendous outburst of cheering.

Sticks were waved, hats were thrown in the air, and the enthusiasm was unbounded when Roberts, carrying the trophy, came into view. The police had all their work cut out to prevent the crowd "rushing" the waggonette, but happily the vehicle passed along the approach without mishap.

10) Ford Motor Company, 1914

In April 1914 the Ford Motor Company announced their intention to improve the wages and conditions of their employees. Earlier that year the company had revealed plans to share their profits with workers, which meant that those based in Detroit would be paid $5 for an 8-hour day. Ford came to Trafford Park in 1911 and quickly established themselves as one of the main employers. By 1914 entire Model T Fords were built on moving assembly lines. They relocated to Dagenham in 1931. This report clearly shows why the Trafford Park venture had been so successful for the American firm. The picture shows Henry Ford (1863–1947), second left, in 1928.

Manchester Evening News. Saturday, April 18th 1914.

Varieties of Employers.

There are all sorts of employers, and in the best section, indubitably, must be included the Ford Motor Company, of Detroit and Manchester, who yesterday announced their intention of setting apart from their profits for the benefit of their employees a sum which will be sufficient to increase the pay of the average workman from ten pence an hour to one shilling and threepence. They and their workpeople may be heartily congratulated on the position in which they find themselves, the firm on having the inclination and the means to do this generous thing, and the workpeople on being in the employ of a directorate so enlightened and so public-spirited. We are afraid that the spread of the glad news will rouse the vice of envy in the breasts of the employees of many other firms and that the applications for any vacant posts there may be at the Ford Works in Trafford Park will be inconveniently numerous. Indeed, unless the advertisement and the popularity which the firm has gained by its action should lead to further large extensions, it is improbable that there will be any vacancies, so anxious will the existing staff be to do

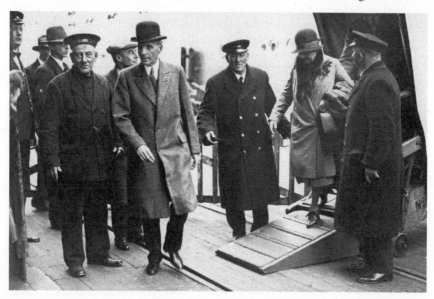

more than their duty for people who treat them so well, and so determinedly will they stick to the positions which they have got, having always in view the extreme unlikelihood of finding any other firm of engineers whose rates of pay are on the same generous scale. Curiously enough, the relations between another employer and his workpeople in a very different branch of industry are engaging the attention of the public at the present time. We refer, of course, to Lord Lilford, the well-known breeder of shorthorns, who has an estate in Northamptonshire. He also has the reputation of a good employer. To his labourers he pays 15s. a week and a few extras, with which surely they ought to be content! But it has come to his ears that these men have actually had the audacity, while serving him, to enter a trade union, an organisation avowedly run to improve conditions of work and rates of pay. They have become parties to an agitation for getting more than 15s. a week, and perhaps even worse, for securing a half holiday every Saturday of their lives. His lordship can not tolerate that – he has told them that they must either leave the trade union or his employ, and some of them, hardened sinners, have accepted their discharge. We are sorry for them and also for the noble lord. He must be aware when he looks around that everybody organises nowadays – peers of the realm, all the great captains of industry, all professional men, artisans, both men and women, by the million, everybody almost. Then why should the bottom dog, poor Hodge, with his pitiable 15s. a week and his hopeless outlook, be discharged because, in the hope of bettering his lot, he copies the example of his betters? We cannot understand it. All industrial history shows that no considerable section of the community has permanently and considerably improved its lot without organisation, and we are driven to the conclusion that those who would kill organisation among working people would prefer to see working people's conditions no better in the years to come than they are now. In this respect the action of the American Motor Company contrasts very favourably with the action of the English aristocrat.

11) Richard Jennison, 1906

The death of Alderman Charles Jennison was headline news in 1914. The Jennison family had built Belle Vue from humble origins in 1836 to a major 50-acre entertainment complex by 1914. Charles, Richard (shown opposite in 1906) and James Jennison were sons of the founder, John Jennison and were proprietors at the time of Charles' death. Their ownership of Belle Vue continued until it was sold by the family in 1925 to Belle Vue (Manchester) Ltd. Over the years the family had extended the existing gardens, built a boating lake, racecourse, the entrance at Longsight, ballroom, brewery, railway station, athletics ground and extended the zoo accommodation.

Manchester Evening News. Saturday, May 2nd 1914.

ALD. C. JENNISON.
A proprietor of Belle Vue Gardens.
USEFUL PUBLIC CAREER.

We regret to announce the death, which occurred at three o'clock this morning, of Alderman Charles Jennison, the senior proprietor of the famous Belle Vue Gardens, Manchester, at the advanced age of 79 years.

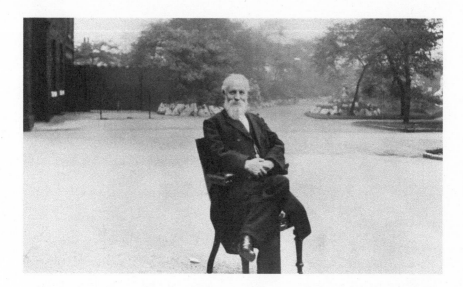

For over half a century Mr. Jennison had been actively identified with the public affairs of Manchester, and more particularly of the Longsight and Gorton districts. Whilst serving the city and the county at large – he was also an alderman of the county – he always felt that he owed a special duty to the district immediately surrounding Belle Vue Gardens. He was immensely popular in that now densely populated and rapidly developing area which the gardens have made famous, and the news of his death will occasion unfeigned sorrow amongst a very wide circle of friends, both public and private. He was an enthusiastic bowler, and for many years was president of the Longsight Cricket Club.

Mr. Jennison was a Conservative in politics. His chief study was natural history, and he was one of the best authorities in the county on this subject. He had a bungalow just below Bradda Head, at Port Erin, Isle of Man, and many of his friends can speak of pleasurable visits spent there and of thrilling experiences in deep sea fishing.

The death of Mr. Jennison marks an important episode in the history of Belle Vue Gardens. A brief sketch of the gardens is appropriate as a record of the principal work of his long and honourable life.

THE FAMOUS GARDEN.
Their Origin and History.
To many thousands of people "Manchester" really means Belle Vue. They think of the city merely as an adjunct of the gardens, for the place has been for nearly three-quarters of a century the greatest centre of recreation, entertainment, and amusement in the North of England, only rivalled in the whole country, indeed, by Crystal Palace in its heyday. And during those many years millions of people from all parts of the Kingdom have spent happy and instructive days and evenings there, often, possibly, without getting even a glimpse of the city.

Belle Vue sprang from small beginnings. Nearly a hundred years ago Mr. John Walker occupied a house and about 36 acres of land in Hyde Road. A bowling green was almost the sole public attraction to the place, which even then was known as Belle Vue Gardens. Mr. Walker's expectations of fortune do not seem to have been realised, for in 1833 he sold

his interest to Mr. William Crisp, who extended the garden by adding to it land which had previously been used for grazing.

FIREWORKS INTRODUCED.

At that time Mr. John Jennison had a garden of about half an acre at Stockport, where he kept a small collection of wild animals. When Belle Vue was sold to him by Mr. Crisp on June 25th 1836, he transferred them to his new home, and as time went on increased their numbers, extended the gardens, and started a botanical collection.

Such developments were often carried out with great difficulty, but his energy and perseverance were fittingly rewarded for the public patronised the place in steadily increasing numbers.

It was not until 1852, however, that Mr. Jennison started a feature which was probably the real foundation of all his subsequent success. In that year he provided the first great out-door spectacle.

Since then the Belle Vue fireworks have become almost world famous.

THE THREE BROTHERS.

Mr. Jennison died in September, 1869, and was succeeded in the ownership and management of the gardens by his four sons, one of whom, however, passed away many years ago, leaving Charles, Richard and James to carry out the work. They did so in the true spirit of great caterers for cheap public entertainment. They appeared to regard Belle Vue as a heritage confided to their keeping by a father whom they held in the highest reverence, and demanding as much care and attention as any landowner could bestow upon a great estate.

James was the one most concerned with their actual management. A great zoologist, and a clever botanist, he studied and tended the animals and plants; an expert chemist, he devised and manufactured the fireworks; a master of organisation, he was chiefly responsible for the arrangements for the great band contests which almost as much as the fireworks, have contributed to the fame of Belle Vue.

Charles concerned himself with the welfare of the gardens where legal rights and interests were involved, and Richard always seemed happiest when moving about amongst the crowds of visitors, interesting himself in the comfort of as many as possible. We should not omit to mention either the notable part which the late Mrs. Richard Jennison played in the management of that part of the huge catering department in which women are chiefly employed.

Beyond these claims upon their thought and labour, Charles and Richard found time for public service also. The former served on the Prestwich Board of Guardians for a time as chairman and also upon the Gorton Urban District Council, and when Gorton was brought within the boundaries of Manchester he, being at the head of the poll of ratepayers, became an alderman of the city. Richard was for a number of years a member of the Chorlton (now the South Manchester) Board of Guardians.

FURTHER DEVELOPMENTS.

The brothers adhered strictly to the policy of their father in making timely additions to the attractions of the property. From time to time the grounds were extended. To-day they cover 50 acres. Buildings for new features were added as the need arose, and to-day, in the great assembly hall and its galleries and the refreshment rooms, cover is provided for 40,000 people. Many great demonstrations have been held in the grounds.

Belle Vue may fairly claim to have had much to do with encouraging and developing a love of music amongst the working classes of the north. Thus, and in many other ways we have indicated – all better perhaps than the ostentatious giving of alms – the Jennisons, with Mr. Charles at their head, have been and are real benefactors of the public.

12) Emmeline Pankhurst

Emmeline Pankhurst (centre, in 1913), was born in Moss Side, founded the Women's Social and Political Union, and was a political activist whose organisation demanded 'deeds not words'. Independent and often violently opposed to established political parties, the organisation became known for its use of force and confrontation. Property was vandalised and police attacked, with the subsequent prison sentences leading to hunger strikes. Arson was a common tactic, so the reported mailbag fire would not appear unusual. In 1918 the Representation of the People Act granted votes to women over thirty. After Pankhurst's death in 1928, the voting age was lowered to twenty-one.

Manchester Evening News. Monday, July 13th 1914.

An explosion took place in one of several mail-bags which were being conveyed from Blackpool Central Station to Manchester and Midland districts on Saturday midnight.

As the train passed through Salwick Station Guard Barlow, of Manchester, was sorting the bags when one suddenly exploded and set fire to six others and also to parts of the van. The guard, although badly burnt about the hands and arms, succeeded in extinguishing the flames and threw the smouldering bags upon the railway embankment at considerable personal risk.

The train was stopped and the mails were removed to the sorting office at Preston Station, where the postal staff were engaged until noon yesterday in endeavouring to forward the contents to their various destinations. In the bag which exploded a burst bottle, a quarter of an inch thick which had contained sulphuric acid was discovered, together with a flashlight filled with white powder. The whole contents of the bag were damaged or destroyed, but by dint of strenuous work the postal officials were able to forward the contents of the remaining bags to their destinations. But for the resources of the guard the damage would have been far more serious.

The outrage is attributed to Suffragettes, and the police are making inquiries.

13) Manchester Liners, 1914

Manchester Liners were founded Tuesday 3 May 1898, as a partner to Furness, Withy & Co. *Manchester Commerce* was built in 1899, was 5,363 tons and was registered at the Port of Manchester (shown below in 1967), as were all Manchester Liners. The second *Manchester Commerce* (1906) was renamed when purchased by Manchester Liners in 1916. In 1917 it was torpedoed and sunk by U-boats in the Straits of Gibraltar. *Manchester Commerce* (1899) was outward bound for Quebec City when it was sunk off north-west Ireland by a mine. The headline is significant in that it was the first merchant ship to be lost in this way.

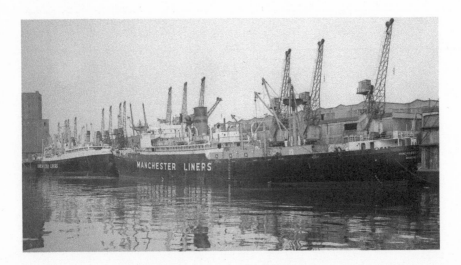

Manchester Evening News. Tuesday, 27th October 1914.

MANCHESTER LINER LOST OFF IRELAND.

STRIKES A MINE.
Fourteen Lives Lost.

Our Belfast correspondent telegraphs:

News reached Belfast this afternoon that the Manchester Liner Manchester Commerce struck a floating mine in the North Channel and sank.

The Captain and thirteen of the crew were drowned.

The survivors were picked up by the steam trawler City of London in the vicinity of the occurrence and called today at Carnlough on the Antrim coast the trawler subsequently proceeding to Fleetwood with the survivors, thirty all told.

(The North Channel is North of the Irish Sea between the coasts of Ireland and Scotland).

POSTED AT LLOYDS.

The following notice was posted at Lloyds this afternoon.

Fleetwood trawler City of London put into Carnlough Bay, County Antrim this forenoon, and reported having picked up 30 of the crew of the S.S. Manchester Commerce (5,363 tons), which foundered after striking a mine, latitude not being stated. Captain and 13 men perished.

Survivors are going into Fleetwood on the trawler, and are due early on Wednesday morning.

The Manchester Commerce was outward bound from Manchester and a report (unconfirmed) from the coast says the disaster happened after midnight, but this is not regarded as likely. Carnlough Bay being only 14 miles from the mouth of Belfast Lough.

LEFT MANCHESTER ON SATURDAY.

The Manchester Commerce left Manchester docks on Saturday, outward bound for Montreal, her usual port of destination. She carried a large general cargo. Several of the boats of the Manchester Liners Limited, have recently been engaged as transports, but the Commerce was not one of them.

NAMES OF THE CREW.

The crew of the Commerce were:

Captain C. Payne, of Hull.
W. A. Caldwell Thornfield, Priory Road, Sale: First Mate.
W. F. Gee, of Henley; Second Mate.
C. H. Evarest, Liverpool; Fourth Mate.
A. W. Millerman, Ewbridge-Street, Salford; Carpenter. F. W. Dennett, Rossall-Street, Pendleton; Boatswain.

ABLE SEAMEN.

John Collins, Gill Street, Pendleton.
A. Savage, Liverpool.

W. Haydock, Johansen-St., Lr. Broughton.

C. Wood, Park Place, Salford.

A. F. Forrest, Hathersage-Street, Oldham.

A. Walker, Edensor Place, Hulme.

J. Hughes, Barton Grove, Patricroft; deck boy.

J. Ahearn, Kinsale.

N. Pederson, Bergen, Norway.

G. Farra, Italy.

ENGINEERS.

W. L. Arter, Humphrey-Street, Old Trafford; First Engineer.

A. H. Warren, Widnes; Second Engineer.

F. Frankland, Maryport; Third Engineer.

J. Grace, Eccles New Road, Weaste; Fourth Engineer.

J. Anderson, Chester Road, Stretford; Junior Fourth Engineer.

FIREMEN.

A. McLacklan, Garston.

E. Haresnape, Liverpool.

C. Maller, Hartlepool; donkeyman. D. Burgess, Penny-Street, Pendleton; Door-Keeper.

TRIMMERS.

P. Flanagan, Southall-Street, Harpurhey.

R. M'Gregor, Howard-Street, Salford.

R. Rae, Garfield-Street, Salford.

P. Wenderberg, Garfield-Street, Salford.

J. Doyle, Park-Place, Salford.

A. M'callum, Henry-Street, Salford.

P. Burns, St. James-Street, Salford.

A. Mossa, Ruby-Street, Salford.

T. M'Keirnan, York-Street, Pendleton.

Sam Ianan, Abyssinia.

T. Morrisey, Hulton-Street, Salford.

John Burke, King William-Street, Salford.

STEWARDS.

R. Speaks, Weaste Road, Weaste (Chief).

F. Denny, Hamilton-Street, Old Trafford (Second).

J. Wilson, Alpha-Street, Seedley.

COOKS.

G. Watson, Westbourne Grove, Higher Broughton.

R. F. Williams, London.

THE CHIEF OFFICERS.

The Captain of the vessel was well known in Manchester and had been with the Manchester Liners Limited, for many years.

Mr. Caldwell, the First Mate, who is also well known in the city, has occasionally commanded liners belonging to the company.

The Manchester Commerce was a steel screw steamer of 5,363 tons and was built at West Hartlepool in 1899. She was owned by the Manchester Liners Limited. According to Lloyd's register her Captain was Mr. C. W. B. Payne.

The crew numbered 44. The liner was on a voyage to Montreal.

14) Inspection at Heaton Park, 1915

Heaton Park (shown *c*. 1915) was home to the 17th Battalion Manchester Regiment. Initially they were accommodated in tents near to Heaton Hall, moving to huts near the St Margaret's entrance, as the winter conditions worsened. Later they were joined by the 18th Battalion, who were previously based at White City, Old Trafford. Despite the quagmire, conditions the training facilities were of the highest order. This article is essentially a 'recruiting aid' and it is no coincidence that the 17th Battalion are referred to as the 'Best Fed Battalion'. The healthy lifestyle at Heaton Park is emphasised, although they were shortly about to vacate this base.

Manchester Evening News. Friday, February 12th 1915.

"PALS IN KHAKI."

17TH MANCHESTER'S NEW SCEME.

Soldiers who grow out of their clothes.

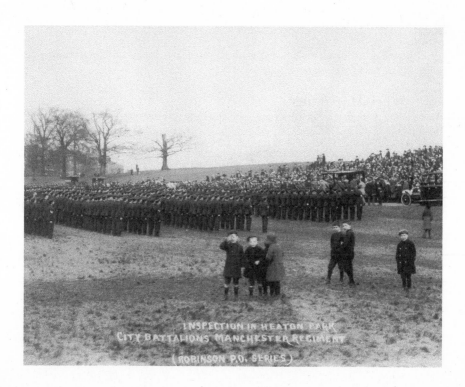

Of the four battalions of the Manchester Regiment now at Heaton Park none have yet secured the full numbers for the extra company which must go abroad with them when they cross the English Channel. The officers and men of one at least, however, – the 17th commanded by Colonel A. H. Johnson – have determined that there shall be no further delay in completing the establishment of 1,300. Indeed, they are aiming even higher, and hope to raise another extra company, a sixth, to act as a feeder for the battalion when it goes on service.

A scheme has been drawn up which will ensure that the 17th Battalion shall be brought prominently before the notice of eligible men. To-morrow morning a recruiting office will be opened, specially for this battalion, at the Market-street end of Spring Gardens, with a doctor and attesting staff in attendance, and next week the members of the battalion will be brought into Manchester to assist in bringing up the men.

THEATRE PARTIES.

The week will be devoted to recruiting as well as to training. On Monday, Wednesday, Thursday and Friday companies of the 17th Battalion, 250 strong, will proceed to the Theatre Royal pantomime, "A," "B," "C," and "D," companies taking their turn on the respective evenings. They will be seated together in the pit, and each evening a five minutes recruiting appeal will be delivered from the stage.

The companies will proceed from and return to the park in special tramcars, which are being provided free by the Corporation. It only needs the illuminated car to be used to make the event complete.

On Tuesday the battalion will have a route march through the city, headed by the R.F.A. Band, by way of Miller-street, Swan-street, Oldham-street, Piccadilly, Market-street, St. Mary's Gate, Deansgate, Peter-street, Oxford-street, Whitworth-street, Chorlton-street, Portland-street, Piccadilly, Mosley-street, Princess-street, to Albert Square, arriving there at 12.30.

The battalion will remain about the town for about two hours, and then reassemble in the Square for the march back.

ISSUE OF KHAKI UNIFORM.

The 17th Battalion are now being served with khaki uniform and new leather equipment. The khaki is of the best quality, and the battalion will no doubt look as soldierly as any in the regiment.

Probably the issue will be completed early next week. Delays, however, may be unavoidable in some cases, as it has been found that the old measurements are of no use. Almost without exception the men have grown broader and taller during the five months they have been in training, and the "small sizes" have all had to be returned to stores.

"THE BEST FED BATTALION."

The open-air life, early rising, and regular exercise have contributed to this improvement, but those who are on the spot are inclined to give credit equally to the excellent commissariat.

Having to-day inspected this week's dietary and also examining the stocks of beef, bacon, etc., in the stores, our reporter is ready to accept the claim that is made for the battalion of being the "best fed in the North of England".

Certainly the dietary is both generous and varied, from the coffee and biscuits in the early morning to the hot soup at night. The fact that the officers tables are served from the same stores is sufficient evidence of quality.

Members of the battalion are to-day visiting some of the Manchester warehouses with a view to securing recruits, and the visits will be continued next week. The number required at the moment is 150, but the battalion hope to recruit up to 400, so that when they are asked to move – which should not now be long – they will have all the men they need.

15) The 17th Battalion and Lord Kitchener, 1915

The 17th Battalion, shown marching past Manchester Town Hall and Lord Kitchener, on Sunday March 21st 1915, was officially raised on Friday 28 August 1914, with arrangements being made for the regiment to be based at Heaton Park for their initial training. They were accommodated in tents whilst the weather was fine but were rehoused in huts during the winter months. They were also instructed at the Manchester Artillery Drill Hall on Hyde Road, Ardwick. Although this newspaper report does not refer directly to the one attended by Lord Kitchener (shown far right below), it gives a good idea of the mood and atmosphere which these events were intended to generate.

Manchester Evening News. Tuesday, February 16th 1915.

MARCH IN KHAKI.

17TH MANCHESTERS IN THE CITY.
Striking Spectacle in Albert Square.

Manchester is making big recruiting records. Nearly a hundred men were enlisted in the city yesterday, and to-day the number of additions to the "Contemptible Little Army"

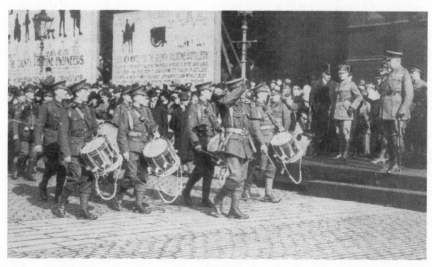

will probably again reach the three figure total, which has been more than maintained as a daily average in recent months.

Today's contribution will, no doubt, be assisted, as was yesterday's, by the special effort of the 17th Manchesters at Heaton Park to be the first of the "City" battalions in possession of the full numbers for its extra companies.

The 17th Battalion had recruited at their new office in Spring Gardens about forty men up to last night. To-day, they should almost double that total as a result of the raid on the city, which culminated at the dinner hour in the arrival of the battalion, 1,100 strong, in Albert Square.

AN EFFECTIVE ARRIVAL.

The recruiting route march which the battalion made from the park to the city was made more effective by the fact of the men being in khaki uniforms, with the exception of some 25 ex-Manchester policemen, recently poined, and some few others – "out sizes" – who were still in blue.

"Soldierly" is the only word with which to describe the appearance of the battalion as they marched into the Square to the strains of the R.F.A. Band, and the scene as it was viewed by the Lord Mayor (Alderman McCabe) and other members of the Corporation from the Town Hall steps was as picturesque as it was inspiring.

The marching of the men had been excellent – in Swann-street the people, crowded on the footpaths and hanging out of the windows, gave them hearty cheers for it – and they were followed into Albert Square by thousands of appreciative sightseers.

Colonel H.A. Johnson was in command, and the other mounted officers were Major Corwell (Second–in-command), and Captains Lloyd (acting adjutant), Macdonald, Whitehead, Kenworthy, and Aitken.

THE BIGGEST MEETING.

When the "Dismiss" was ordered there must have been three or four thousand at least in the Square. The recruiting meeting which had been fixed for this point was therefore sure of a big audience.

The crowd, in fact, was the biggest that had been so far attracted to a Manchester recruiting meeting either before or since the Belle Vue demonstration. Mr. J.B. Martindale's address in the opening meeting was worthy of the occasion. Mr. Martindale, who is the prospective Liberal candidate for Widnes, was wearing the uniform of an officer in his capacity of organising secretary of the Red Cross work in the East Lancashire Division. His appeal, expressed in a voice which carried to the borders of the crowd, was couched in terms which could not fail to convince. He reminded the meeting of the great and glorious history of the Manchester Regiment, which had "never gone abroad to fight for England's glory without achieving distinction." In France the Manchester Regiment had done greater and braver deeds than ever before. Manchester had a commercial fame as well as a military fame, and men engaged in its commerce had now gone into the ranks of the army to uphold both.

A PARABLE.

They had all heard of the parable of the vineyard, in which those of the labourers who entered at the eleventh hour received the same hire as those who entered at the first. "The battalions at Heaton Park have laboured in the vineyard for some months. They now ask you to join them at the eleventh hour at the same pay," said Mr. Martindale. "It is a

glorious opportunity. Support the officers and men who are doing so much for you. Join the 17th Battalion, and make it complete."

Mr. Basil Jones, transport officer of the East Lancashire Red Cross Society, also spoke, and whilst Messrs. W.F. Wallis, A.W. Hildreth, Tom Smith, and other speakers waited their opportunity to urge the nation's call from the rostrum, the men of the 17th went about the fringe of the crowd whispering the same message into the ears of the likely-looking men who formed part of the big audience.

The battalion reassembled in the Square shortly after two o'clock, and their marching off was witnessed by another large crowd.

The visits of the respective companies of the 17th Battalion to the Theatre Royal pantomime will be continued to-morrow, Thursday, and Friday evenings, and on each occasion a recruiting appeal will be made from the platform. The Lord Mayor has promised to say a few words from the stage on Friday evening.

OFFICIAL INSPECTION OF RECRUITING.

Colonel Wilson who has taken over the command of the No. 3 Regimental District – a section of General Sir H. Mackinnon's command – paid a visit to Manchester to-day, and made a tour of the recruiting centres, accompanied by Captain Walkley.

At all the centres there was something doing, and some stations were quite busy. At the Houldsworth Hall fifty men had offered themselves for the vacancies in the Mechanical Transport Department.

Here also men are being accepted for the 25th Royal Fusiliers (Frontiersmen) – a battalion which is being specially raised for colonial duty and to which it is hoped to attract a number of ex-soldiers.

Members of the Legion of Frontiersmen – who must be either good shots or ex – soldiers, and between the ages of 20 and 45 – are being invited by Colonel Driscoll, their leader, to join this battalion, which is expected to proceed to a colonial post almost immediately.

Full information can be obtained at the Veterans' Club in Market-street, and men can be enlisted at any station, subject to final approval at Great Scotland Yard, London.

THE HOUSEHOLD CANVASS.

Captain Walkley, the Manchester recruiting staff officer, has so far dealt with 7,500 of the returns sent to him containing the names of men understood to be fit to join the Army.

Just under one-third, or 2,350, have responded, and of these 626 have been accepted, 1,238 rejected, and 486 are employed on Government work. The effort to secure the attendance of the others is being continued, but the task is not an easy one.

Among the men who presented themselves at Palatine Buildings yesterday was an ex – soldier of the Manchester Regiment who since his discharge has lost three fingers of his right hand by an accident at his work. He was offered enlistment for depot duty at home, but he protested that he could use a rifle perfectly, and he pleaded hard to be taken for general service. At last he was accepted, subject to the approval of the depot authorities.

16) Port of Manchester

This *Manchester Evening News* article describes the 'exciting passage of Manchester vessel'. The *Ousel*, of the Cork Steamship Company, was sailing on its regular route between Rotterdam and Manchester docks (shown on the next page in 1951), when it was attacked

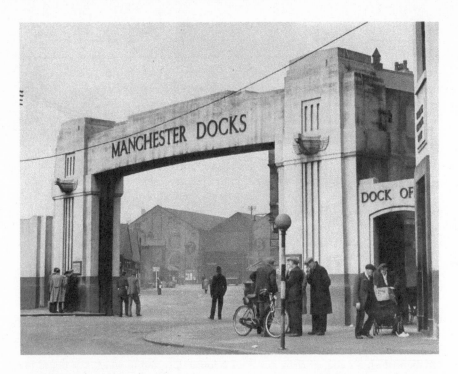

and 'bombed' by German hydroplanes. The method of attack would appear to be rather primitive to the modern reader, but it must be remembered that if it had not been for the skilful seamanship of the *Ousel's* captain the outcome could have been much worse. The crew were unarmed and it must have been a terrifying experience for them, although the story makes good reading!

Manchester Evening News. Thursday, April 8th 1915.

BAFFLED AIRMEN.
EXCITING PASSAGE OF MANCHESTER VESSEL.
Eleven Bombs Dropped.

Another Manchester vessel, the Ousel, has had an exciting experience, as a result of Germany's terrifying form of attack on British shipping – the dropping of bombs from aircraft. On this occasion two German hydroplanes did their best to sink the steamer, dropping no fewer than eleven bombs without success.

The Ousel, a vessel of 1,234 tons register, is on the regular service between Manchester and Rotterdam, and is the third steamer of the Cork Steamship Company to be attacked in this way, the others being the Lestris and the Pandion. As in the previous cases, no damage was done, though one or two bombs dropped so near the Ousel that water splashed on to the decks.

According to the story of the skipper of the Ousel, Captain M'Neill, and the chief officer, Mr. J. Jamieson, the vessel left Rotterdam for Manchester on March 27th with a general cargo. When about fifteen miles east of the Galloper lightship two large German

hydroplanes were seen, evidently bent on overtaking the Ousel, for they made straight for her and manoeuvred to get directly over the steamer.

BOMBS DROPPED FROM 500 FEET.

At the time the weather was perfectly clear, with a fresh north-east breeze blowing. The air ships succeeded in getting over the vessel, and from a height of about 500 feet they dropped eleven bombs, which fell into the water and exploded with terrible force, and threw up a column of water as high as the masthead. Thanks, however, to skilful seamanship the vessel escaped disaster. Captain M'Neill altered the Ousel to windward, and steering a zig-zag course, the bombs fell harmlessly into the water, the nearest missile being twenty-five feet and the farthest fifty feet. While Captain M'Neill and Mr. Jamieson were on the bridge the crew stood by the lifeboats in readiness for emergency, the second officer being ready to fire explosive rockets should the aircraft come low enough for a successful shot at them. They, however, kept outside range.

THE NEED OF A RIFLE.

During the fight the engineers and stokers kept up full pressure, and having been once more baffled the Germans made off for the Ousel to complete her journey without mishap.

The chief officer says that if he had only had a good rifle the aircraft might have been brought down.

The aim of the Germans was good, and had it not been for the manoeuvring of the Ousel the bombs would probably have hit the vessel. The captain has taken the precaution to provide himself with a rifle and plenty of ammunition for the return journey to Rotterdam, which began a day or two ago.

Another of the Rotterdam vessels has put into the Manchester docks, and reports a passage unattended by any incident of an unusual nature.

17) Lewis's Department Store

The original tower of the store, complete with a chime of bells, was demolished in order to make way for the new premises. The first store was built across nine floors, with the 1915 building which replaced it, extended in 1929 (shown in 1949 on the next page). The store was one of the first retail concerns to mass advertise in local newspapers, a technique they are using to great effect on the front page of the *Evening News*, in order to advertise their new store on Market Street. David Lewis was not just a successful businessman but put much of his wealth back into the local community and charitable concerns.

Manchester Evening News. Thursday, October 7th 1915.

The New Lewis's.

MANCHESTER'S FINEST STORE.

History of Lewis's – Lewis's was originally founded in the year 1856. The well-known Manchester store was opened in 1880. The foundation stone of the New Lewis's was laid on September 6th 1912. In the autumn of 1913 the work of demolishing the old Manchester building commenced.

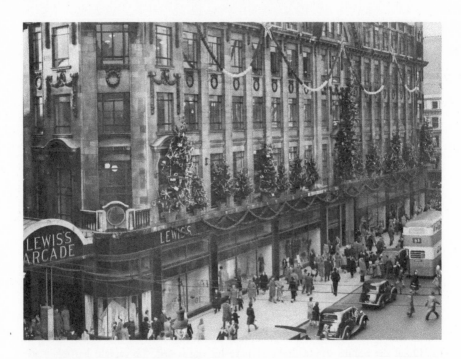

It is entirely new throughout. The building is of steel and concrete, with a facing of Portland stone. Over 2,000,000 bricks, 36,000 cubic feet of stone, and 4,000 tons of steel were used in its construction. It occupies two-and-a-half times more ground floor space than the old Lewis's and the building consists of six stories, basement, and sub-basement, the latter being 30 feet below the street level. The total amount of floor space amounts to nearly 5 acres, of which about 4 acres are open to the public.

The store is divided into three sections, pierced by wide openings which can be closed automatically with revolving steel shutters in case of fire. It is a fireproof building throughout, with sprinkler installation on every floor. A large interior dome rises from the centre of the ground floor to the roof, 105 feet above the street level. Its supports and balustrades are of Doulton's Carrara, and the roof is of wired glass. The shop fronts and doors are of bronze, and window casements are of steel. All shelves, counters, tables, show cases, and garment wardrobes are of mahogany. The building is perfectly heated and ventilated – and provision has been made in a striking degree for the comfort and convenience of both customers and employees. Special facilities of the new Lewis's consist of:- Grand Restaurant, Grill Room, and Smoke Room (5th floor) (Express Lift Services); Hairdressing Department for ladies and children (3rd floor); Postal and Telegraph Office, and Telephones (3rd floor); Writing Room, Rest Room and Toilet Rooms (3rd floor); Soda Fountain (in Basement); Ten Electric Passenger Lifts; Parcel Chutes from all floors, to Despatch Room in sub – basement; Pneumatic Tube Cash – carrying system.

18) Hyde Road Tramcar Works, 1915

Hyde Road Car Shed, with accommodation for 265 tramcars, initially opened in 1903 and in 1905 Hyde Road Car Works opened for the construction and repair of

tramcar bodies. By 1915 trams were the most popular and widespread form of public transport, with the City of Manchester creating 200 million passenger journeys a year on 662 vehicles. The last tram in Manchester ran on January 10th 1949, with the last of the old tramcars stored at the Hyde Road depot, until on 16 March 1949 they were set ablaze and destroyed. The depot was later converted to use by trolleybuses and is now a bus depot.

Manchester Evening News. Tuesday, October 26th 1915.
CITY TRAMWAYS EXTENSION.
Lord Mayor Opens New Hyde Road Works.

The Lord Mayor of Manchester (Alderman D. McCabe) to-day opened the Hyde Road tramcar extension and new stores, built at a cost of £46,059.

In presenting the Lord Mayor with a gold key and case, Alderman Bowes, the chairman of the Tramways Committee, declared that there was no more fitting person in the city to whom the honour of opening the premises could be given, since Alderman McCabe was chairman of the committee appointed in 1895 to carry out a great part of the work of buying out the old Manchester Carriage Company and installing the present electric tramcar system. To the judgement and discretion then exercised Manchester citizens were largely indebted to-day for the magnificent system that was now at their services.

In declaring the building open, the Lord Mayor paid a special compliment to the general manager (Mr. M'Elroy). The Manchester tramway system, he said, had enabled thousands of Manchester people to get out into the country at a very cheap rate and in an enjoyable manner. It had been a triumph of organisation.

Subsequently Alderman Bowes was presented with a piece of silver plate in recognition of his twenty-five years' service in Manchester municipal activity.

Mr Day, in making the presentation, characterised the Alderman as a "jolly good judge of human nature."

Alderman Bowes, in a brief reply, pointed out that 2,000 men had joined the colours from the department, and that the army service allowance and the special war bonus to the 4,222 men engaged to-day would entail a cost of £90,000 per year. It was at the instigation of the Lord Mayor that the collecting box system had been installed on the cars, and up to the present £15,000 had been collected for war relief in Manchester out of a total of £23,500 collected by similar means throughout the whole of the country.

19) Manchester 'Pals', 1915

Recruiting in Manchester, as well as other major cities throughout the United Kingdom, was becoming a major issue by 1915, with reliance on a volunteer army until the introduction of conscription in January 1916. Heavy losses at the front made it increasingly difficult to attract new recruits for the impending Dardanelles campaign of March 1915. This ill-fated naval attack resulted in further casualties and was the precursor to the Gallipoli Campaign, which was also unsuccessful. Ardwick Green Barracks,

opened in 1887, were the mobilisation centre for the 8th Battalion of the Manchester Regiment, who were based there.

Manchester Evening News. Monday, July 26th 1915.
RECRUITING IN MANCHESTER.
Men Wanted for the Dardanelles.

Recruits are still wanted by the 8th Manchesters to provide the necessary drafts for the first line at the Dardanelles and for the second and third lines now at their respective training quarters.

Suitable men should apply at the depot, Ardwick Green, where full khaki kit and equipment will be issued at once and the men sent forward without any delay.

A boxing competition will be held at Ardwick depot on Wednesday night, followed by a grand assault-at-arms on Friday night of this week. All men will be welcome. It is hoped that the provision of these entertainments will give the necessary stimulus to recruiting for the regiment.

MORE BANTAMS WANTED.
Colonel G.E. Wike stated that as the result of a request from the General Officer commanding the Western District it has been decided to ask the Mayors and the chairmen of the district councils in the districts which includes Salford, Bury, and Rochdale to assist in raising another 700 "bantams" for the Lancashire Fusiliers. This number is to provide a reserve company of 250 for each of the two battalions already formed and 200 to provide for wastage that has already occurred. The conditions of service and allowances are the same as for any other branch of the service, and young men of five feet will be accepted. It is desired that candidates should be sent to the depot of the 17th Battalion at Chadderton, or of the 18th at Garswood.

The total enlistments in Manchester for last week were 850, of whom 50 were recruited on Saturday.

An effort is being made to arrange a series of meetings to be held during August Bank Holiday week with a view to strengthening the City Battalions.

Manchester Evening News. Monday, November 29th 1915.
MANCHESTER "PALS."
THE FIRST CASUALTY.

The first casualty among the Manchester Pals Battalions is announced to-day, the parents of Second-Lieutenant A.E. Townsend having received official intimation that he has died of wounds received in France.

Lieutenant Townsend, who was 27 years of age, lived with his parents in Lansdowne Road, West Didsbury, and was an officer in the 18th (Service) Battalion Manchester Regiment.

He had been for years in a Manchester Territorial Battalion, and at the outbreak of war he again endeavoured to join the Territorials, but owing to the fact that he had just undergone an operation for varicose veins he was not passed. He got all right again, and at once joined the "Pals." Before being given his commission he had occupied all ranks

as a non-commissioned officer. His brother J.E. Townsend, is a captain in the 22nd (Service) Battalion Manchester Regiment.

In business the unfortunate officer was engaged at the Alliance Assurance Company, King-street, Manchester. Only last Tuesday his parents received a letter from him stating that he was alright.

20) Conscientious Objectors, 1916

By the end of 1915 conscription was seen as a necessary step, with a quick outcome to the war unlikely. The Military Service Act came into force 2 March 1916. Local tribunals decided between conscience or cowardice, with the individual objector having to demonstrate proof of their beliefs. Some refused to co-operate with the authorities, while others became stretcher bearers or munitions workers. From March 1916 until the end of the war, only 16,000 men were registered as conscientious objectors, with unarmed work in the Non-Combatant Corps, or Royal Army Medical Corps. tribunals were harsh, with many regarded as 'shirkers'.

Manchester Evening News. Tuesday, March 28th 1916.
TRIBUNAL SCENES.
MORE CONSCIENTIOUS OBJECTORS AT SALFORD.
Chairman's Strong Rebukes.

Mr. P.W. Atkin to-day presided over another sitting of the Salford Tribunal. There was a remarkable scene during the hearing of an appeal for exemption on the ground of conscientious objection. The applicant was Herbert Barlows, of Higher Broughton, who was accompanied by the Rev. A.O. Broadley, of the Bible Christian Church.

Applicant said he was a clerk and bookkeeper, and declared that "he could not turn a mental somersault and accept war as a settlement of international difficulties." The appellant went on to urge "common sense methods to settle differences."

The chairman: Use common sense, you say. Don't you know it is fear of force that makes people take protection of a court of law?

Applicant said he did not think so. Fear would not impel him.

REFUSAL TO ANSWER QUESTIONS.
The applicant refused to answer a question put by Mr. Desquesnes, the military representative.

The chairman: You are not doing yourself justice. You are a little bit too clever.

The applicant continued in this attitude, and was told by the chairman to leave the room.

As he was leaving Mr. Bradley spoke to the applicant, and Barlows turned to the chairman with the remark, "The prosecuting solicitor."

The chairman: I ask you to leave the room.

"I am representing this man," said Mr. Broadley.

The chairman: You had no right to speak to this man before we have finished the hearing. You are taking notes, and that is an abuse of the privilege you have.

ACCUSED OF PARTISANSHIP.

Mr. Broadley was speaking again when the chairman replied: You don't come here as a member of the public. You come here as a partisan, and I am going to ask you to keep out. If you came in and took an intelligent interest and have something beyond what you are pleased to call a conscience we should have no objection.

Mr. Broadley: Are we not allowed to look after the interests of these people? Had I been a solicitor I might have been allowed to come in and say what I want.

The chairman: Will you leave the room?

Mr. Broadley: Am I not permitted to come in again to-day?

"No" replied the chairman.

Not at all? – No.

The applicant was told that he would have a temporary exemption for one month.

Applicant: I cannot accept any service in this war.

"FULL OF SELF IMPORTANCE."

The chairman said a committee was sitting in London considering the position of conscientious objectors. Mr. Atkin went on to say: "My own opinion is that you are so full of your own importance that you cannot listen to advice or accept anything which is not in strict accordance with your views."

Another conscientious objector, named George Holmes, of Pendleton, said his views were based on biblical grounds, and the chairman was speaking when the man interrupted.

Mr. Atkin: "Your mind is so closed down to accepting advice that you have not grasped what I said."

Appellant: "But Jesus said –"

Mr. Blundell (a member of the Tribunal). "He always wants to talk about Jesus."

The chairman: "They come here, take no notice of anything we say, and then tell us they will appeal against our decision."

Exemption for one month was granted.

COULD NOT EAT ARMY RATIONS.

A conscientious objector stated that two years ago he became a vegetarian, and if he went his conscience would not let him eat the army rations. The case was adjourned until April 28th the chairman remarking that a committee was now sitting in London, and by the date named they (the Tribunal) would know what conclusion had been arrived at.

AGED MOTHER'S COMFORT.
Exceptional Case Before Court Tribunal.

The Appeals Tribunal for the Salford Hundred met again at the Manchester Town Hall to-day, the Manchester County Stipendiary Mr. J.M. Yates, K.C., presiding in one court and Judge Mellor in the other. There were 60 cases before the courts, all from the Manchester district. In one case an applicant stated that the comfort of his aged mother depended to a great degree upon himself. His wages, less his army pay, would be paid if he was called up, and his point was that his mother could not look after herself.

Exemption was granted for three months, Judge Mellor remarking that this was an exceptional case and must not be regarded as a precedent. In another instance an employee of an insurance company said insurance companies had always been specially considered, and most of them had got their staffs reserved before appeal. Judge Mellor replied that insurance companies had the reservation because they had given up a certain number of employees. Postponed to April 30th.

FIRM'S PATRIOTIC ACTION.

A postponement until June 30th was allowed in the case of a manager of an oil company's depots at Halifax and Huddersfield. He maintained that he was in a starred occupation, but said his firm, "as a patriotic act," was appealing for no one. His mother was totally dependent upon him.

Little heed was paid to the sentiment expressed by an applicant who said he was not of a "fighting disposition." It was found that if he went his home would be just as well off financially, and the court summarily dismissed the appeal.

NO EXEMPTION FOR CORPORATION CLERK.

The Manchester Electricity Department's appeal for a clerk failed. They had been much inconvenienced owing to the fact that 88 out of 90 men of recruitable age had gone from the department. The clerk's physique was not such that he would be any use in the fighting line.

The military representative said the military doctor might reject him.

21) Women Munitions Workers

The Munitions of Work Act 1915, and the introduction of conscription in 1916, made the need for skilled munitions employees even more important. By 1918 950,000

women, like the ones shown at Thomas Storey's Munitions Works, Empress Street, Old Trafford, *c.* 1915, were employed in munitions factories and were commonly referred to as 'munitionettes'. They became the most visible face of the female worker in the First World War. Women produced 80 per cent of the weapons and shells used by the British Army and daily risked their lives working with poisonous substances, poor protective clothing and inadequate safety measures.

Manchester Evening News. Wednesday, January 17th 1917.
MUNITIONS OUTPUT.
Much Greater Effort Needed.
Women's Splendid Work.
How They Saved Our Armies.

The Ministry of Munitions forwards the following for publication:

Mr. F. Kellaway M. P., Parliamentary Secretary to the Minister of Munitions writing of an exhibition in London of 300 photographs designed to show the variety and value of women's work in the munitions factories, says that,

There is a sense in which it is true that our armies in the field have been saved by the efforts of our women.

There are at present in national factories and controlled establishments close on half a million women working day and night who are as really protecting the sanctity of their homes and the national honour as are the men, who with incomparable bravery, storm the present positions.

But we cannot afford to rest satisfied with what has been accomplished. A much greater effort is needed unless we are to lose the advantage secured to our armies by the work done under the direction of Mr. Lloyd George and Dr. Addison at the Ministry of Munitions.

Germany is making a new and gigantic effort to overtake us in this war of material. She is bringing back from the colours great numbers of skilled men. Her levee en masse is placing at her disposal an immense supply of additional labour.

We should be making one of the greatest mistakes of the war if we do not realise the grave significance of the fact that Germany is striving to increase beyond anything yet imagined the material at her disposal when the time for a sustained extended offensive recurs.

Germany, to a great extent, is relying on forced labour, our women have come forward voluntarily, and will come forward in greater numbers as soon as they realise the national need. If we succeed, as we shall succeed, in overwhelming the mass of material which Germany will have prepared, it will be because the women in this Kingdom have shown themselves willing to work for the cause for which their men are prepared to die.

22) The Battle of Arras, 1917

On Wednesday 11 April 1917, at 04.45 a.m., tanks headed towards the German lines around Bullecourt, signalling the start of the Battle of Arras. One was destroyed by German artillery, while others got stuck in barbed wire. Fresh snow meant they provided

an easy target for enemy shells. The majority of the tanks were destroyed and others were halted by mud. One arrived at Bullecourt, but the absence of British infantry and heavy artillery fire meant it had to be abandoned. Another, the Germans' first, was captured and examined, resulting in their use of armour penetrating bullets, as a defence against tanks.

Manchester Evening News. Thursday, April 12th 1917.

TANKS' GREAT WORK.
FERIOCITY OF BRITISH SHELL FIRE.
Captured Officers' Shame.

Mr. Philip Gibbs, special correspondent of the "Daily Chronicle" and other journals, wiring on Tuesday night from the war correspondents' headquarters says:

Some day a man must give a great picture of the night in Arras before the battle, and I know one man who could do so – a great hunter of wild beasts, with a monocle that quails the human soul, and a very parfit gentil knight, whose pen is as pointed as his lance. He spent the night in a tunnel of Arras before getting into a sap in No Man's Land before the dawn, where he was with a "movie man," an official photographer (both as gallant as you will find in the army), and a machine-gunner ready for action. Thousands of other men spent the night before the battle in the great tunnels, centuries old, that run out of Arras to the country beyond by Blangy and St. Sauveur. The enemy poured shells into the city, which I watched that night before the dawn from the ramparts outside; but in the morning they came up from these subterranean galleries, and in a little while no more shells fell in Arras, for the German gunners were busy with other work, and were in haste to get away.

WHERE THE TANKS DID WELL.

The fighting was very stiff round Blangy, the suburb of Arras, where the enemy was in the broken ruins of the houses and behind garden walls strongly barricaded with piled sandbags. But our men smashed their way through and on. Troops of old English regiments were checked awhile at strong German works known as the Horn, Hott, Hammel, and Hangest positions, and at another strong point called the Church Work. It was at these places that the Tanks did well, on a day when they had hard going because of the slime and mud, and, after a journey of over three miles from their starting point, knocked out the German machine-guns, and so let the infantry get on.

In higher work, at a point known as Railway Triangle, east-south-east of Arras, where the railway lines join, Scottish troops were held back by machine-gun fire. The enemy's wire had not been destroyed by our bombardment and our barrage had swept ahead of the troops. News of the trouble was sent back, and presently back crept the barrage of our shell-fire, coming perilously close to the Scottish troops, but not too close. With a marvellous accuracy the gunners found the target of the triangle, and swept it with shell-fire, so that its defences were destroyed. The Scots surged forward over the chaos of broken timber and barricades, and struggled forward again to their goal, which brought them to Feuchy Well and to-day much further. A tank helped them at Feuchy Capel, cheered by the Scots as it came into action, scorning machine-guns bullets.

The Harp was another strong point of the enemy's which caused difficulty, as I have already told on the first day of the battle, and another Tank came up, in its queer, slow way, and the gallant men inside served their guns like a Dreadnought, and so ended the business on that oval-shaped stronghold.

CAPTURED OFFICERS ANGRY AND ASHAMED.

So English and Scotch troops pressed on, and gathered up thousands of prisoners. "So tame," said one of our men "that they ate out of our hands." So ready to surrender that a brigadier and his staff who were captured with them were very angry and ashamed of men taken in great numbers without a single wounded man among them.

Fifty-four guns were captured on this eastern side of Arras, and six were howitzers, and two of these big beasts were taken by cavalry working with the troops. Some of the gunners had never left their posts for four days before, and were suffering from hunger and thirst. Trench mortars and machine-guns lay everywhere about in scores, smashed, bruised, flung about by the ferocity of our shell-fire. German officers, wearing iron crosses, wept when they surrendered. It was their day of unbelievable tragedy. A grave thing, almost comical in spite of tragedy, happened to some German transport men. They were sent out from Douai to Fampoux. They did not know they were going into the battle zone. They drove along until suddenly they saw British soldiers swarming about them. Six hours after their start from Douai they were eating bully beef on our side of the lines. While they munched they could not believe their own senses.

The prisoners I saw below Vimy Ridge to-day – those masses of grey-clad men who had come down from the great hill, like the population of a bombarded town – belonged to many branches of the German army, from infantry of reserve, field artillery, Landwehr, foot, artillery, pioneers, entrenchment companies, telegraph battalions, Red Cross, trench wireless stations, and supply columns. Our troops treated them with the greatest good humour, throwing chocolates and cigarettes into their enclosures, and

crowding round to speak to men who knew the English tongue. There seemed no kind of hatred between these men. There was none after the battle had been fought, for in our British way we cannot harbour hate for beaten enemies, when the individuals are there broken and in our hands. Yet a little further away the fighting was fierce, and there is no softness and no mercy in the hearts of our men until the enemy throws up his hands.

23) Racing at Castle Irwell, 1917

It was technological innovations in the nineteenth century which led to horse racing becoming the most popular sport in the country, with millions of people watching. As a result of this expansion there was an increase in gambling and in newspaper coverage. Of course bookmakers had to adhere to a code of conduct introduced by the Jockey Club and a method of handicapping horses in any given field of runners was developed. Its popularity is illustrated clearly in the *Evening News*, in that horse racing was one of only two sports that continued during the First World War, albeit on a very limited scale.

Manchester Evening News. Tuesday, July 10th 1917.
RACING AT CASTLE IRWELL.
A Bank Holiday Meeting.
November Handicap to be Run.

The allocation of three days' racing at Castle Irwell has given general satisfaction to the racing fraternity of Manchester.

It was expected August Bank Holiday is one of the days, and there is sure to be one of the greatest events ever seen at Manchester on these days. The munitions workers will be on holiday, and as all other handicaps will be temporarily suspended their number will be greatly swelled by other members of the community anxious to get some little relaxation from work.

The other days on which there is to be racing at Manchester are August 4th and November 17th The official announcement of the fixing of other race meetings, besides those already arranged at Newmarket, was called by the Press Bureau last night in the following report.

At a meeting held to-day between the Secretary of State for War, the President of the Board of Trade, Sir Herbert Walker, chairman of the Railway Executive Committee and a representative of the Ministry of Munitions, the Stewards of the Jockey Club were authorised to hold meetings on the following days and in the following places, it being the opinion of the representatives above-mentioned that racing would in no way interfere with war work:-

Manchester – August 4th 6th; November 17th
Windsor – August 11th; September 17th
Brighton – September 4th; November 3rd

Two other meetings in the South of England will be allowed later. Racing is not to commence before two in the afternoon at those places, unless specially authorised by the Ministry of Munitions. The Board of Trade will require special regulations respecting the use of racing-bets.

THE NOVEMBER HANDICAP.

A director of the Manchester Racecourse Company, seen by an "Evening News" representative, to-day, said that the executive had as yet received no official intimation from the Jockey Club that the fixtures had been authorised at Manchester. It was rather early to give any particulars with regard to the earlier dates – August 4th and 6th – but the duties of arranging the programme were in the hands of the Clerks of the Course – Messrs. Frail Bros., of Windsor – and when this was drawn up it would be submitted to the Stewards of the Jockey Club for confirmation.

The information that the November Handicap would be run at the fixture sanctioned on November 17th was conveyed to our representative by the director.

"And what is more," added the official "it is highly probable that we shall put up the same stakes as in pre-war days. Manchester, it seems, is once more to have the honour of bringing down the curtain of the flat-racing season, and it will be inappropriate if there is no November Handicap."

Little anxiety exists in the minds of the executive with regard to the prices of admission to races which will be insisted on. It is pointed out that at all race meetings which were run before the ban was put on that the state charges for, admission was 6d. and it was not expected that any reduction will be made for the new fixtures that have been allowed.

It may be of interest to state that the last race meeting held at Castle Irwell was on Easter Tuesday, 1915, the Government's original ban on racing being put into force just before the Whitsuntide meeting of 1915 was due to be decided.

24) Manchester Carter's Wage Dispute, 1917

In the closing months of the First World War and into 1919 there was an increasing level of military unrest at poor treatment and conditions for the average soldier, especially in relation to delayed post war demobilisation. This unrest was also prevalent in the civil sector, with workers' desire for improved conditions and wages, as wartime deprivations began to have an effect. Germany's attempt to blockade the British Isles with a U-boat campaign against merchant shipping put pressure on food supplies and inevitably drove up prices, despite controls, leading to increased agitation and demands, as the Russian Revolution began in 1917.

Manchester Evening News. Tuesday, September 18th 1917.

CARTER'S WAGES.

Manchester Leaders Summoned to London.

The settlement of the wages to be paid to two-horse men in Manchester and Salford is to be made in London and communication was received today from the Chief Industrial Contingent to Mr. A. Hilton, of the United Carter's and Motormen's Association, and Mr. John Crawford, of the Manchester Team-Owners' Association, informing both that officials and the Central

Conference of Carters that the Government committee on production would meet on Thursday next at four o'clock to hear the case and arbitrate on the points at hand.

The trade union is claiming an advance of 5s. per week for two-horse men on current rates, and saying that the last agreement making the war bonus conditional on a full working week being put in be amended. Mr. Hilton, on behalf of his union, stated that the agreement referred to is not being carried out in that amicable spirit which it was hoped would be the case, and that it be substituted by making the increase then given, 1s. 6d. per week, operative at the rate of 5d. a day.

25) Three Manchester Road Accidents, 1917

Road accidents had been a concern, even in the nineteenth century, when urban areas grew rapidly. Drinking and driving a horse, cart, carriage, or cattle was an offence from 1872 and the Locomotive (Red Flag) Act of 1865 introduced speed limits of 4 mph in open country and 2 mph in towns. In 1903 driving licences, compulsory registration and number plates were introduced, with further restrictions on the speed limit. In 1904 some attempt was made to standardise road traffic signs, although automatic traffic lights were not introduced to the UK until the mid-1920s. These reports show that there was still some work to do in making Manchester's roads safer.

Manchester Evening News. Wednesday, September 26th 1917.
STREET FATALITIES.
THREE ACCIDENTS IN MANCHESTER.
Well-known Clergyman's Death.

Three fatal street accidents were investigated by the Manchester City Coroner (Mr. W. Sellers) to-day. The first case was that of the Rev. William Burns (former Vicar of St. Simon's and St. Jude's, Manchester), who lived at George-street, Ardwick, and who was a well-known local clergyman. He was walking along Downing-street, near the Co-operative Hall, on Saturday afternoon, when he was knocked down by a taxi-cab going in the direction of Ardwick and received such injuries that he died the following day at the Royal Infirmary.

The taxi-driver said that the deceased gentleman suddenly left the footpath when the cab was only two or three yards away from him. Witness at once applied the brakes and pulled up in the cab's length, but Mr. Burns was struck by the near-side wheel and the cab passed over him. Mr. Burns, as he left the footpath, held up his umbrella as though to signal a tramcar driver to stop his car on the other side of the road. Witness was driving at only six miles an hour, as he was going up an incline.

It was stated by Miss Florence Burns, daughter of the deceased gentleman, that her father had bad eyesight, and he used very strong glasses. The jury returned a verdict of accidental death.

Similar verdicts were returned in the cases of Jean Edna Davies (3), of Chorlton Road, Hulme, who was run over by a tramcar near her home on Sunday afternoon, and William Dunnicliffe (31), of Richmond-street, Moss Side, who was knocked down by a bicycle in Princess-street, Manchester, yesterday morning.

In the former case the driver said the child left the footpath in Chorlton Road about five yards in front of the car. Witness, who was slowing down, at once applied his brakes, but owing to the very greasy state of the rails the car skidded on, and the child was knocked down. She was dead when taken from under the car.

In the third case it was stated that Dunnicliffe was sent on an errand from Princess-street to Sackville-street and passed in front of a horse and cars in Princess-street when he collided with a boy riding a bicycle. His skull was fractured, and he was dead when he reached the Infirmary.

26) Zeppelin L49, 1917

Airship raids on Great Britain were approved by the Kaiser on Thursday 7 January 1915, although London and historic buildings were excluded as targets. Raids were to include military sites on the east coast and around the Thames estuary. Bombing accuracy was poor, due to the height at which Zeppelins flew, and navigation was difficult. Blackouts meant that many bombs often missed their intended targets. L49, pictured below, was lost to engine failure and the weather over France. All the airships listed in the report were hindered by an unexpected strong headwind at altitude. This was the last major Zeppelin raid of the war.

Manchester Evening News. Monday, October 22nd 1917.

THE LYING HUN: FICTION ABOUT MANCHESTER.

THE ZEPPELINS.

Berlin's Account of the Raid.

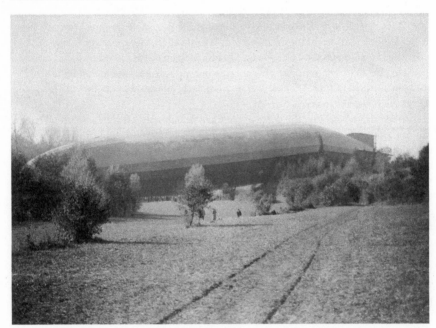

MANCHESTER AMONGST PLACES ATTACKED.
Loss of Four Aircraft Admitted.

SILENCE ABOUT FATE OF OTHERS.
Amsterdam, Monday – The following Berlin official telegram has been received here:

The Admiralty staff announces that during the night of October 19–20 (Friday – Saturday) a naval airship squadron, under Captain Baron Prensch von Buttlen Braudeniels, attacked with special success.

London.	Lowestoft.
Manchester.	Hull.
Birmingham.	Grimsby.
Nottingham.	Norwich, and
Derby.	Mappleton.

On the return journey, owing to adverse wind and dense mist, four airships, under Captain Hebart, Koolle, Hans Geyer, and Schwander, came over the French battle zone, where they, according to the French official communication, were shot down or forced down.

No details regarding the fate of the vessels and their crews are available at present. – Press Association War Special.

Note. – There are two Mappletons – one in the East Riding of Yorkshire and the other in Derbyshire.

The Zeppelins which raided England on Friday night met with unparalleled disaster on the return journey.

Four were brought down by French anti-aircraft guns or by the airmen of our Allies.

A fifth is believed to have been destroyed.

Three others, more or less damaged, were wandering about France, or even the Mediterranean when last heard of.

The following is the record so far as is known at present.

1. One vessel brought down by anti-aircraft guns at Saint Clement, near Luneville, from a height of nearly 19,000ft. Totally destroyed and all the crew dead, at 6.45am., on Saturday.
2. L49 driven down at 9.20am., by aeroplanes near Bourbonne-les-Bains (Haute Marne). Airship captured undamaged, with entire crew of nineteen officers and men.
3. L50 descended at Pammartin (not far from Bourbonne), landed two officers and fourteen men, detached and destroyed a gondola, and then reascended.
4. One airship brought down at Laragne, near the Italian frontier. Burnt by its crew. Five officers and fifteen men captured.
5. Another airship brought down near Latagne at 4pm., on Saturday.

GRAPHIC STORY.
HOW ONE OF THE RAIDERS CAME DOWN.
Commander prevented from destroying it.

Bourbonne-les-Bains, Sunday. – Large crowds have been visiting the spot where the Zeppelin L49 was brought down to earth. The front and rear of the airship are resting on trees on two hillocks, and the middle is thus suspended above the ground.

M. Dusmesnil, Under Secretary of State for Aeronautics, General Castelnau, and Admiral Localye have been to examine the Zeppelin. M Dusmesnil had previously been to Dijon, where he congratulated Lieut. Lafargue, of the 152nd Squadron, "The Crocodile," which compelled the Zeppelin to land.

A metallurgical worker who recently returned from the front was present at the fall of the Zeppelin, and gave the Havas representative the following story.

It was 9.30 on Saturday morning. I was out shooting, when suddenly the noise of a motor caused me to look up. What was my surprise to see an immense airship surrounded by little French aeroplanes, which were pelting it with machine gun fire. The Zeppelin was flying very slowly and extremely low. Suddenly its forepart turned down into a group of trees on a hillock, and the airship remained stationary a few yards above the ground.

The nineteen men composing the crew immediately jumped to earth. The last of them was the Commander, who arranged his men in good order and gave them their final instructions, and then discharged his pistol into the envelope of the balloon. Realising that he intended to set it on fire, and determined to prevent this at all costs, I, who was standing thirty yards away, loaded my sporting rifle and shouted "stop or I fire."

The threat was sufficient, and the commander threw down his pistol and held up his arms, crying "Kamerad."

Then the Germans stood quiet, while I continued to watch them, ready to fire on the first who should attempt to flee.

Soon a crowd gathered round the airship, and we were all able to place the crew under a strong guard. The commander seemed to be furious, but the men appeared delighted. They were stalwart fellows, warmly clothed in leather combinations, and had evidently been chosen for their powers of physical endurance.

General Castelnau and M. Dusmesnil warmly congratulated the man who told me this story.

L49 is a naval airship of the most recent type, and is almost absolutely new.

A second Zeppelin, L50, came at midday, and for nearly a quarter of an hour flew over the prostrate L49, but being harassed by French aeroplanes made off and stopped about twelve miles away in the environs of Dammartin, whence she left again after having landed sixteen members of her crew, and it was afterwards impossible to find trace of her.

The L49 measures 144 metres in length and carries four fish tail propellers. The two Mercedes motors are each 250 horse power. The airship has a total capacity of 25,000 cubic metres. Her average speed is over fifty miles per hour, and she has accommodation for a crew of eighteen men with two officers.

It appears that she was one of the Squadron returning from the raid in England, which was diverted from its proper course by contrary winds. – P. A. War Special.

Note. – Bourbonne-les-Bains lies between Nancy and Belfort, and is about fifty miles from the German front line.

STRUGGLE FOR AIR MASTERY.

The French Expert Commentator, writing last night, says:

The story of the German aerial disaster is now fully confirmed. Of eight Zeppelins which returned from England and flew over France five have been lost, and their loss is

admitted by the enemy, one of them which was captured intact by our airmen will serve to reinforce our own air squadrons.

The event is of particular interest at the moment when the Germans engrossed with the idea of seeing the aviation resources of the Allies about to be strengthened by those of the United States, and to seize the incontestable mastery of air, are making a great effort to convince us that they possess the mastery, and that we should accept their ruling in this domain. Our Verdun heroes have made a suitable reply to the first manoeuvres of the pacifists. Indeed, our gunners and airmen speak the only language which can be understood by people who persist in attacking the peaceful populations of London, Dunkirk, Bar le Duc, to mention only a few of the towns bombarded by the Germans. – Press Association War Special.

27) Atomic Research at Manchester University

Sir Ernest Rutherford (1871–1937) was a New Zealander, who came to Manchester in 1907 as Professor of Physics at the Victoria University of Manchester. He was awarded the Nobel Prize for Chemistry on Thursday 10 December 1908. Two years after this report, in 1919, he 'split the atom' at the University's laboratories on Bridgeford Street, off Oxford Road. Rutherford advanced atomic orbital theory and during wartime studied submarine technology and underwater acoustics, but in 1916 was allowed to resume atomic work at Bridgeford Street. This report shows us that the university (shown in 1951 below) was actively encouraging atomic research, particularly in relation to the war effort.

Manchester Evening News. Monday, December 10th 1917.

Manchester's Radium Committee.

PHYSICAL LABORATORY TO BE EQUIPPED.

A special meeting of the Manchester Radium Committee was held in the Town Hall today, the Lord Mayor (Sir Alexander Porter) presiding.

The question of Dr. Arthur Burrows and Mr. Hartley Lupton joining the colours was discussed, Sir William Milligan stated the departure of Dr. Burrows and Mr. Lupton would mean that the radium department would have to be closed, as it would be quite impossible to carry on the work.

Sir Ernest Rutherford said there was a certain amount of military work being done in the radium department.

Sir Edward Holt considered that under the circumstances it was inadvisable to allow Dr. Burrows to leave his present duties. The case of Mr. Lupton was left in the hands of the Lord Mayor and Sir William Milligan, Sir Alexander undertaking to make a personal appeal to the tribunal.

The committee unanimously agreed to proceed with the equipment of the physical laboratory for the purpose of research work. Sir Wm. Milligan intimated that they had the money in hand, and that the cost would be about £1,000.

Sir Ernest Rutherford declared that the longer they postponed the matter the more difficult it would be to make a start. It was desirable that research work should be carried on under reasonable conditions.

The question of securing official recognition from the military authorities for the work that had been carried out was left in the hands of Sir Edward Holt.

28) Food Hoarding, 1918

Agriculture and food distribution suffered from the effects of war and naval blockades, reducing food imports and fertiliser supplies. Men and horses were removed from farm work to help the war effort. In turn, prices were forced up, encouraging hoarding. Price controls were introduced and food queues became commonplace. Germany's U-boat campaign against the Allies was intended to produce a crisis in food production, with Britain responding by attempting to increase their own supplies. However, the government's main success was the introduction of rationing, to London in early 1918 and the rest of the country by the summer, without much opposition.

Manchester Evening News. Wednesday, February 6th 1918.

FOOD.

By order of the Food Controller, from Monday next until the following Monday food hoarders will be allowed to unburden themselves of their surplus supplies through the local food committees, and will be paid half the price of the food of which they are dispossessed. After the lapse of the period of grace, after Monday week, we assume, all tolerance of food hoarding will be at an end. Imprisonment will be the fate of everyone and anyone who is found guilty of the shabby practice of accumulating large stores of

surplus necessaries at a time when everyone should be on short commons and exercising his bit of self-denial.

Under these circumstances a large section of the community who are anxious to be scrupulously fair have considerable doubts about their position. They know that the ordinary householder is bound by the following regulation:

No person shall after April 9th 1917, acquire any article of food so that the quantity of the article in his possession or under his control at any time exceeds the quantity required for ordinary use and consumption in his household or establishment.

How ought the order to be interpreted? On this point the widest differences of opinion exist, as is clear from the defence which has been put forward by many food hoarders who have been brought before the magistrates.

According to some of the defendants they ought not to be interfered with, though they have accumulated six months' supply. Those gentry the magistrates, very properly, have taught differently by fining them and sending them to prison.

How far may a person safely go? The answer should be found by each individual exercising his common sense. May we give a concrete case? Suppose a family has been in the habit of purchasing and consuming weekly three pounds of ham. Suppose one day they find themselves in a position to try a ham weighing 20lbs. Would they be justified in making the purchase? If they did would a magistrate convict them? It is a nice point. Many people who would take the risk of buying one ham under such circumstances would flatly decline would take two, even if the opportunity presented itself. And if, while they were getting the extra supply of ham, they were at the same time accumulating other foodstuffs in equal measures, they would be in very considerable danger even from the one ham. Each case has to be separately considered.

While the nation is busy arranging for a fairer distribution of food, attention is also attracted to the means that may be taken to improve supplies. Of these the fish supply is one of the most important, though it is handicapped for the moment by the number of fishermen who have been taken into the service of the Navy. We have wonderful supplies of fish all round our shores. They have been shamefully neglected in the past. Will the neglect continue? That is a question, the public will be glad to learn, to which many influential men in the fish trade are prepared to give a vigorous answer in the negative. The importance of abundant fish supplies is becoming more and more recognised.

WHAT IS HOARDING?
No Exact Definition.
Housewives to use Discretion.

The problem as to what constitutes food hoarding was submitted this morning to the Ministry of Food, and an official said:

We have purposely specified no period or to what extent a housewife may lay in stores. That is left to her discretion. Obviously we cannot specify any period, for in country districts where shopping facilities are not so good, people have to lay in large supplies than in places such as London, where ordinarily they can live from day to day.

The burden of proving that the supplies are only normal will rest upon the person prosecuted, and no doubt the magistrate will be guided in his decision by the shopping facilities of the locality. So the problem is left.

In London it may or may not be a crime to possess 2lbs. of margarine, and in a country district it may be legitimate to possess as much as 14lbs. of that commodity.

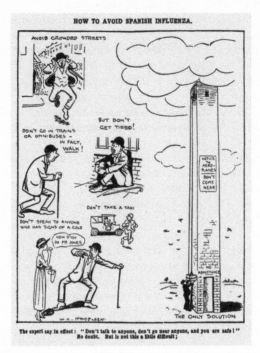

29) Spanish Influenza, 1918

This headline shows how the ravages of 'Spanish Flu' affected Manchester during the worldwide epidemic of 1918. The epidemic would appear to have fundamentally affected the infrastructure of the city, from transport to the postal service and education, although the death rate remained relatively low. It is thought to have been spread by soldiers returning home from the trenches at the end of the war. Young adults aged twenty to thirty were particularly affected, with the disease progressing quickly in these cases, often with pneumonia. During the pandemic of 1918/9 over 50 million died worldwide, with 228,000 in Britain.

Manchester Evening News. Wednesday, July 3rd 1918

INFLUENZA'S PROGRESS.
EVERY PART OF THE CITY AFFECTED.
More Schools Closed.

The tide of the Influenza epidemic is still un-stemmed.

Every quarter of the city is now involved in its remorseless advance, the toll of workers continues to increase, the strain on the doctors is reaching breaking point, and the depletion of all the public services involves serious inconvenience and delay in all departments of city life.

The position in the tramways remains about the same. Again today, the services are short of sixty cars, though the shortage is compensated for to some extent by the growing

diminution in the number of passengers as the result of the spread of the epidemic. Two hundred drivers and guards (men and women) are still on the sick list, and there is a similar depletion of the staffs in the repairing sheds. No department has escaped. The parcels delivery system is severely handicapped by the temporary loss of 40 employees, and the clerical staff has suffered to such an extent that the statistical and secretarial work is gravely hampered.

Three more Manchester elementary schools have had to be closed to-day, but on the other hand it has been possible to reopen two others which were closed at an earlier stage of the outbreak.

Dr. Alexander Brown Ritchie, School Medical Officer, told our representative that the epidemic will probably continue to spread. "We may not have to close all the schools," he said "but it is very likely that more will be affected."

When asked if the cases were generally serious, Dr. Ritchie said only a small proportion of the schools were really badly affected.

"An Influenza epidemic," he added "invariably takes a big toll, but a vast proportion of the cases in this instance are light."

At the Post Office the position has not grown any worse, but every department is still working with greatly diminished staffs. The main Telephone Exchange has been rather badly hit. No fewer than 195 employees are down with the complaint – a state of things which of course involves a large amount of delay in dealing with the work. Happily the public is showing a sympathetic spirit. Accepting the inevitable, callers-up show a disposition to put up with the unavoidable inconvenience without those little ebullitions of temper which are not infrequent when delays occur in normal times.

In the Manchester home trade warehouses the conditions show no improvement; indeed, in one or two cases there are many more employees away this week than last.

The munition works in the Manchester area are all more or less seriously affected, and in one instance the epidemic has incapacitated 10 per cent of the workers.

The test of the gravity of an epidemic is the death – rate. Happily, there is no cause for alarm in Manchester, as the deaths last week only numbered nine.

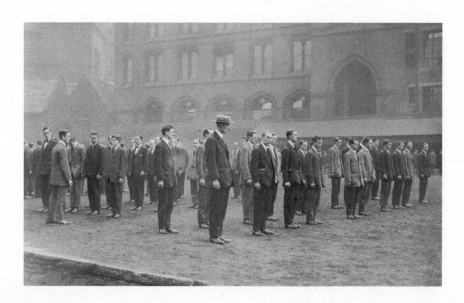

This is by no means an exceptional figure, and – what is also very gratifying – there has been no marked increase in the deaths from pneumonia, one of the most deadly sequels of Influenza. Last week the deaths from this disease numbered 19, which is about the average.

30) Public Schools Battalion, 1918

This report on the Public Schools Battalion (shown drilling at Chetham Hospital, 1914) memorial service at Manchester Cathedral reminds us how the First World War affected those of all social classes. Many of the original Manchester Grammar School volunteers would not have been figuring on a career in the armed forces way back in 1914, as the article suggests. However, there were many who eventually sacrificed their lives volunteering for a cause in which they implicitly believed. Manchester Grammar School's war memorial is located in the school hall, at Rusholme. The First World War memorial contains a total of 481 names, on wooden name boards.

Manchester Evening News. Friday, July 19th 1918.
PUBLIC SCHOOLS BATTALION.
Memorial Service at Manchester Cathedral.

It may be a common place to say that in times of universal mourning memorial services supply a deep spiritual need, but one has to attend such a service as that at the Manchester Cathedral to day in memory of the fallen members of the University and Public Schools Battalion to realise how real and sincere is the desire of sorrow – stricken humanity to find expression in some form of public devotional exercise.

Probably there were few in the large congregation who had not lost some relative at the historic Battle of the Somme, in which so large a number of Manchester's young manhood laid down their lives. But the anglo – saxon temperament, in grief as in other emotions, is undemonstrative, and there was still little on the surface to indicate the grief and sadness that sought a silent outlet in the familiar forms of public worship.

Canon Green addressed a few words in memory of the brave men who have fallen, and dwelt on the fact that few indeed of the young men who joined the 20th Royal Fusiliers had any sympathy with militarism or any thoughts of military life. Their sacrifice was a refutation in the noblest form of the reproach so commonly heard before the war of the degeneracy of Britain's young manhood.

Members of the Manchester Grammar School O. T. C. brought wreaths which were afterwards laid on the monument to the Lancashire Fusiliers in St. Ann's Square by the Lady Mayoress and her daughters, Miss Porter and Miss Elsie Porter.

31) J. R. Clynes MP

John Robert Clynes (1869–1949) became Labour Party leader in 1921–22; was MP for Manchester Platting, 1906–31 and 1935–45; Minister of Food Control, 1918–19; Deputy Leader of the Labour Party, 1922–32; Lord Privy Seal, 1924; and Home Secretary, 1929–31. The General Election of Wednesday 4 December 1918 was the first to be held after the Representation of the People Act, 1918, including all men over twenty-one and women

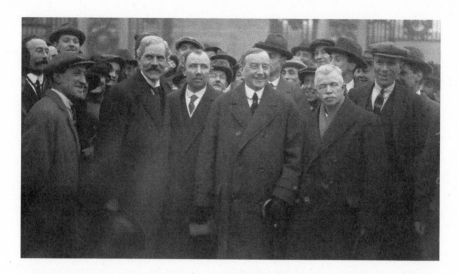

over thirty in the vote. It was the first General Election held on one single day and was won by the Coalition Conservative Party. John Robert Clynes (second right, in 1924 on the opposite page) was returned to Parliament for Manchester Platting.

Manchester Evening News. Wednesday, December 4th 1918.

NOMINATION DAY.

LARGE NUMBER OF MEMBERS RETURNED UNOPPOSED.
Mr. J. R. Clynes, Senior M.P. for Manchester.
STATE OF PARTIES.
State of parties at 5 o'clock.

Coalition Unionists..........39
Coalition Liberals.............27
Labour9
Nationalists1
Sinn Fein..........................13 (Total 89)

 The nominator of candidates for the General Election took place to-day, commencing at 10am, an d operating for any two hours between then and 3pm.

 Under the new Act the nominations will all take place to-day, and between the same hours. By three o'clock this afternoon a considerable proportion of the new House of Commons, probably amounting to 100 members, had been elected, and these being for the most part members of the old Parliament.

 The number of members to be elected is 707, as against 870 before the passing of the new Reform Act. At the same time the voters have increased to about 10 millions, or nearly double.

 Much interest is being taken in the contest, in view of the rearrangement in some cases and extinction in others of many constituencies in the three Kingdoms. In the case of the London boroughs, the number of members has increased from 62 to 63. In other boroughs to 258, a gain of 33.

In the counties there will be 372, a loss of five, and in the universities fifteen members, a gain of six. Altogether the total representation of England in the new Parliament will be 492, an increase of 31; Wales 36, an increase of two; Scotland 74, an increase of two, and Ireland 103, an increase of two, making a total membership of 707.

FOUR CANDIDATES FOR HULME.
Mr. Clynes Returned Unopposed.
Nomination day in Manchester was characterised by no unwonted circumstances. In the Lord Mayor's Parlour, where the papers were handed to the Lord Mayor (Alderman Makeague), the candidates chatted affably and calmly together.

There was indeed an entire absence of the customary undercurrent of excitement which usually pervades proceedings of this kind, and as no last-minute surprises were forthcoming nomination day was completed with the same air of calm that has been so notable a feature of the election so far.

The effect of the nominations is that Mr. Clynes is returned unopposed, as everyone thought he would be, for Platting; that there will be contests in all the other nine divisions, and that the list of six candidates in Hulme has been cut down to four, Mr. J. Pendlebury (Progressive) and Mr. W. Chapman (Independent) being the two to fall out.

No surprise was felt at this last fact. There were people, as a matter of fact, who thought that not more than three of the candidates would be nominated. With Major Nall and Mr. George Milner, of the Discharged and Demobilised Soldiers' and Sailors' Association in the field, there are two claimants for the soldiers' vote, which doubtless will now be split.

FIRST AND LAST.
The time for handing in the nominations was between 10 o'clock and 12 noon, and amongst the earliest arrivals were the Unionist candidates from all the eight divisions which they are contesting and Mrs. Pethick Lawrence (Lab), who is the only woman candidate in Lancashire. The first papers received were those of Mr. Harold Briggs (U and C) in the Blackley division, and the last at 11.40, those of Mr. Geo. Milner, though the last named candidate was only just preceded by Mr. J. R. Clynes. Most of the candidates put in an appearance, but a distinguished absentee was Mr. John Hodge, whose throat is giving him so much trouble that he will probably not be able to visit his constituents at Gorton this week.

Mr. S. Hague, his election agent, has written him advising him to run no risks and to be sure he "makes a proper job of it for next week."

A feature of the papers of Major Hurst (U and C) was that one of them was signed entirely by the staff, including the nurses, at the Manchester Royal Infirmary.

MR. J. R. CLYNES, M.P.
Manchester's Part in After-war Problems.
No objections were lodged to the nominations and no withdrawals took place during the hour between 12 and 1 o'clock, set apart for events of this character. The Lord Mayor thereupon declared that Mr. J. R. Clynes had been elected for Platting.

Returning thanks to the Lord Mayor, Mr. Clynes, M.P., observed: "You occupy, my Lord Mayor, a great and distinguished office. Next to the distinction of being Lord Mayor

of Manchester, I regard it as a great distinction to be now, as I am by your declaration, senior representative of the City of Manchester in the House of Commons. (Applause).

He wanted to express the thanks of the assembly to the Lord Mayor and his officers for the manner in which the task of receiving the nominations had been conducted and completed. He would not say a single word of a party, or controversial character.

"Indeed," said Mr. Clynes, "We feel generally that at this moment there should be less of the ordinary party conflict than is noticeable in an ordinary election. (Hear. Hear).

PRAISE FOR MANCHESTER.

Throughout the war, he proceeded, Manchester had maintained its great reputation by the manner in which it had played its part. In men, in material, and in many other forms Manchester had made a great contribution towards the great victory which we now enjoyed, and of which Manchester would be proud for many centuries to come. To that all he wanted to add was that the problems which were left to solve were problems in which Manchester would have to play its part also. For some time there would be difficulties of an industrial character, difficulties that might relate to food, for instance – if he might dare to broach such a subject at such a gathering.

He broached the subject personally to acknowledge as Minister of Food for the time being the greatest assistance he had received from the civic authorities of Manchester, and from the local Food Committee presided over by Sir Daniel McCabe, and from all those who had co-operated with him in what had been rather a difficult task.

He confidently expressed the hope that Manchester would tackle the problems left after the war in no less worthy fashion than it had done in bringing the war to a successful issue.

32) General Strike, 1926

The General Strike was called by the TUC in support of miners, striking against cuts in pay and longer hours. It began on Monday 3 May 1926 and was called off by the TUC on Wednesday 12 May 1926, with the miner's strike lasting until the end of the year. On Saturday 1 May, Manchester saw thousands parade in the annual May Day march from Ardwick Green to Belle Vue, after which a meeting took place in the Great Hall at Belle Vue. On Monday workers took joint action, to engage in the General Strike. At the same time the police ensured transport and emergency services kept running.

Manchester Evening News. Saturday, May 1st 1926.

LABOUR'S VOLUNTEER FOOD SCHEME.

BUT NO WORK IN TRANSPORT AND VITAL SERVICES.
MIDNIGHT CESSATION.
"WAR FORCED BY SORDID CAPITALISTS."- Mr. Bevin.

The conference of 200 trade union executives in London to-day decided to call a general strike of vital services, including transport, on Tuesday morning, if there is no settlement of the miners' dispute.

The qualification regarding settlement points to a renewal during the week–end of efforts to find a way to agreement, but both the Government and the Labour organisations are moulding their plans in anticipation of the worst.

Mr. Bevin, the dockers' leader, was the spokesman of the Trades Union Council. Among vital decisions announced by him that form corollaries to the declaration of a general strike are:

"We are stopping vital services, such as transport and staple industries. Volunteer arrangements are being made to feed the people."

"No person must go to work after starting time on Tuesday morning.

The injunction to refrain from work, it was explained by Mr. Bevin, is directed to "those upon whom a serious and grave responsibility has been taken to take part in this struggle."

A special supplement to the "London Gazette," issued this afternoon declares "that a state of emergency exists."

As a precautionary measure the Government have moved certain detachments of troops into South Wales, Lancashire and Scotland.

Up to the time of going to press no statement on the situation had been issued by the mine owners or the Government.

THE PLAN OF CAMPAIGN.
Co-ordinated Action on Part of All Affiliated Unions.
The following plan of campaign was unanimously adopted by the Conference:

The Trade Union Congress General Council and the Miners' Federation of Great Britain having been unable to obtain a satisfactory settlement of the matters in dispute in the coalmining industry, and the Government and the mine owners having forced a lock-out, the General Council, in view of the need for co-ordinated action on behalf of affiliated unions in defence of the policy laid down by the General Council of the Trades Union Congress, directs as follows:

TRADES AND UNDERTAKINGS TO CEASE WORK.
Except as hereinafter provided, the following trades and undertakings shall cease work, as and when required by the General Council:

Transport, including all affiliated unions connected with transport i.e., railways, general transport, docks, wharves, harbours, canals, road transport, railway repair shops and contractors for railways, and all unions connected with the maintenance of, or equipment, manufacturing, repairs, and groundsmen employed, in connection with air transport, printing trade, including the Press.

Productive Industries:
(a) Iron and steel.
(b) Metal and heavy chemicals group,
Including all metal workers and other workers who are engaged, or may be engaged, in installing alternative plant to take the place of coal.

Building Trade.
All workers engaged on building, except such as are employed definitely on housing and hospital work, together with all workers engaged in the supply of equipment to the building industry, shall cease work.

FOOD SUPPLIES.

Electricity and Gas. – The General Council recommend that the trade unions connected with the supply of electricity and gas shall co-operate with the object of ceasing to supply power. The Council request that the executives of the trade unions concerned shall meet at once with a view to formulating a common policy.

Sanitary Services. – The General Council direct that sanitary services be continued.

Health and Food Services. – The General Council recommend that there should be no interference in regard to these, and that the trade unions concerned should do everything in their power to organise the distribution of milk and food to the whole of the population.

With regard to hospitals, clinics, convalescent homes, sanatoria, infant welfare centres, maternity homes, nursing homes and schools, the General Council direct that affiliated unions take every opportunity to ensure that food, milk, medical and surgical supplies shall be efficiently provided.

TRADE UNION DISCIPLINE.

The General Council direct that, in the event of trade unionists being called upon to cease work, the trade unions concerned shall take steps to keep a daily register to account for every one of their members. It should be made known that any workers called upon to cease work should not leave their own district, and, by following another occupation, or the same occupation in another district, blackleg their fellow-workers.

The General Council recommend that the actual calling out of the workers should be left to the Unions, and instructions should only be issued by the accredited representatives of the Unions participating in the dispute.

TRADES COUNCILS.

The work of the Trades Councils, in communication with the local officers of the Trade Unions actually participating in the dispute, shall be to assist in carrying out the foregoing provisions, and they shall be charged with the responsibility of organising the trade unionists in dispute in the most effective manner for the preservation of peace and order.

TRADE UNION AGREEMENTS.

The General Council further direct that the Executives of the Unions concerned shall definitely declare that, in the event of any action being taken and trade union agreements being placed in jeopardy, it be definitely agreed that there will be no general resumption of work until those agreements are fully recognised.

PROCEDURE.

These proposals shall be immediately considered by the Executives of the Trade Unions concerned in the stoppage, who will at once report as to whether they will place their powers in the hands of the General Council, and carry out the instructions which the General Council may issue from time to time concerning the necessary action and conduct of the dispute.

Further, that the Executives of all other affiliated unions are asked to report at once as to whether they will place their powers in the hands of the General Council, and carry out the instructions of the General Council from time to time both regarding the conduct of the dispute and financial assistance. (signed) A. Pugh, chairman.

INCITEMENT TO DISORDER AND SPIES.

A strong warning must be issued to all localities that any person found inciting the workers to attack property, or inciting the workers to riot, must be dealt with immediately.

It should be pointed out that the opponents, will, in all probability, employ persons to act as spies and others to use violent language in order to incite the workers to disorder.

Mr. Ernest Bevin (Dockers) stated that the stoppage of industries included in Schedule I, would take place at the end of the night shift on Monday.

33) Doctor Buck Ruxton, 1936

Indian doctor Buck Ruxton (shown with eldest daughter, *c.* 1935) murdered his wife and nursemaid, cutting up their bodies in the bathtub, at 2 Dalton Square, Lancaster, before disposing of them in the countryside, 100 miles from his home. He was hanged at Strangeways Prison on Wednesday 12 May 1936, with the *Evening News* headline 'Keep Execution Dates Secret' appearing after a 10,000 signature petition, requesting that Ruxton's death penalty be commuted to life imprisonment. Ruxton's motivation was jealousy of his wife's society lifestyle, but his murder of their nursemaid, who probably witnessed Ruxton attacking his partner, meant the execution went ahead. The case was notable for its use of new forensic techniques.

Manchester Evening News. Wednesday, May 13th 1936.

KEEP EXECUTION DATES SECRET. HOME SECRETARY TO BE

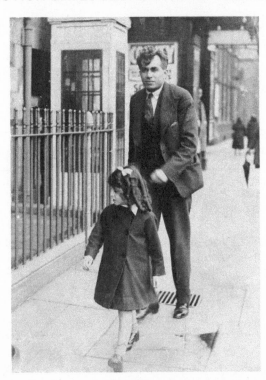

QUESTIONED.
Reform That Would Relieve Thousands of Minds.
DISTRESS AT DEATH HOUR.

MANY M.P.s ARE GIVING SUPPORT TO THE RECOMMENDATION PUT FORWARD BY THE "MANCHESTER EVENING NEWS" THAT THE TIME OF AN EXECUTION SHALL NOT BE DIVULGED UNTIL IT HAS BEEN CARRIED OUT.

Tomorrow will see the first practical step when Sir John Simon, the Home Secretary, is asked in the House of Commons whether he will consider amending the law.

There is general agreement that acute mental distress is caused to many people by the approach of what they know to be the precise moment at which a condemned person is to die.

The suggested reform, which would give relief to thousands, would not interfere to any degree with the working of Justice, since the official notification that an execution has taken place is all that is required.

MANY M.P.S GIVE SUPPORT TO PROPOSAL.

Mr. J. R. Clynes, M.P. for Platting and former Home Secretary in the Labour Party is also in favour of the proposal.

Mr. Vyvyan Adams, Conservative member for West Leeds mentions other considerations, he believes, on balance, that the reform would be desirable.

"I shall welcome anything" he said, "which would prevent people with morbid minds massing themselves as near as possible to the site of an execution, but it may be that to other sections of the community knowledge of the exact moment of the execution might bring home the ghastly nature of the death penalty and cause them to consider whether it was really necessary. On the whole however I think the advantages of not publicly stating the exact moment would outweigh the disadvantages of suppressing it."

CROWDS OUTSIDE.

Mr. R.A. Cory, M.P. for Eccles told us that he was very pleased to see the question put on the Order Paper for tomorrow; "I am totally in favour of something being done," he said, "There is no doubt that much needless suffering is caused to people by the pressing announcement of the date and time of execution.

"Another important aspect is the crowds which accumulate outside the prison in which the unfortunate person is being executed."

ADVANTAGE OUTWEIGHED.

Support for the proposal was expressed today also by Major C.F. Entwistle, K.C., one of the Conservative members for Bolton.

"I cannot see that any useful purpose is served by advertising the time and date of an execution," he said. "Some people might argue that it acts as a further deterrent to crime. But I think it is so slight that the objections far outweigh it.

"If the subject is discussed in the House of Commons, as it would be if an amending Bill were introduced, I understand that several M.Ps intend to raise another aspect of the death penalty – the interval that lapses between sentence and execution.

"They consider it far too long. It is pointed out that once it has been decided not to lodge an appeal there can hardly be grounds for putting off the end until the execution period of about three months has elapsed."

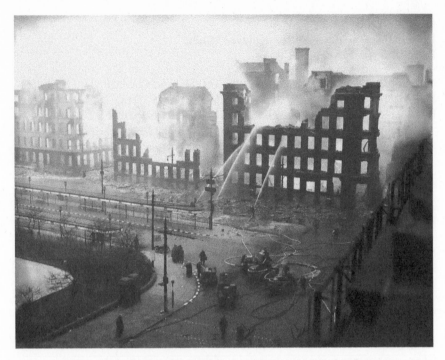

34) Christmas Blitz, December 1940

The Christmas Blitz began on the night of Sunday 22 December 1940 and continued until Tuesday 24 December 1940. Bombing killed more than 680 people and left more than 2,360 injured. On the night of 22/23 December a squadron of 270 aircraft dropped 272 tons of high-explosive and 1,032 incendiary bombs on the city. On the night of 23/24 December another 171 aircraft dropped 195 tons of high explosive and 893 incendiary bombs. Among the buildings destroyed (including Piccadilly, pictured above) were the Free Trade Hall; Cross Street Chapel; Corn Exchange; Smithfield Market, and the Shambles. Manchester Cathedral and Manchester Royal Infirmary were also hit.

Manchester Evening News. Monday, December 23rd 1940.

Bombs Shower on City: Shelterers Trapped in Wreckage.
MANCHESTER BLITZ. MANY BUILDINGS FIRED.
TWO RAIDERS BELIEVED DOWN IN NORTH – WEST: VIVID FLASH – SILENCE.

Manchester had its longest and most severe aerial bombardment last night. For many hours hundreds of incendiary and explosive bombs were dropped, and a pall of smoke hung over the city to-day.

The raid started shortly after dusk, when enemy raiders apparently approaching the city from the south, spread front-wise over a wide area and adopted the familiar tactics of flare dropping, followed by incendiary bombs at various points.

Manchester Evening News. Tuesday, December 24th 1940.

BUILDINGS DYNAMITED IN LANCASHIRE TOWN.

Bomber Brought Down at Old Trafford.
Big Warehouses Fired: A.F.S Men Machine-gunned.

Hospitals, two shelters, and a number of shops, houses and commercial buildings in a Lancashire town were damaged or destroyed in another heavy raid on the North-West last night.

Though many incendiaries and high-explosive bombs were used, the casualties are thought to be few.

An enemy bomber was reported to have been brought down at Old Trafford, Manchester – the fourth destroyed in the North-West area in three nights.

After dropping incendiary bombs on a block of shops in the Lancashire town Nazi planes swooped low and tried to machine gun some of the firemen.

To prevent flames and fires from spreading in one of the main business streets where a number of large warehouses were on fire, the authorities used dynamite.

Streets were cleared of firemen for an area of more than 500 yards and several boxes of dynamite were used … Walls on fire and in grave danger of collapsing fell. By these efforts the fires were more quickly extinguished and dangerous walls demolished.

TRANSPORT KEEPS ON.
…But all were smiling and it is impossible to speak too highly of the way Lancashire folk have faced up to the intensive raiding with real Lancashire courage.

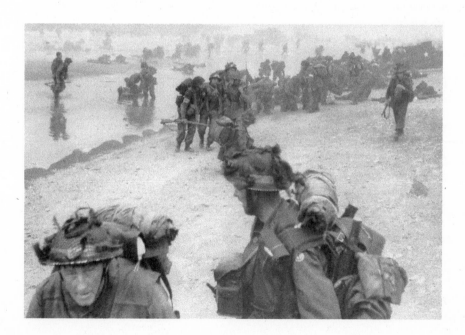

35) The 1st Battalion South Lancashire Regiment, 1944

On D-Day, Tuesday 6 June 1944, the 1st Battalion South Lancashire Regiment (shown on previous page) stormed Sword Beach together with a section of the Middlesex Regiment. They were a part of the Battle of Normandy, June–August 1944, which began with the D-Day landings and resulted in the Allied liberation of Western Europe from Nazi Germany's control. Codenamed Operation Overlord, 156,000 American, British and Canadian forces landed on five beaches along a 50-mile stretch of Normandy's heavily fortified coastline. The invasion was one of the largest amphibious military assaults in history. By the spring of 1945, the Allies had defeated Hitler's Nazi Germany.

Manchester Evening News. Tuesday, June 6th 1944.

FRANCE INVADED: TANKS PIERCE WALL.

Air Troops Lead Way, Then Beachhead Stormed.
4,000 Allied Ships: Normandy Ports Attacked.
PARACHUTISTS STORMING CHANNEL ISLANDS – NAZIS.

Europe was invaded by the Allies at 6 a.m. to-day, when, said the first communique, "naval forces, supported by strong air forces, began landing Allied armies on the northern coast of France." This afternoon the news was flashed that a beachhead had been secured by British and Canadian troops at Normandy.

Photo reconnaissance pilots said this afternoon that the Allies were "slashing their way ahead." From Berlin it was reported that Allied troops had landed at Arromanches, and at the same time the landing of parachutists in the Channel Isles of Jersey and Guernsey was reported.

They landed, said the Germans, on both Jersey and Guernsey by air and were at once engaged in battle.

Late this afternoon the Germans admitted that the troops from Arromanches – a fishing port 15 miles north – west of Caen – had penetrated several miles to the south – east of Caen and Isigny. Paris Radio said "The enemy is retreating deeper inland."

FIVE AIR DECISIONS.
German official placings of Allied forces were that the 88nd and 101st U.S. Airborne Divisions were attacking Cherbourg and the First, Second and Sixth British Airborne Divisions were engaged in the Seine estuary.

Reconnaissance pilots who were over the beachhead and coastal regions have reported: "We saw everything we expected – except enemy aircraft. It looked as if every town and village over a wide area was ablaze. It was magnificent to see the troops swarm through the sea. The French public appear to be keeping off the roads."

Radio reported that 80 Allied warships were approaching Cherbourg and other landing craft were heading from England.

German radio claimed that east of Cherbourg German counter attacks were making good progress. Official statements said that British, Canadian and U.S. forces landed in Normandy between 6 a.m. and midday, with Airborne landings and naval bombardment

being carried out, over 640 naval guns, from 16 inch, were bombarding beaches and strongpoints.

The Prime Minister made a statement to a packed House of Commons. Mr. Churchill said: "An armada of upwards of 4,000 ships, with larger and smaller craft have crossed the channel,

Allied airborne landings have been successfully effected behind the enemy's lines. The landings on the beaches are proceeding at various points at the present time. The fire of the shore batteries has been largely quelled. The obstacles which were constructed in the sea have not proved so difficult as was anticipated."

"IT WAS HELL LET LOOSE."

From a Military Observer who landed with the First Assault Forces.

Allied warships began their umbrella bombardment to-day as soon as dawn broke.

It seemed that hell itself had been let loose. From left, right and centre our guns opened up and from our vantage point at sea we could see that targets ashore were being pounded out of existence as the assaulting infantry sailed slowly and surely ahead to let bayonets do whatever work remained.

MAGNIFICENT SIGHT.

From sea and sky the bombardment continued until our infantry went ashore. It was a magnificent sight.

Wave upon wave of khaki-clad figures surged up the beaches overcoming any opposition in their way, and surging on.

PREMIER SHOOK WITH LLOYD GEORGE.

There was a scene of almost wild enthusiasm in the House of Commons when Mr. Churchill made his announcement on the progress of the invasion. Members gave him a great ovation when he appeared, somewhat late and was at once called by the Speaker.

When the Premier had finished Mr. Greenwood described the speech as second only to the declaration of war.

Mr. Gallacher (Comm. West Fife) then said: "This is one of the most solemn moments in the life of this Parliament, and it is certainly not a time for trying to make speeches."

Lowering his head and speaking with emotion, he added: "I would like to express my own feelings and, I think, the feeling of every Member of this House, that our hearts and our thoughts are with those lads and the mothers who are at home."

There was a murmur of sympathetic cheering.

HANDSHAKE.

Mr. Churchill then rose from the front bench as Mr. Lloyd George, who was sitting on the front Opposition Bench, rose to leave the Chamber.

Mr. Churchill crossed the floor of the House and he and Mr. Lloyd George shook hands vigorously.

36) Newton Heath Street Party, 1945

Victory in Europe Day was the 'end of one of the darkest periods in history.' At exactly 9.32 p.m. peace was declared. War in Europe finally came to an end and the people of

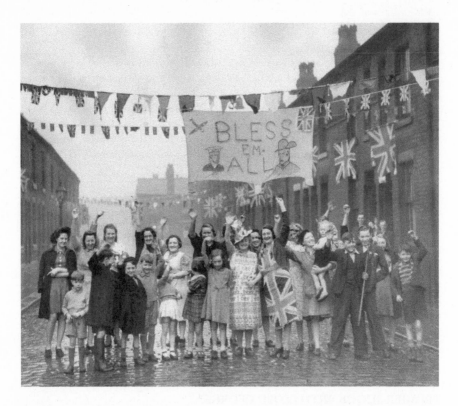

Manchester flooded out onto the streets to rejoice. Street parties and singalongs took place across the region (shown at Newton Heath) and the city centre soon became full of celebrating crowds, with bunting and flags adding to the occasion. Huge crowds gathered at Piccadilly Gardens and even more flocked to Albert Square, with the mayor addressing the crowds and Churchill making a radio address to the nation at 3.00 p.m.

Manchester Evening News. Tuesday, May 8th 1945.

Mr. Churchill Announces Official Peace from Midnight.
CHEERING CROWDS AND CRACKERS.

Several thousand joyous but not hysterical people gathered in Albert Square at 3 o'clock to hear the Prime Minister announce that the war in Europe, the greatest in history, was ended.

From 2 o'clock they had listened happily to the Police Band, waving and cheering madly.

Over five hundred younger spectators climbed on top of the three air-raid shelters in the Square. Exploding rip-raps echoed in the streets.

Then the crowd hushed as the band ceased and Mr. Churchill's voice rang with an echo throughout the Square.

When he finished the cheering rolled out again and again as the Union Jack was broken on the main flag pole.

A mighty peal from the Town Hall bells, and the Lord Mayor, Alderman W.P. Jackson, spoke from the Town Hall steps.

Flags of 44 nations flew, the band played national anthems of the Allies.

Then altogether the crowd sang "God Save the King."

But the biggest cheer of all was reserved for what was hoped was the last all-clear.

Through a second microphone the BBC recorded the whole ceremony for reproduction.

TEDDER SIGNS BERLIN SURRENDER PACT TO-DAY. CEASE FIRE CONFIRMED IN HISTORIC STATEMENT.

National victory celebrations reached their peak to-day – after much preliminary and unofficial rejoicing overnight – with the broadcast of the Prime Minister declaring the War in Europe at an end.

Mr. Churchill said: "Yesterday morning at 11 a.m. at General Eisenhower's Headquarters General Jodl, representative of the German High Command and of Grand Admiral Doenitz, designated head of the German state, signed an act of unconditional surrender of all German land, sea and air forces in Europe to the Allied Expeditionary Forces and simultaneously to the Soviet High Command.

General Bedell-Smith, Chief of Staff of Allied Expeditionary Forces, and General Francois Sevez signed a document on behalf of the Supreme Commander of the Allied Expeditionary Forces, and General Susloparov on behalf of the Russian High Command.

Today this agreement will be ratified and confirmed when Air-Chief Marshall Tedder, Deputy Commander of the Allied Expeditionary Forces and General Lattre de Tassigny will sign on behalf of General Eisenhower. General Zhukov will sign on behalf of the Soviet High Command. The German representative will be Field Marshal Keitel, Chief of German High Command, and Commander-in-Chief of the Army, Navy and Air Forces…

After gallant France had been struck down we from this island and from our united Empire maintained the struggle single-handed for a whole year, until we were joined by the military might of Soviet Russia and later by the overwhelming power and resources of the United States of America.

We may allow ourselves a brief period of rejoicing, but let us not forget for a moment the toil and efforts that be ahead. Japan, with all her treachery and greed, remains unsubdued.

We must now devote all our strength and resources to the completion of our task, both at home and abroad. Advance Britannia! Long live the cause of freedom! God Save the King.

The Prime Minister went to the Commons immediately after his broadcast, and there was a great roar of cheering when he rose to repeat his statement in the House.

"HITLER'S BODY FOUND"

By NED NORDNESS with British Second Army, Tuesday. Russian troops have found a body, purported to be Hitler's, in the ruins of Berlin, it has been disclosed here by a Red Army General.- A.P.

37) 'Victory in Japan' Day, 1945

Wednesday 15 August 1945 was declared 'Victory in Japan Day', shown at Albert Square, with the end of the war marked by two-day holidays in the United Kingdom, the United States and Australia. At midnight the Prime Minister, Clement Atlee, confirmed the news in a broadcast, which occurred on the same day as the state opening of Parliament. Later, at 9.00 p.m., the king addressed the nation and the Empire in a broadcast from his study at Buckingham Palace. Crowds of people flocked onto the streets of every town

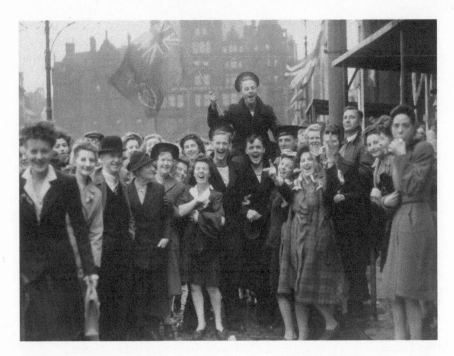

and city, shouting, singing, dancing, lighting bonfires and letting off fireworks, in scenes
similar to VE Day.

Manchester Evening News. Wednesday, August 15th 1945.
BANDS, DANCING, BONFIRES AND THANKSGIVING SERVICES.

JAPANESE FLAG BURNED IN ONE TOWN.
Lancashire and Cheshire celebrated the first VJ Day to-day in wholehearted
fashion, even though there was a similarity in all the people's rejoicings. In
every town there was dancing in public squares, fireworks and bonfires, as well
as bands and torchlight processions. A Japanese flag captured by a Canadian
Sergeant in the Far East fighting was publicly burned in Blackburn's Town Hall
Square. Throughout the country the flags of the Allied nations flew from public
buildings. There were thanksgiving services in all the churches, hymns were sung
at Cenotaphs, and there was also much community singing. In Bury there were no
buses after the early morning services and in many Lancashire towns workers went
to mills only to find them closed.

THOUSANDS PARADE ON BLACKPOOL PROM.
Celebrations in Blackpool began shortly after midnight when soldiers and airmen of many
nationalities with residents and visitors gathered in front of the Town Hall in Talbot Square.

Many of the crowd of 10,000 had turned out of bed. They joined community singing,
while fireworks were set off and flares and rockets fired into the air.

Motor-cars were held up by crowds of people who clambered onto the roofs and bonnets and rode the promenade from one end to the other. Many were in night attire – men with dressing gowns over pyjamas and women with short coats over night dresses. Some people were half dressed and others were in evening dress, just as if they had rushed from a party.

MORECAMBE: Celebrations were centred around Happy Mount Park this afternoon and opened by Jessie Matthews. A crowd of 4,000 was expected.

In the town there were no official celebrations, and there was very little boisterous celebrating as intoxicating liquor is in short supply. Owing to the non-arrival of beer several public houses cannot open today.

MANY WENT TO COTTON MILLS.

BOLTON: Owing to the lateness of the announcement many cotton workers went to the mills only to find they were not running. Those who heard the announcement at midnight danced and sang in the park.

Before 9 a.m. long queues had formed outside stationery shops in the hope of buying fireworks. At 11 a.m. a thanksgiving service was held from the Town Hall steps.

To-night a huge bonfire will be lit on Spa Road Recreation Ground and there will be open-air dancing. A tour of the town will be made by an illuminated bus.

ROCHDALE: Led by an accordion player, a crowd of over 200 people assembled in the Town Centre after midnight and joined in community singing. Later they went to the Cenotaph to sing hymns.

The town centre will be gaily illuminated to-night and to-morrow there will be bands in the park and an illuminated bus.

BURY: After running the early services Bury Corporation Transport workers ceased work for the day, and from eight o'clock onwards the borough was without buses or trams. This was decided by a meeting of the men last night. Normal services will be resumed to-morrow morning. The Mayor, and Corporation of Bury, attended a thanksgiving service at the parish church at noon and this afternoon a limited thanksgiving service was held on the Wellington Playing Fields.

FLAG BURNED.

BLACKBURN: After a crowd of several thousand people had ended their jubilations in the Town Hall Square at 3.30 a.m. they saturated with petrol and publicly burned from the balcony a Japanese National Flag produced by a Canadian Sergeant who had captured it in the Far East.

The Mayor, Councillor E. Holden, and the Town Clerk, Mr. C.S. Robinson, called from their beds soon after midnight, remained on the Mayor's balcony until nearly four o'clock, joining in community singing, cheers for the King and the Army, and "Auld Lang Syne."

The Mayor told the people, "You jolly well deserve two days holiday." Though very jubilant the crowd behaved remarkably well.

EARLY SHOPPERS BOUGHT VJ2 HOLIDAY FOOD.
Clearing Fish.

Traders in the fish industry are working throughout the holiday to clear supplies. Only small quantities, mainly plaice, reached Smithfield Market, Manchester, to-day, to be dispatched to retail shops, which stayed open until all the fish was sold.

There have been fairly heavy landings at the ports and supplies will be picked up and put into store at the market to-morrow to be brought out again on Friday.

The fruit market was flooded with extra supplies of fruit and vegetables. It is expected that the market will close to-morrow.

38) Aneurin Bevan, 1948

The National Health Service began on Monday 5 July 1948, when its founder and Labour's Minister of Health, Aneurin Bevan (below), toured the world's first NHS hospital, 400-bed Park Hospital at Davyhulme, now Trafford General. He is seen in the photograph below with Sylvia Diggory (née Beckingham), the first NHS patient, who apparently was too shy to ask him any questions. The plan was to bring good healthcare to all under one organisation, which provided services free for everyone at the point of delivery. It was to be financed entirely from taxation, which meant people paid into it according to their means.

Manchester Evening News. Monday, July 5th 1948.
The State and the Hospitals.

To-day the hospitals become state property and the public is asking – Will there be a better or worse service from them now all treatment is to be free?

The answer is the same as that given to those who asked whether the nationalisation of mines would mean more coal being produced – Do not expect a miraculous improvement immediately.

The amount of service the hospitals can give could only be increased immediately by "diluting" the quality of the service.

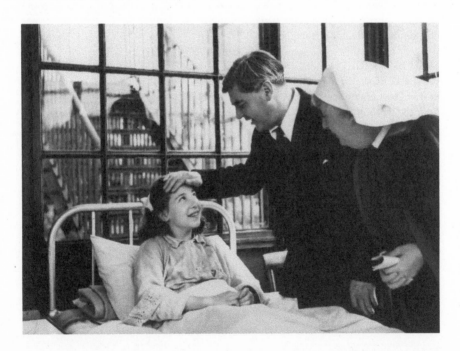

It is certain that increased demands will be made on the hospitals now that the comprehensive service is theoretically available, and one of the dangers to be avoided is the appointment of men and women of inadequate qualifications to posts of responsibility in a mistaken effort to meet these demands.

If this temptation is not resisted it will be to the disadvantage of medical science and the patient. Some things cannot be forced: they must be allowed to develop.

On the need for a co-ordinated hospital service there is no conflict of opinion. Thus far the Minister of Health, Mr. Aneurin Bevan, has had everybody with him. In fact the hospitals themselves had devised schemes that would eventually have produced co-ordination.

But Mr. Bevan has been in a hurry. He was obliged to keep pace with Social Insurance, which from July 5th provides a comprehensive health service.

What have been the admitted shortcomings of this country's hospital services? The chief one has been the failure to combine in regional schemes, and this criticism applies equally to the voluntary and the municipal hospitals.

The report of the Voluntary Hospitals (Sankey) Commission in 1937 gave examples of the results of this individualism:

New hospitals or extensions were sometimes provided without sufficient regard to the general need;
Hospitals were expanded without proper consideration of increased maintenance costs;
Many lacked any real association with teaching and research;
The more important hospitals were apt to be congested while others had empty beds;
The scope of particular hospitals was not defined with sufficient clarity;
Some of these happenings made defects in staffing irremediable;
And, in general, the outlook of many hospital boards tended to be parochial.

Such frank confession created an impetus to reform, and but for the war great advances would have been made. The movement for the regionalisation of hospitals was quickened by Lord Nuffield's gift of £1,250,000 and the setting up of a provincial hospitals trust for the regionalisation of services by the methods the Sankey Commission had advocated.

Joint bodies of voluntary and municipal authorities were already operating in Birmingham, Bristol, Liverpool, Oxford, Manchester, and other places.

These bodies recognised that for good reasons progress could not be fast. There was – and there remains – a shortage of medical men, particularly of specialists, who have a key position in all schemes of hospital reform.

There is – and there remains – an equally grave shortage of nurses.

Mr. Bevan's breadth of outlook has been shown by his desire to give special thought to teaching hospitals, and the recognition that research should be given its head. By providing the Act, he has encouraged the raising of funds by voluntary subscription to support this freedom.

PUBLIC HEALTH 1848.

It is an interesting coincidence that the year which sees the advent of the new National Health Service should also mark the centenary of the first great English Public Health Act ... for the first time the Government by legislation admitted that it was concerned about the conditions under which the people of Britain lived and about the factors making for their physical well-being.

For this reason the Public Health Act of 1848, with all its limitations, was the first essential step on the road which led to the National Health Service – though it has taken a century for this further milestone in social progress to be attained.

39) FA Cup Final, 1956

This final is principally remembered for the heroics of Manchester City goalkeeper and former German paratrooper, Bert Trautmann. He stayed on the pitch, throwing himself at the feet of opposition attackers as they bore down on his goal, despite having broken his neck in the second half. Trautmann was knocked out by the collision which led to his injury, but pulled off a series of outstanding saves before the game concluded, none of which he could recall. Shown is Captain Roy Paul on his team- mates shoulders, holding the FA Cup aloft, after their 3–1 victory against Birmingham City.

Manchester Evening News. Monday, May 7th 1956.

Bert was in pain – but he saw his medal.

When the festooned cup special snorted its way to Manchester's London Road Station this evening and the cheers of the crowd roared its greeting to Manchester City's Wembley heroes it was "the end of the road" for at least six personalities – Manager Leslie McDowall, trainer Lawrie Barnett, and Roy Paul, Bert Trautmann, Bill Leivers and Ken Barnes.

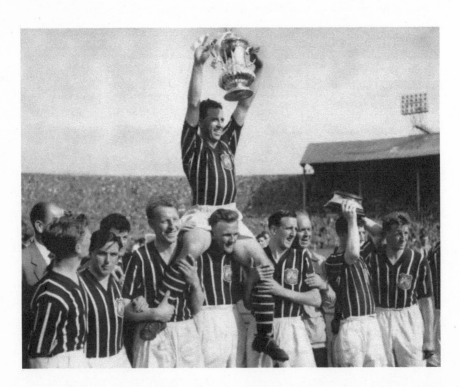

MR. MCDOWALL has completed his plan to get City back on the top. You'll remember, of course, they were a very average team when he left West Ham to take over the manager-ship of a side he had once captained.

It was hard going but gradually he grouped the nucleus of a small team, moved them gradually up the league ladder, and then built them into a fighting force.

And so we all say congratulations Leslie McDowall.

ROY PAUL. He obtained the signatures of all his City teammates on the ball with which they had just beaten Birmingham.

"Never lose it."

Then easing open the outer door from the revered precincts of the dressing room to the outside world, Roy quietly passed out the ball to Ray Little's son, with the words: "Never lose that son. It was the ball that won the Cup for your Dad."

Then he spent a jubilant 20 minutes walking round and round the dressing room in just a vest, making certain every one of his friends had had a drink from the Cup.

Gradually he manoeuvred some of his friends from the Rhondda Valley into the dressing-room and the dressing-room and everybody could have been forgiven thinking they were really in Welsh Wales. But Paul couldn't have cared less – IT WAS HIS GREATEST MOMENT.

BERT TRAUTMANN had his eyes set on the target from the moment he signed for City … playing for Germany and being presented with a cup medal by Her Majesty the Queen.

It was a severe blow to his pride when Germany passed him over for the Wembley match with England.

I will never forget bringing trainer Barnett with a dressing room message to treat the pain in Trautmann's neck at the end of the Wembley triumph against Birmingham. He put both his great hands on my shoulders and said: "The pains shooting right through me…"

KEN BARNES is a different character to the rest. Like his great friend Ray Little, he's a keen humourist – yet deep down this brilliant right – half from Stafford has been nursing a dream for years.

Having been born just outside Birmingham City's headquarters at St. Andrews he naturally wanted to show them what they had missed. Yet every time City played down there they seemed to take a thrashing At least that was the way of things until the sixth round there last year when City triumphed and Ken was one of the heroes.

At the start of this season he said to me: "I'd love to have a Wembley winner's medal to show everybody in Birmingham." Now he's got it and if you'd spoken to him this weekend, as so many of his close friends did, you'd have heard him reiterating this phrase: "I just want to die. I'm so happy."

So there you are. A bunch of great hearted fellows who have "reached the end of the road."

40) Viscount Crash at Ringway Airport, 1957

On Thursday 14 March 1957 twenty-two people were killed when a BEA Viscount airliner from Amsterdam crashed into two council houses, with a third house badly damaged. Five crew and fifteen passengers in the plane were killed. Two people died on the ground, as the aircraft struck one of the houses. The Viscount was making its final approach for landing when it veered and crashed into a field. Eyewitnesses spotted

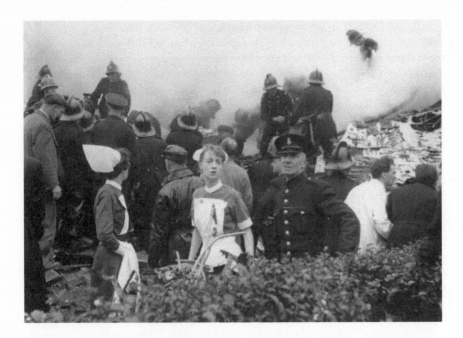

engines in gardens, yards away from the wreckage. Rescue teams were on the scene within a few minutes and bodies were still being recovered several hours after the crash.

Manchester Evening News. Thursday, March 14th 1957.

Airliner. 20 aboard, crashes: Toys in wreckage: Houses wiped out.
VISCOUNT HITS RINGWAY HOMES: 24 FEARED DEAD. HUSBAND RUSHES TO CRASH SCENE – "MY WIFE AND BABY IN THERE."

Hurtling out of the sky near Manchester's Ringway Airport this afternoon, a B.E.A. Viscount airliner smashed against houses in Shadow Moss Road, Wythenshawe, and burst into flames. The plane had 20 on board. There were no survivors and four people in the houses are feared dead.

The plane, from Amsterdam, was coming in to land. It came down 200 yards on the wrong side of the runway and shattered two houses. The time was 4.50 p.m.

Immediately a sheet of flame shot up. Debris from one of the houses crashed down on the mangled plane.

Neighbours who heard the plane coming in "very low" raced out on hearing the crash. They formed emergency rescue parties. But within minutes fire engines and ambulances from all over the city were at the scene.

Two housewives from the wrecked houses were rushed to hospital. And rescue workers fought desperately to reach a woman and a little girl believed trapped in the wreckage.

An hour and a half after the crash casualties were still being counted.

"No hope for anyone."

Said a Manchester Ambulance official "As far as we know most of the people on board are still beneath the wreckage."

And a spokesman at Lancashire Police Headquarters said "As far as we know there are no survivors. We have had none reported, and from what we have heard it seems very unlikely that there could be any."

Withington Hospital was warned to stand by to receive casualties. Nurses and medical orderlies went out with ambulances to the scene. "We don't know how many may be injured," said a hospital official.

THE PLANE, a four-engine Viscount airliner, was bound for runway 24. An official said it was on radar course, but veered off and crashed into the houses.

"Straight through front door."

An eye-witness who lives in Robinsbay Road, Woodford Park, Wythenshawe, said: "We saw the plane coming in very low and rushed to see where it had crashed. A few of us formed a rescue party, but the firemen and ambulance men were soon on the spot.

"The plane looked as though it was going straight through the front door of one of the houses. It flattened out two houses."

Mr. Roy Isherwood, who lives nearby, said: "The plane was flying perfectly normal coming in to land, but appeared to veer at some distance.

"It came down 200 yards on the wrong side of the runway, hit the houses, and burst into a sheet of flame."

POLICE at Manchester said the airliner bounced on the runway at Ringway and then hit the houses.

"Wreckage is everywhere and the plane is blazing fiercely," they said.

Another eye-witness, Mr. Adam McAllum, aged 32, of Robinsbay Road, a porter at Ringway Airport, said: "I was in the back kitchen and saw the plane flying low over the field at the back of the house.

His engines cut out. One wing seemed to dip then swing right over the other way, and he crumpled into the row of houses. It seemed the pilot was trying to pull the plane on to open ground. He was doing his best."

Another witness Mrs. Mary Nash, aged 29, an expectant mother, whose house backs on to the demolished row, said: "I thought at first that a plane had broken the sound barrier, but it was much too big a bang. I dashed to the window.

"The whole plane and the houses underneath it seemed to be falling apart. Then they went up in flames. It was horrible."

Another witness in a bungalow 200 yards away, said: "The plane's wing almost dipped into my front garden. It seemed as though he was in a low air pocket or something – then he tried to pull away from the houses. It was no good. His wings spun and he hit the row in Shadow Moss Road."

"Bounced on the runway."

The anxious minutes dragged by – and then came the sad message: "We have no hope of getting anyone out of the plane alive."

A B.E.A. official said all on board the plane – 15 passengers and five crew members – were killed in the crash.

It is understood there were at least three Dutch passengers on board.

The bodies of two victims were brought out of the debris. Police cleared nearby Shadow Moss Church of England School to use it as a mortuary.

Hope had gone – but willing hands still formed a human chain passing back rubble and wreckage to surrounding gardens.

Desperate search goes on.

This was the scene more than an hour after the crash.

Thick grey smoke rose from the 30ft. mass of wreckage.

Firemen, ambulance men, and civilian volunteers climbed over the foam-covered debris, clawing desperately to get to the heart of the fire and see if there were any survivors.

Nurses stood waiting with stretchers. A crowd of nearly 2,000 gathered, from them came more and more volunteers – including women who helped to heave on a rope attached to masses of debris, to make a way to the heart of the fire.

Children's toys, teddy bears and dolls – were thrown from the blazing wreckage.

Two houses in the next row were completely shattered. Another was badly damaged. And there were the people whose homes were damaged.

THE DEE FAMILY husband, wife and two boys. Mrs. Dee was injured and taken to hospital.

THE DEANS – husband, wife and two children lived next door.

Mrs. Dean is thought to have been out at the time with her three year old baby son.

THE WILDINGS – husband, wife and two children, one of whom was at school. Mrs. Wilding was pulled from the wreckage and taken to hospital.

"My wife is in there…"

The houses at the crash corner are all three bedroom homes built in semi-detached blocks and terraced rows of four.

Roy Peacock, aged 24, bus conductor, of Swithin Road, whose home was 28 yards from the scene of the crash, said: "I saw flames spurting from the plane before it crashed. I was getting off the bus at the corner of the road and I was terrified, because it looked as though the plane was bound to crash into my house.

"I knew that my wife Irene, aged 24, and two of my children – Leonard, aged four, and Audrey, aged two – were in the house."

He went on "I ran as fast as I could and found that the plane had torn through the houses on the other side of the block, and stopped about 20 yards from our house.

"My wife was in the back kitchen and saw the houses before her crumble as the plane tore through."

Mrs. R. Phillips, of Swithin Road, Woodhouse Park, said an airport official told her that if the plane had not overturned many more houses would have been destroyed.

"It was lucky that it did not take all the houses," she said. "Of course, we have been fearing this would happen."

Many neighbouring houses were evacuated. Other neighbours stripped their beds of blankets in case there were survivors to be attended to.

THE VISCOUNT was the world's first propeller-jet airliner. About 180 of them, with room for 43 passengers are in service all over the world. Officials said this was the first time there had been passenger loss of life since the planes came into service in 1952.

The Viscount that crashed this afternoon was the first to be delivered to B.E.A. Since going into service in April 1953 it had flown more than 5,000 hours. B.E.A. have over 38 Viscounts in service.

This was the first B.E.A. crash with loss of life since January 6th 1953, when a B.E.A. Viking crashed at Feltham, with a loss of 24 passengers. Since then B.E.A. have carried more than 16M passengers without fatal injury to any.

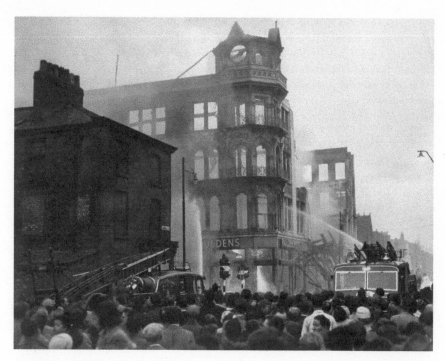

41) Pauldens Department Store Fire, 1957

In 1957 Paulden's department store was completely renovated and on Sunday 9 September 1957, before it was due to reopen a fire broke out, completely destroying the building. The cause was never identified. Pauldens then traded temporarily from an army barracks on Medlock Street, with some staff transferring to Affleck & Brown's department store. Others were re-employed as debt collectors, to recover outstanding payments for credit purchases, as Pauldens was the only store to offer credit facilities at the time. Eventually Pauldens relocated to Market Street, at Ryland's warehouse, now occupied by a Debenhams store, Paulden's owners from 1928.

Manchester Evening News. Monday, September 10th 1957.

"Picture News" captures the white – hot drama as Pauldens dies in a sea of flames.

Fire wrecked Pauldens will rise again…
…A team of Paulden's staff, led by Mr. Jack Mullins, managing director, is seeking alternative premises so that sales can start again.

They have goods on order that customers will never see…He was facing the problem by promising a "Customers' Inquiry Bureau." The messages were to suppliers…

To all parts of the country today SOS's are going out from Paulden's temporary operations room in the nearby REME drill hall.

Already on Way.

Squads of firemen were on standby to save the building. When the caretaker, aged 25 and of Failsworth, heard the fire alarm, he flashed from his cable on the Cavendish Street side door to the front entrance to look at the fire alarm indicator.

It told him that there was a fire on the first floor.

He phoned the brigade but firemen were already on their way – called automatically.

It was 5.20 p.m. when the automatic fire alarm started on the store's first floor.

LESS THAN TWO HOURS LATER THE ROOF WAS GONE AND THE WHOLE OF ONE MIGHTY WALL HAD CRASHED INTO THE STREET.

All that was left of Pauldens was a deep pool of fire as the inferno roared on in the basement and cellars.

Said Mrs. Irene Hamilton: "When the main wall crashed down the noise was terrific. People didn't stay very long here."

With a side wall collapsed into the street a mass of twisted girder work was exposed to the sky…and all that remains of the store still blazes furiously as firemen pour water into the interior.

As dusk fell the streets around All Saints were lit by the blazing interior of the store as firemen battled to control the blaze. Hemmed in by the crowds of sightseers firemen continued to tackle the blazing store.

42) Fire at Belle Vue, 1958

The ballroom block was destroyed, as was Syd Lane's studio and 5,000 of Fred Bonelli's musical scores were lost. By the time the fire brigade arrived it was too late to save anything and the fire, fanned by strong winds, threatened animal accommodation, resulting in their evacuation. The Lion House remained close to the

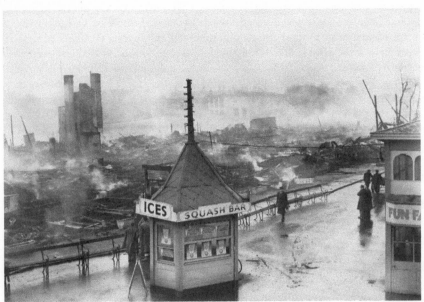

fire and while evacuation was not possible, firemen hosed the area to minimise the risk. Armed police were on standby and one lioness 'Judy' was destroyed, as reported. The devastation was so extensive (shown on the previous page is the York Restaurant and Coronation Ballroom) the *Evening News* quoted a £1 million repair bill for the famous entertainment complex.

Manchester Evening News. Friday, January 17th 1958.
FIRE MAY COST BELLE VUE £1M.

SHOWGROUND TO RISE AGAIN.
Seconds save a lion "massacre."
 DEVASTATION caused by the giant blaze at Manchester's world-famous Belle Vue may cost the owners about £1M.
 DAMAGE alone is estimated to cost over £250,000.
 LOSS OF REVENUE will run into "thousands of pounds a week."
 Dawn had revealed a scene of blitz – like chaos.
 Palls of smoke hung grimly over the four acre site as firemen still poured thousands of gallons of water on the smouldering ruins.
 BUT AMONG THE TANGLED WRECKAGE AND DESPAIR THERE WERE WORDS OF HOPE.
 Said Sir Leslie Joseph, managing director: "We shall make Belle Vue bigger and better."
 He added: "Our plans to make Manchester the entertainment centre of the North-West will go on."
 "We hope to start rebuilding within 12 months."
 Mr. Eric Iles, Belle Vue chairman, travelled to Manchester from Brighton to-day to inspect the damage.
 None of the regular staff will be out of work.
 Alternative jobs will be found for most of the casual workers.
 WRECKED Coronation Ballroom which has a capacity of more than 4,000. The Tudor Suite (Ballroom and bar) with a capacity of about 500, the Baronial Hall, the Popular Café and artist's studio, the Pagoda Restaurant, staff canteen, the public seating at the fireworks stand, the gallery, American and York bars, and five shops.
 SHOT Judy, the 17-year-old lioness and one of the oldest inhabitants of Belle Vue.
 Split seconds had saved this Belle Vue blaze from becoming the Belle Vue slaughter.
 60ft. FLAMES.
 At the height of the blaze Mr. William Wilson, the new zoo superintendent, and Mr. Richard Morris, chief security officer, stood a few feet away from 60ft. flames, ready to shoot animals nearby.
 Mr. Wilson said at one period it did not seem possible the fire could be prevented from reaching the animal house.
 THE TWO MEN STOOD INSIDE THE ANIMAL HOUSE AS FLAMES LICKED AND CRACKED THE WINDOWS.
 "The heat became so intense that we almost had to shoot all the animals and retire immediately."
 Mr. Wilson said.

But firemen, directed by Manchester Fire Chief, Commander K.N. Hoare, suddenly played a curtain of water between the blazing block and the animal house.

The situation was saved.

Mr. Wilson had been awakened by flames leaping nearly 75ft. to his bedroom window above the office block.

FLASHBACK…

Memories of a night of horror in 1950 when all the animals in his father's circus in Utrecht, Holland, died in a raging blaze came rushing back again to horse trainer Jos Mullens.

"The picture of that terrible night when all 35 of my horses perished came immediately into my mind and made me feel sick," said Jos to-day.

Immediately he ran to the hall behind the blazing buildings where the horses were stabled.

"The first inclination of a horse is to run into a fire," he said "and I was terribly afraid. My troupe of 10 Liberty horses were in a panic. It was all I could do to get them clear."

Helped by his wife, Conchita, aged 28, his brother Harry, aged 22, and his sister Jose, aged 29, and her husband Henry Strassburger, aged 33, Jos ran the terrified animals to safety, well away from the blaze.

Belle Vue greyhound stadium was not affected by the fire and racing will go on as usual to-morrow night.

STAMPEDE RISK.

Roused from his bed, elephant trainer **Rudy Jurschat** faced a dilemma…

Should he wait before moving his five elephants from their stable or risk a stampede taking them out while scores of people were milling about.

"I loosened the chains on their legs and had boys standing in front of the building ready to warn me if there was any danger of the King's Hall catching fire.

"I heaved a sigh of relief when I was told the danger was over."

To-day squads of men were still carrying cages of rare birds from the flame blistered 100-yard-long aviary.

BIRDS PANIC.

Flames shooting right over the 60-foot building had made the birds panic stricken.

Gangs of Belle Vue workers were brought in to-day to begin clearing up.

Sir Leslie Joseph told me: "I don't wish to appear frivolous but we shall make Belle Vue bigger and better.

"Meanwhile the circus travel exhibition and what amusements are not affected will be open to the public.

"But there can be no more dancing for the time being."

Sir Leslie was entertaining circus performers at a private dinner when the alarm was first given. He said: "The fire brigade was here within seconds. And there in front of it was a sheet of flames. It was a dreadful sight."

Blaze wrecks North's playground.

HORROR CREPT ON AND ON…

BILLOWING smoke shooting high above the towering flames lit up Ardwick Green.

THOUSANDS of people for miles around were wakened up by the roar of crashing buildings. Hundreds dashed to give aid.

And as the workmen and firemen doused the blitz-like wreckage the small left-overs of the centre of amusement only a few hours earlier could be seen.

There was the concrete gnome, still holding a waste-paper basket on the fringe of the wreckage.

Steel beer bottle crates, holding only shattered pieces of glass, stood defiantly 13 high in the centre of the wreckage.

And the County-Fare stall was shattered and empty.

BEWILDERED.

Mr. Wilson, zoo superintendent, said later that the animals were not fear ridden by the fire.

"Some of the lions lay in the corner of their cages quiet and bewildered."

The leopards, always more agile, were jumping around.

Thinking of Judy, the 17-year-old lioness, he said: "It was a most unhappy thing to have to do. These animals are like one of your own."

Judy was valued between £80 and £160.

HUNDREDS OF POUNDS WORTH OF BEER AND SPIRITS WERE LOST IN THE FIRE.

Said one Belle Vue official: "The 'booze' was popping like shotguns. The Irish Whiskey was just going off."

While firemen were still fighting the flames a conference was held of all Belle Vue chiefs.

Everybody was allocated a job and got down to work immediately trying to restore order.

NO. 1 PROBLEM.

"The immediate problem," Sir Leslie said, "is to find alternative catering accommodation for circus parties and private organisations. By using other buildings we think we will be able to cope."

Two new exhibition halls nearing completion – one will be ready at Easter and the other at Whitsun – will provide catering facilities for 20,000 people.

Paying tribute to the firemen, Sir Leslie said: "They did a magnificent job in saving the lion house."

Investigations into the cause of the fire will take some time.

But, said Sir Leslie: "It is possible that it could have started either in the kitchen or the boiler-house of the Tudor Suite."

Later, while touring the wreckage, Sir Leslie said: "As soon as the firemen have finished demolition work will start."

Belle Vue sky 'glowed red.'

FIREMEN HURT.

From Manchester firemen were injured and taken to hospital but only one – **Fireman Anthony Conway,** from Mill-Street Station, who had head injuries, was detained.

Fireman Ellingworth, of London Road Station, with burns to his body, arms and legs; Fireman Middleton, of New-Street Station, with a burned neck; and Fireman Carter, of Great Jackson-street Station, with an injured ankle, were all ready for duty later to-day.

Fireman Conway was "quite comfortable" in Manchester Royal Infirmary.

But amid all the drama life went on as normal in some quarters.

The laughing jackass just went on laughing.

Two tiny kittens still had their christening day. They were the daughter of Whisky "Chief Security (Mouse) Officer" in the aviary.

SPEEDWAY BLOW.

Belle Vue's telephone switch-board never stopped ringing to-day as people inquired about alternative arrangements for private dances.

Insurance investigators are now holding meetings with company officials.

Said Sir Leslie: "All the buildings are, of course, insured. Other insurance matters are being considered."

Plans were only finalised last night to make the Pazesta Restaurant available to Belle Vue Speedway supporters as a clubroom.

It was intended to send parties on Saturdays with visiting speedway supporters.

SKY WAS RED.

Eye-witnesses of the blaze gave these accounts. **Mrs. Beatrice Whitehead** who has a shop opposite Belle Vue entrance said: "The whole sky was red. It was terrible to see."

Mrs. Margaret Jones, Norman-street, nearby, added: "It was dreadful. We could feel the heat as we stood at our front doors. It was just like the blitz."

Hyde Road tobacconist **Mr. A. Pike** moved a van from his garage further up the road. "The fire seemed to be coming nearer all the time. We didn't know where it would end."

Mrs. Marjorie Williams of the Coach and Horses, within a stone's throw of the office block, said: "My father-in-law (Mr. John Williams), aged 67, woke us up. From his bedroom window we could see the fire spreading. We thought it was war-time again."

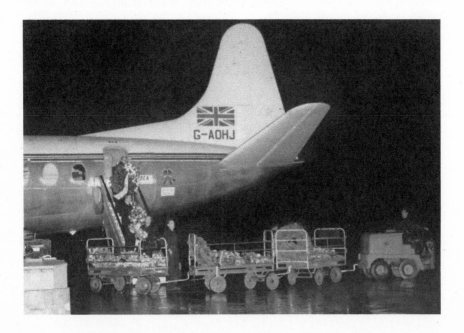

43) Munich Air Disaster, 1958

Twenty-three of the forty-four passengers on board the Elizabethan charter aircraft G-ALZU *Lord Burghley* lost their lives in the Munich Air Disaster on Thursday 6 February 1958. These included eight Manchester United players, officials, members of the press, including Manchester City legend Frank Swift, passengers and employees. Duncan Edwards was to die after a two week battle for life, while manager Matt Busby was seriously injured and the team were decimated (shown on the previous page, wreaths and coffins at Ringway Airport). The average age of the 'Busby Babes' was twenty-four and they were arguably on the brink of becoming one of the greatest sides in English domestic and European football.

Manchester Evening News. Thursday, February 6th 1958.

UNITED CUP XI CRASH: "28 DIE."

Plunged into houses at Munich, exploded.
SURVIVORS SAVED IN BLAZING WRECKAGE.

One of the greatest disasters to befall British football struck Manchester United this afternoon when the plane carrying the £350,000 wonder team crashed at Munich. At least 28 of the 40 aboard were killed; some reports said higher casualties were feared.

The plane, a B.E.A. Elizabethan, had just taken off and climbed to 60ft. when it crashed on the outskirts of the city.

The team were returning from Belgrade, where yesterday United drew 3-3 with Red Star, the Yugoslav champions, and so qualified for the semi – final of the European Cup.

The plane came down in the suburb of Kirchtrudering, exploding as it hit the ground. Several houses were set on fire.

Confirmation of fears that 28 had died seemed to come in a B.E.A. statement at Munich that there were 12 survivors.

But the position was confused when another report said the number on board was not 40 but 38 passengers and six crew.

Pulled from blazing wreck.

It was also stated that the scene of the crash was Riem, a village near Munich airport.

THEN a B.E.A. spokesman said at least 10 to 15 people were pulled alive from the blazing wreckage.

The plane had landed at Munich from Belgrade for refuelling.

It is not yet known whether any local inhabitants were injured in the crash.

The plane had been due to reach Ringway, Manchester, at 5 p.m. to-day.

MINISTRY INSPECTOR FLIES OUT.

The crash had happened at 3.10 p.m. Within an hour the Ministry of Transport and Civil Aviation in London said Mr. G.M. Kelly, an inspector of accidents, was leaving immediately for Munich.

As he prepared to leave, it was learned that the crash had occurred in a snowstorm.

One unconfirmed eye-witness report said 16 badly-burned bodies were recovered from the wrecked airliner.

The Munich B.E.A. office promised a full statement on the accident within an hour.

On hearing of the crash, Mr. Alan Hardaker, Football League Secretary, contacted League president Joe Richards, of Barnsley, and the Wolverhampton club, who are due to play United on Saturday.

Manchester's Lord Mayor, Alderman Leslie Lever, said: "I am very deeply grieved to hear about this tragic accident, and I am sure that everyone in Manchester and beyond will feel the same."

Football officials were trying to notify Sir Stanley Rous, F.A. Secretary. They hoped to reach him in Edinburgh before he flew back to London to-night.

And **BACK IN MUNICH** fire brigades which had sped to the scene were battling with flames which had fired two buildings.

SPORT'S BIGGEST TRAGEDY.

This air crash is the greatest blow British sport has ever suffered.

Because when that plane crashed on take-off from Munich airport it wrecked the lives of so many members of a team which had been flying the flag for our soccer.

From the ashes of the old pre-war poverty-stricken Manchester United they had lifted the team sky-high to world fame and were cruising towards the greatest soccer treble history has known.

But Fate stepped in with all its unexpectedness and viciousness. And struck the greatest blow at what the world has become to recognise the greatest club.

It was a team which carried transfer market value of more than £250,000, according to present-day values.

CUP THREAT.

And, furthermore, this unfortunate crash could also wreck the European Cup competition and turn the heads of all clubs against flying to and from matches.

League champions and cup runners-up, United were on their way home from their great Cup triumph against Red Star, Yugoslavia, in Belgrade yesterday. They had halted at Munich for a break. They took off again and misfortune stepped in…

Stepped in with dramatic suddenness to throw up a doubt also about the staging of Saturday's First Division game with Wolves at Old Trafford.

Matt Busby, the man who built this United from a struggling pre-war unit into such a terrific monument to soccer was with them. So also was Tom Curry the trainer, and Bert Whalley the coach.

THE BUSBY GENIUS.

Matt Busby started his career in a quiet way with Denny Hibernians, a little-known Scottish club. When Manchester City brought him south he was struggling, until suddenly switched to wing-half. Then he blossomed, won a Scottish "cap," and was transferred to Liverpool.

Come the war he went into khaki, became a Sergeant, and travelled Europe with Army teams. On his return, Manchester United invited him to take over their vacant post of manager, and he began his long job of building up the fortunes of the Old Trafford club.

He took them to three League championships, a winning Cup – final in 1948, and to Wembley again last May.

Twelve months ago they reached the semi-final of the European Cup, as they had done by beating Yugoslavia Red Star, in Belgrade 24 hours ago.

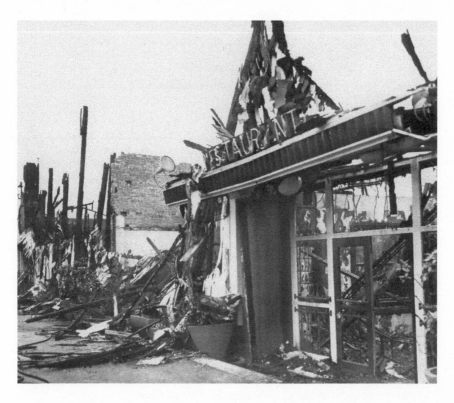

Of firm, but quiet disposition, Matt was a slow-speaking Scot with a delightfully warm character.

44) Belle Vue Fire, 1964

On the evening of Sunday 4 October 1964 a fire broke out in the Cumberland and Windermere Suites at Belle Vue. The fire started in the north west corner, close to the Belle Vue Aces speedway stadium and required that a bingo game in the nearby Kings Hall be abandoned. 3,000 people were evacuated. Four fire engines responded to the blaze and two firemen were injured in the incident. The fire spread to the nearby stadium but not to tanks holding diesel fuel. An electric substation was affected, resulting in a blackout of parts of the garden and nearby homes.

Manchester Evening News. Monday, October 5th 1964.

Belle Vue Suites will be 'rebuilt in 7 months.'
PLANS GO AHEAD TO HONOUR BOOKINGS.

Officials of Belle Vue, Manchester, were today trying to salvage a massive programme of bookings after the fire which destroyed two of the pleasure ground's biggest suites.

Belle Vue was besieged by phone-calls from anxious officials of events and organisations and firms who have booked the two rooms. They were assured that everything possible would be done.

A buffet dance for 830 for Seymour Meads in the Cumberland Suite and the annual meeting of a National Society, for 830 in the Windermere Suite, are to be accommodated in other suites.

The fire, which was tackled by 72 firemen, used 23 appliances.

The Cumberland and Windermere Suites – built only seven years ago at a cost of £100,000 and the exhibitions hall and restaurant were completely destroyed.

Tangled metal and charred woodwork marked the scene where signs once flashed and lights glimmered at the entrance to the Cumberland and Windermere Suites at Belle Vue.

There was a general scene of devastation at Belle Vue.

45) Public Transport, 1965

The forgotten, half-built remains of an underground railway line lie 9 metres beneath the Arndale Shopping Centre. This void was the initial construction of what would have been a 3.7-kilometre railway, linking the city centre to the newly built shopping area. The 'Pic-Vic' line, which superseded an earlier proposal for a monorail, received parliamentary powers in 1972. Building work was due to start September 1973 and finish 1978, but the infrastructure grant application was turned down on Wednesday 8 August 1973, by John Peyton, Minister for Transport Industries. On Thursday 19 December 1974 the scheme was cancelled. The line would have linked fadilly and Victoria stations, aim of the recently proposed Ordsall Chord.

Manchester Evening News. Tuesday, November 30th 1965.

City could have 50mph monorail by 1971.
GOVERNMENT MAY BE ASKED TO SHARE COST.

CIVIC leaders are likely to seek a Government subsidy for a £1M-a-mile monorail system in Manchester following an on-the-spot inspection of a monorail test track in France by leaders of three major committees and top officials.

With Government backing a double-track monorail system could be operating in the city by 1971. The system would stretch from Manchester Airport in the south to a point on the north-eastern boundary of the city in the vicinity of Rochdale Road.

Travelling time between the airport and the city centre would be 17 minutes with stops. The monorail would have a cruising speed of about 50mph, and it is estimated that at peak periods about 10,000 passengers an hour could be catered for.

The target date of 1971 would be the one to which the city's transport, highways, and planning officers would work to if the go-ahead were given by the city council.

TEST REPORT.
A joint report on the visit to France by the six-man delegation to see the test monorail system, near Orleans, is now being drawn up by the transport department general manager, Mr R.F. Bennett; city engineer, Mr John Hayes, and city planning officer, Mr John S Millar.

This is expected to be put to the transport, highways and town planning committees next month. With the officers were the chairmen of the three committees, Alderman Chris Blackwell, Councillor S Rimmer, and Councillor E Mellor.

The delegation inspected the system from all angles on the three-quarters of a mile long test track, and Alderman Blackwell, who took over the controls, reached 30 mph.

A STUDY.

It is expected that the three committees will be asked to agree to a "feasibility study" being carried out by Taylor Woodrow Construction Ltd, of London, which has obtained a licence to manufacture the system in Britain.

In addition, they are almost certain to be urged to consider asking the Transport Minister to share the cost of such a study, estimated at £28,000. The study would inquire into the passenger potential, the exact route, and carry out a geological survey of the route. This would take about six months to complete.

Stations along the route would be spaced at intervals of between a quarter and half a mile and would be provided with car parks.

Manchester Evening News. Saturday, August 18th 1973.
Pic-Vic? The axe should be on the motorways.

ONE WONDERS how far the refusal of a Government grant in connection with the Pic-Vic project is due to pressure exerted by the roads lobby, whose past activities are largely responsible for the high stakes which now exists in transport. Perhaps it is significant that at a time when drastic cuts are to be made in Government expenditure, nothing has yet been said about axing the motorway programme.

Yet more and more people are demanding that it shall be axed because it is clear that this programme is not only proving environmentally disastrous but also that the vast public expenditure incurred contributes considerably towards inflation. More and more people also question the wisdom of relying so extensively on roads at a time when there is growing uncertainty about the future of oil supplies.

Those who believe the oil situation to be merely a figment of the imagination on the part of conservationists should read a recent publication by the Conservative Political Centre "The Energy Equation," by Peregrine Fallowes, formerly of Shell, whose involvement contrasts sharply with the super-optimism of Mr Boardman, the Minister of Trade and Industry. Indeed, to conserve oil supplies Mr Fallowes recommends the electrification of all existing main-line railways.

In the past, Manchester has proposed not a few ill-conceived schemes which have rightly been refused financial support by the Government. The Pic-Vic scheme is, however, sensible and is essential, better for local journeys and a vital link between Inter-City railheads. It is far more important for the region than new motorways, and its construction should go forward without delay.

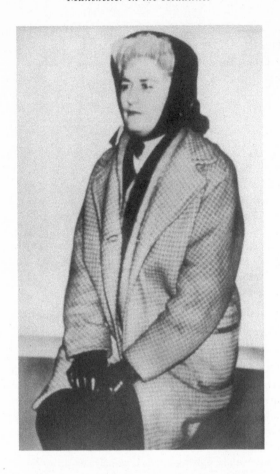

46) Moors Murders, 1966

Ian Brady and his partner and accomplice, Myra Hindley, were responsible for the notorious Moors Murders of five youngsters. Shown above is Hindley, dressed in the clothes she wore on Saddleworth Moor, *c.* 1963. Pauline Reade, sixteen, disappeared on her way to a disco on 12 July 1963. John Kilbride, ten, was snatched while helping stall holders on Ashton Market in November 1963. Keith Bennett was abducted 16 June 1964, after he left home to visit his grandmother. Lesley Ann Downey, ten, was lured away from a funfair on Boxing Day 1964. Edward Evans, seventeen, was killed in October 1965. All were buried on Saddleworth Moor, with Pauline Reade's body located in 1987 and Keith Bennett's body never found. Hindley died in prison, in 2002, while Brady remains in a secure hospital unit and on hunger strike since 1999.

Manchester Evening News, Friday,, May 6th 1966.
Moors Trial – Today's Closing Scenes at the Assizes.

BOTH GUILTY: LIFE FOR BRADY, HINDLEY. 'Calculated, cruel and cold-blooded.' By Staff Reporters, Chester, Friday.

After a trial lasting 14 days and after one of the most sensational murder cases ever investigated by police in the North the Moors Trial jury at Chester Assizes reached their verdicts:

IAN BRADY, aged 28, stock clerk, of Wardle Brook Avenue, Hattersley, near Hyde, charged with murdering Edward Evans, Lesley Ann Downey, and John Kilbride. He was found guilty of all these murders. He was sentenced to life imprisonment concurrently on the three charges.

MYRA HINDLEY, aged 23, shorthand typist, of Wardle Brook Avenue, Hattersley, near Hyde, charged with murdering Edward Evans, Lesley Ann Downey, and John Kilbride, and also with harbouring Brady, knowing he had murdered Kilbride.

She was found guilty of murdering Evans and Downey and not guilty of murdering Kilbride. She was found guilty of being an accessory to Kilbride's murder.

47) Stockport Air Disaster, 1967

Holiday charter flight G-ALHG from Parma, Majorca, owned by British Midland Airways, crashed in Stockport town centre, killing seventy two people. Ten passengers, a stewardess and the pilot survived. The Canadair C-4 Argonaut crashed into an electricity sub-station by open land at Hopes Carr, on the edge of the town centre. The pilot, Captain Harry Marlow, averted even greater disaster by steering the plane away from a block of flats and a gasometer. After skimming the tops of terraced houses, the plane

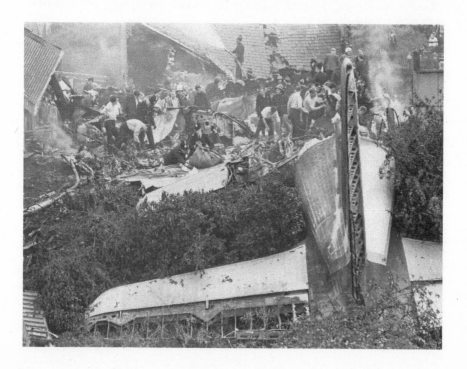

smashed into a garage and the substation, before breaking into three pieces. Two stone memorials commemorate the event.

Manchester Evening News. Monday, June 5th 1967.

Death Strikes from the Sky.

Nightmare on a grey morning.

Death dropped out of the sky into the centre of Stockport just a few minutes after 10 o'clock on a drab Sunday morning. There was only a policeman on a lonely beat and a wide-eyed little boy to see it.

They watched motionless from Waterloo Road, five minutes walk from the heart of the town, as the giant Argonaut airliner loomed low and swung crazily towards them.

THE BLACKEST.

It lurched over the damp rooftops, crumpled a wing into a shop and ploughed into a grassy dell.

In the nightmare of fire and explosions that followed, 72 of the plane's 84 passengers and crew died.

Twelve, including the pilot and a hostess, were dragged alive from the heap of metal that was once a British Midland Airways plane on a tour flight from Palma, Majorca, for Arrowsmith Holidays, of Liverpool.

The disaster made it the blackest 12 hours in British aviation history.

On Saturday night a DC4 carrying North West holiday-makers crashed into a mountain side near Perpignan, south-west France – and all 88 on board perished.

For Stockport, it was the worst disaster in the town's history, – said Chief Constable Mr. Leonard Massey.

The moment brought "terrific heroism" from civilians and the uniformed services, who fought to drag survivors from the blazing wreck.

And it was tarnished by the thoughtless curiosity of thousands of sightseers who turned up hindering the emergency effort.

In the beginning, however, there was just the policeman and the little boy…

PC GEORGE OLIVER, aged 36, was on motor-cycle patrol.

"I saw the plane coming over the rooftops and said to myself: 'My God, he's coming down.'

"I radioed HQ…there was a great gash in the fuselage and I could see people inside, strapped to their seats and slumped, all arms and legs.

I climbed in with some other chaps who had run up and dragged out those I could – perhaps three or four. Some of them I couldn't move – they were hopelessly trapped by their legs. Then the explosions started and we had to get out. The rest is too horrible to talk about."

SCREAMED.

Francis Riley, aged 9, of Waterloo Road, was outside his home.

"The plane came over the factories with one wing pointing to the sky and flames coming from one engine. Then it seemed to stand on its tail and sit down. I ran in and my sister screamed."

The plane had taken off from a rainy airport at Palma before breakfast.

It came down like a stricken whale, its front section buried in an electricity sub-station, cutting off power in the area, including the Central Police Station 200 yards away.

Its belly pancaked on a TV aerial company's fleet of vans parked in a private compound and the tail hung, broken-backed, among the hawthorn and elder of a small clough with a stream at its foot.

The survivors were in the nose section.

EXPERTS SIFT WRECKAGE.

TEAMS of experts working 700 miles apart today were sifting through a mass of information salvaged from the mangled wreckage of two airliners in which 160 people died.

Of the dead 152 were holiday makers and eight crew members.

AT STOCKPORT, 72 people on their way back from sun-drenched Majorca were killed when the British Midland Airways DC4 Argonaut ploughed into the edge of a clough and burst into flames.

AT PERPIGNAN, in south-west France, another 88 people died when their DC4 airliner crashed into a Pyrenean mountainside.

Experts from the Board of Trade, the Ministry of Aviation and the airlines were flown to the disaster spots immediately to investigate.

The six Board of Trade investigators at the Stockport crash set up headquarters in a conference room at Manchester airport.

Led by Mr. William Tench, principal inspector of accidents in the accident investigation branch, they were examining every scrap of evidence – and looking for more.

CARAVAN BASE.

…Three major piles – two from the plane itself and another made up of cars flattened in the crash. The huge tail section made up a fourth section of wreckage.

The investigators paid particular attention to one of the engines which had broken off from the main body of the plane and lay in a hollow.

Parts of the engine were put in plastic bags to be taken away.

It is believed that clearance of the site will begin tomorrow. Residents in the Hall Street area of Stockport, about half a mile from the crash, today found pieces of charred material scattered in their gardens.

They believe it could have come from the plane as it passed overhead. There had, they recall, been what sounded like an explosion as it droned over.

SURVIVORS IMPROVE.

Roads near where the wreckage lies were cordoned off to keep sightseers away but a handful stood watching the operations.

Airline crews were allowed through by the police to view the scene from a distance.

The crash also damaged an electricity sub-station and the electricity board moved in with a mobile generator today. The police said relatives were still ringing in asking for news and have offered accommodation to relatives expected to arrive to identify the crash victims.

The victims of the crash will be transferred from the temporary mortuaries to the mortuary at Stepping Hill Hospital, and inquests are to be held on groups of 13 or 20, for identification in the next few days.

Among the dead were **Mr and Mrs Bernard Dowd** from Marlston Avenue, Lache, Chester. Mr Dowd had been headmaster of the 300-pupil St Bede's Roman Catholic secondary modern school since it opened 16 years ago.

Mr and Mrs Dowd leave a married son, Gregory, aged about 24, and a daughter, Jane, 19.

TWO CHILDREN.

Mr Dowd, aged about 58, had planned to retire on health grounds when he reached 60.

Mr Alan Hughes, aged 35 and his wife, **Kathleen**, of Everest Drive, Blackpool, also among the dead, had chosen an 11-day holiday in Majorca – their first trip abroad since they were married – to help Mr Hughes to recover from a serious road smash.

Their children, Marshall, aged eight, and Alison, aged five, were left behind in Blackpool to be looked after by Mrs Hughes' parents at Brentwood Avenue.

Thomas Walsh and his wife **Jean**, of Midgenall Drive, Rochdale, both died. Mr and Mrs Walsh had a chemist's shop at Kirkway, Middleton.

For **Mrs Dorothy Ackroyd**, aged 76, of Cheadle Heath, Stockport, flying held no fear. She had spent holidays abroad six or seven times. She died with three friends.

Mr Brian Stott, aged 33, sub-postmaster at Stockport Road post office, Cheadle, for three years, died with his 31 year old wife, **Ann**. They had left their two children – Philip, aged three, and Mandy, aged seven – with relatives.

Television writer, **Mr Harry Stansfield**, of Burnage, Manchester, who wrote scripts for a new Jimmy Clitheroe series to be shown next October, was among the dead. His wife, **Joan**, aged 38, and their 10-year old son, **John**, also died.

Mrs Elisa Booth, of Stockport, celebrated her 63rd birthday while she was on holiday. She died with her husband, James, aged 65.

Mrs Katie Brooks, aged 63, of Rostherne Road, Adswood, Stockport, had gone on the holiday with friends.

Mr Herbert Benton, from Bramhall, near Stockport, had taken his wife, **Phyllis**, their daughter, **Christine** (15), and Christine's 15-year-old friend, Fiona Child, on the holiday. Only Fiona was pulled out alive.

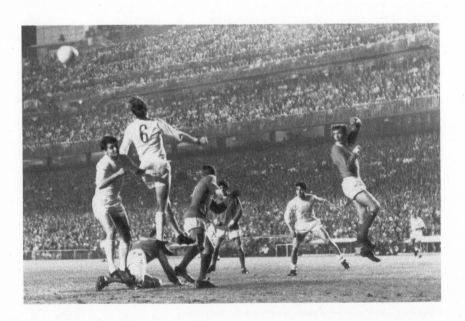

48) **Real Madrid** *v.* **Manchester United, 1968**

For many who followed Manchester United in the 1960s this European Cup semi-final is almost as well-remembered as the final. United took on the might of Real Madrid, who had dominated European football for the previous decade. At half-time and 3–1 behind, United were seemingly down and out. But in a stunning second-half performance they fought their way back into the tie and achieved a 3–3 draw (4–3 on aggregate) putting them into the final at Wembley. Spurred on by manager Matt Busby's half-time team talk, United were one step closer to achieving their 'holy grail.'

Manchester Evening News. Thursday, May 16th 1968.

Real Reds Reign in Spain.

The Fighting Comeback of all Time.

In Yugoslavia it was a trial of temperament, in Poland a trial of tactics, and now here in Spain it was the fighting comeback of all time.

Manchester United are in the final of the European Cup after trailing 3–1 at half time to mighty Real Madrid in this pulsating semi-final.

Not many in the 120,000 crowd would have given a peseta for their chances of pulling back into the match at that time.

But Matt Busby, with the 11-year ambition of winning this competition at stake, put it boldly to his players in the dressing-room during the interval. "Although we were 3–1 down I reminded the players that the aggregate score was 3–2 and that we were in effect only one goal behind.

I told them to go out and play. After all, if you are 3–2 down at half-time in an FA Cup tie you don't consider you are finished."

Flair and Force.

And this is what United did with such flair and force that the Spanish champions crumbled and lost their grip for the Reds to force a 3–3 result and take the tie on an aggregate of 4–3.

United defended well for the first half–hour. Although it was a rear-guard action in which they had five men back in defence and only two – George Best and Brian Kidd – up front, they stayed cool and calm.

Then the Real pressure told its tale with a goal from Pirri after a free kick and then a breakaway burst by Gento.

Zoco raised United hopes by putting through his own goal, but Amancio put the Spaniards ahead again to establish a 3–1 lead at half-time.

In the last 20 minutes David Sadler side-footed a smart goal and then Bill Foulkes equalised.

United in this half were magnificent. They shattered Real and one felt that if the game had gone on any longer the Reds would have had a winning result in Madrid.

United were obviously at their happiest when they were attacking. So should they have steered clear of this defensive approach to the match which rebounded on them in that fatal first half? United manager Matt Busby is quite clear about the answer.

"It was the right thing to do, even if it looked as if the tactics had gone wrong. I would play it exactly the same way if we turned back the clock.

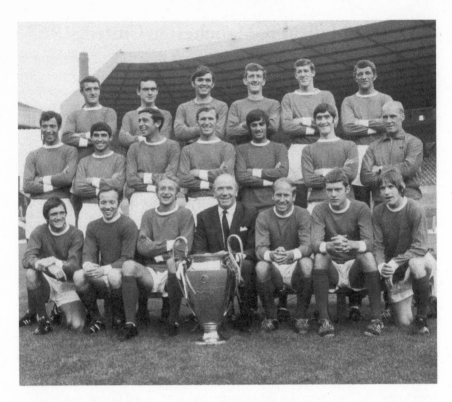

You just cannot come here and leave yourself wide open. We had to play it tight while we were in front."

Bill Foulkes, a stalwart with Nobby Stiles in defence, managed to get the winning goal, and Britain's most experienced player in European football more than justified the manager's faith in his recall.

To inside-left David Sadler went the testing versatile role of helping in defence in the first half and then moving fluently into attack in the hour of need, while Stiles had the most difficult task of marking Amancio, Real's leading scorer.

Best and Kidd largely had to struggle on their own in the first half, but after the interval they came powerfully into the game.

49) European Cup Final, 1968

On Wednesday 29 May 1968 Manchester United became the first English club to win the European Cup. Manager Matt Busby had achieved his eleven-year ambition by winning the trophy. The memory of the Busby Babes of 1958 was also honoured, with Bobby Charlton and Bill Foulkes the only survivors of Munich in the team that night. Matt Busby later received a knighthood and retired after becoming general manager. George Best was named European Footballer of the Year. 1968 was to be the highlight of his football career. Bobby Charlton scored forty-eight goals for England, a record, and was knighted in 1994.

Manchester Evening News. Thursday, May 30th 1968.

BUSBY'S EXTRA SPECIAL TONIC.

MATT'S PEP TALK ROUSED THE REDS.

Matt Busby has achieved his 11-year ambition and made Manchester United the champions of Europe.

Every player was a hero but it was the "boss" who came to the rescue when the teams paused for extra time in a 1-1 deadlock.

Benfica's equaliser 10 minutes from the end of normal time put United on the ropes. The Reds lost their "legs" and their confidence.

And Nobby Stiles, a seasoned Wembley warrior, summed up: "If the game had had another 10 minutes to go we would have lost. We were on top, but when they scored it knocked the heart out of us. We were tired. It was like the World Cup Final all over again for me."

Then United's manager, using the know-how of his four campaigns in this elite competition, strode onto the pitch to meet his tired team during the five minute break before extra-time.

MAGNIFICENT.

I told them they were throwing the game away. They were giving the ball away and hitting it anywhere instead of focusing.

I said they must hold it and start to play football.

Magnificently the Reds roused themselves with three goals in seven minutes of the first half of extra time.

This time it was Benfica who had the heart torn out of them in an assault as formidable as the match two years ago when United slaughtered the Portugese champions 5-1.

It was as if that little on-the-field pep talk had been composed of magic words.

Which of the players does one salute first? Perhaps Alex Stepney contributed the biggest single factor on the pitch toward victory with his save from Eusebio just before the end of 90 minutes when United were down and almost out. It was a save that even the Black Panther applauded.

DEVASTATING.

But the devastating performance overall came from John Aston, who reached a peak of left-wing play. This youngster made the fans who were on his back earlier in the season eat every one of their critical words.

He cut full-back Adolfo and even the wing-half covering the Benfica player to pieces, and used his pace in the wide open spaces of Wembley with marvellous effect.

It was a story book finish to what at times has been a difficult season for him. As Aston conceded after the match "the result, of course, is great, but I must admit that the contribution I was able to make gave me a great deal of personal satisfaction."

He also gave his manager a fine thank you for the faith he had shown in him and found time to think of his father when the bouquets were flying.

"Blue is a good colour. After all, it was in a blue shirt that my father won an FA Cup Winners' medal with United 20 years ago."

And what of Nobby Stiles, victim before the match of accusations that Eusebio needed special protection by the referee.

The little terrier wing-half played the Benfica star with superb understanding, the emphasis all the time on tactical positioning rather than physical contact.

It was a happy Stiles who explained: "I was frightened before the match of the terrific ballyhoo about how I was going to mark Eusebio. People were suggesting I am a clogger.

RESPECT.

"But I have never gone out to kick Eusebio. In fact, I don't believe he ever said he wanted protection from me. I respect him and I find him all right.

But I must thank Alex Stepney for two great saves that kept my sheet clean in four matches I have played against him, in which the only time he had scored has been from the penalty spot."

Certainly Eusebio had nothing to contend with compared with the punishment meted out early on to George Best by full-back "Crunch" Cruz. Cruz tempered his tackling in the second half. The reason, according to Best: He tired. "Kicking me tired him out."

Brian Kidd duly celebrated his 19th birthday and said: "There's my birthday present, the European Cup."

Kidd scored to join Best and Bobby Charlton (2) as match scorers in their 4-1 win.

David Sadler might easily have been among those scorers with a couple of chances, and in typical fashion commented: "I was ready to shoulder the blame of losing after missing those chances early on."

What a splendid night for two of United's longest serving players, Bill Foulkes and Bobby Charlton. Foulkes dominated Torres to make it crystal clear why manager Matt Busby has just re-signed him on a further two-year contract.

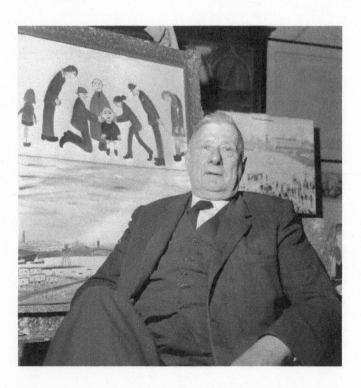

50) Death of Lowry, 1976

Born in Stretford in 1887, he lived at Victoria Park and moved to Station Road, Pendlebury, in his childhood. Lowry (shown previous page in 1967), studied at the Manchester Academy of Fine Art and graduated to the Salford Royal Technical College, in Peel Park. From 1948, until his death, he lived in the same, small, unmodernised house in Cheshire. He died of pneumonia at the Woods Hospital, in Glossop, Derbyshire, on Monday 23 February 1976, aged eighty-eight and was buried in Southern Cemetery, Manchester, next to his parents. During his life Lowry created over 1,000 paintings and 8,000 drawings and rejected five honours, including a knighthood in 1968.

Manchester Evening News. Monday, February 23rd 1976.
Lowry dies after stroke.

ARTIST L.S. Lowry died early today, aged 88.
He was admitted to hospital after a stroke and suffering from pneumonia nine days ago.

Mr Lowry – his Christian names were Laurence Stephen – was found collapsed at his home in Mottram-in-Longdendale by a friend. A doctor was called but he refused to go into hospital for treatment until nine days ago.

Shortly after he was admitted, a senior nursing officer at the hospital, near Glossop, said that they were nursing "an extremely ill old gentleman."

A spokesman for the hospital said the funeral arrangements for Mr Lowry, a bachelor, were being handled by his solicitors. His association with Lowry, he said, had not been as an art dealer but as a personal friend. "Anyone who knew him intimately as a man, knew him as a very good friend. He was a very good warm person," he said.

Since 1938 Lowry's original work had been handled by the London gallery which "discovered" him as artist – Alex Reid and Lefevre, in Bruton Street, London.

"The late Mr Alex Reid, the son of the founder of the company, first saw some of Lowry's paintings on the floor of a picture framers in London and persuaded us to take a more serious look at his work," said Mr Gerald Corcoran, the present president of the gallery.

Lowry originals now range in price from £3,000 to £40,000, said Mr Corcoran. Mr Arthur Cottle, 65, storekeeper at the Lefevre who remembers the artist first coming to the gallery in the 30s, said: "He used to come down here now and again. But he didn't really like big city life."

At Salford Art Gallery, which is integrated into the University site and houses the largest single public collection of Lowry's works, initial discussions were taking place about a special salute to an artist who had many links with the Salford area.

Mr Stanley Shaw, the curator, said it would probably be a special memorial exhibition of his paintings. Salford owns 150 Lowry works and 70 of them are always on show in a permanent exhibition.

Lowry, a member of the Royal Academy since 1962 always said he worked better when he didn't feel like painting. Sir Hugh Casson, a friend of the artist and President of the Royal Academy, said in London today, "When people used to ask him – as they always did – why he painted like that with all those people scuttling about he said that was the way it came out," added Sir Hugh. "The things like that will always stick in my mind.

Direct, straightforward, he hated pretension of any kind. He was marvellous company, sincere and very North country."

The artist had a great sense of self discipline and was "totally uninterested in the trappings of fame." Added Sir Hugh, "He will be a very great loss. He was a remarkable man."

Lord Feather, a friend of the artist, said: "He was one of the outstanding painters of this century. People will be talking about him in 100 years."

LOWRY...HE CAPTURED THE HEART OF LANCASHIRE.

Laurence Stephen Lowry, who died this morning, aged 88, was the quiet man of British art. He did not receive world acclaim until he was nearly 70, and in spite of a prolific output it was not until he had painted his major industrial scenes that the art world began to take him to its heart.

Then his work began to command thousands, but it made no difference to the shy bachelor, whose lifestyle in Mottram-in-Longdendale, on the edge of the Cheshire moors, was frugal.

The son of a Manchester estate agent, Lowry, who was born in Old Trafford, began painting when he was six and went to art college in Salford and Manchester. But in his later years he became disenchanted with art.

Apart from his liking for drawing boats, there were few early signs that Lowry had any exceptional talents for art, but his interest was strong. In 1905, after a year's private tuition in drawing and painting, the 18-year-old Lowry became a full-time student at Manchester School of Art.

EXTRA.

It was here that he learned the disciplines of formal art training and also came into contact with a product of the French Impressionist School, his teacher, Adolphe Valette. But the young Lowry "never wanted to paint like the Impressionists" and went his own way. Another teacher in Lowry's early years in Manchester was the American portrait painter, William Fitz, from whom he received private tuition.

Meanwhile, Lowry's family had moved to Pendlebury in 1909, and Lowry attended extra classes at Salford Art School.

He found a strange beauty in the red-brick mills, with their towering chimneys, and although from the middle class, he was able to identify himself with the lives of working people who were born, lived and died surrounded by the mills.

Of this period – his most formative- he said: "I didn't like it at first. I'd never seen cotton mills before and then I got interested.

INTEREST.

"I said to myself: 'No one has done these seriously.' It was a wonderful subject, so I started to paint them." The first "official" recognition of Lowry's work was in 1926 when his painting, An Accident, was bought by Manchester Corporation for the City Art Gallery, but it was not until 1939 that Lowry's first one-man exhibition was held. This was at the Lefevre Gallery, London, after one of Lowry's canvasses had been seen (by accident) at the framer's by Alexander Reid, a co-director of the gallery.

Until the show at the Lefevre, Lowry's reputation had been localised, Manchester had shown interest, and Salford Art Gallery had begun a collection of Lowry's which was to grow steadily over the years. But outside the North-West, little was known of him.

The exhibition at the Lefevre changed that, for one of Lowry's pictures was bought by the Tate Gallery. Fifteen other pictures were sold. From then on there was increasing interest in his work. Further one-man shows at the Lefevre were presented in 1939, 1945, 1948, 1951, 1953, 1956, 1958, 1963, and 1964, and most leading galleries had a Lowry.

Lowry's invalid mother, with whom he had lived in Pendlebury, died in 1939. "I have never felt much interest in life since then," he once said. In 1948, Lowry moved to a house on the edge of the moors at Mottram where he lived alone with a vast collection of classical gramophone records, and the 16 clocks that had once been his mother's ("Companionable creatures," he called the clocks.)

He once said: "Had I not been lonely, none of my work would have happened. I should not have done what I've done, or seen the way I saw things. I paint because there's nothing else to do. Painting is a marvellous way of passing the time when you get into it."

With the decline of King Cotton, bringing mill closures and the demolition of buildings he knew well, Lowry's output increased to almost frantic proportions as he tried to capture the image of a fast-disappearing era. In 1962 the Tate staged a retrospective exhibition of Lowry's work. That was the year that Lowry, an ARA since 1955, was elected a Royal Academician a year before reaching the age-limit of 75. In 1964 the Halle Orchestra gave a concert at the Free Trade Hall, Manchester, to mark his 77th birthday. Because no singers were available for his first choice – Bellini's Norma – the programme included his next musical choices, Beethoven, Brahms, and Mozart. Hindemith's Mathis the Painter was added.

In 1965 Lowry was installed as an honorary freeman of Salford, and in 1966 was the first person to gain the Man of the Year award organised by Manchester Junior Chamber of Commerce. The values put on his work have risen dramatically. When Lowry's painting Good Friday, Daisy Nook, fetched £16,000 at Sotheby's in 1970

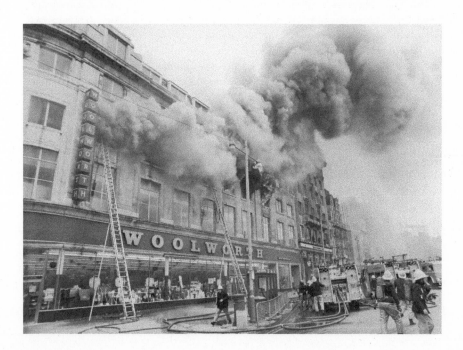

it was more than double the previous record price paid for a Lowry. But in March 1971, the artist commented: "Don't think I have made a fortune out of painting. When you hear that one of my pictures has sold for £10,000 remember the money is not coming to me. Very likely I finished the painting 25 years ago and got only £100 for it."

51) Woolworth's Fire, 1979

Almost 500 customers and staff were in the building at lunchtime, with the tragedy claiming the lives of ten people. Six firemen were injured as they rescued twenty-six people trapped inside the burning department store, with forty-seven customers taken to hospital. The blaze was believed to have been caused by the ignition of flammable, toxic furniture on the ground floor. Locked fire escapes and bars on windows meant that many shoppers were unable to escape the devastating fire. The store was believed to be the largest Woolworths in Europe and had no sprinkler system fitted.

Manchester Evening News. Tuesday, May 8th 1979.

44 Injured: Screaming girls at window.

Ten dead in Woolies store fire.

AT LEAST ten people died in a big store blaze in Manchester city centre this afternoon.

It was feared the death toll could rise still further as firemen continued searching Woolworth's in Piccadilly.

Forty-four others were taken to three hospitals, including four firemen overcome during heroic rescue attempts. Police believe the ten victims whose bodies were recovered died when they were trapped by flames and smoke on the upper floors.

A total of 150 firemen with 26 appliances were fighting the blaze, which was raging on the second, third and fourth floors of the five-storey building. Police late this afternoon appealed to drivers to avoid the city centre as they left work. Piccadilly, Oldham Street and Lever Street were sealed off.

As the injured were taken to Ancoats, Manchester Royal Infirmary and Salford Royal, Woolworth's employees gathered for a roll call at Debenhams across the road.

It was not yet known whether the bodies recovered were men or women, or where in the building they were found. At the height of the blaze three girls were seen hanging out of windows, screaming for help. One man was rescued by turntable ladder from a third-floor window and helped to an ambulance.

Mr David Collier, a senior executive at Woolworth's head office in London, said the fire started in the furniture department on the second floor. The store's general manager, Mr David Williams, his face blackened by smoke and blood seeping through his trousers from a leg wound, said Woolworth's employed about 150 staff during the day.

He thought the blaze had begun in the restaurant or in the furniture department nearby. One report said the fire may have been caused by an explosion, but Mr Williams said he had not heard anything. About 100 people were in the restaurant at the time. He had received his leg injury when kicking out a window to release some of the smoke.

"I tried to get as many people out as I could," Mr Williams went on. "We couldn't use the emergency exits because the smoke was too thick, so we had to use the side stairs." The store has five storeys and a basement.

The city centre was brought to a standstill as police, fire and ambulance crews converged on the Piccadilly site. Hundreds of shoppers watched in horror as giant flames shot from the windows and thick black smoke billowed into the sky.

The blaze started during the busy lunchtime shopping period when the store would have been crowded with workers. Fifteen-ft. flames shot out from second-floor windows and within a few minutes the building was well alight.

Later flames and smoke belched from the third-floor and a man waving a white handkerchief was seen hanging out of a broken window. As a turntable ladder inched its way to the trapped man, firemen could hardly be seen through the thick black smoke. Eventually a fireman reached the man and got him onto the turntable to safety.

As the rescued man, a representative for a clothing firm, was taken to an ambulance suffering from the effects of smoke, he said he did not think there was anyone upstairs in the room where he was trapped. "I did not hear anything or know anything was wrong until the smoke started pouring under the door," he added.

Meanwhile thousands of people gathered in Piccadilly and more arriving all the time. Twelve people were trapped against barred windows and firemen fought a desperate battle against time and the thickening smoke to release them.

The bars were removed from the window frames and the trapped people were brought down ladders to safety. One of those rescued was Ian Carter, a 19-year-old Woolworth's assistant. He said: "I was in the stockroom on the fourth floor when the alarm went. Smoke was coming up the stairs so I retreated to the roof.

"There were 10 or 20 people there, among them a pregnant woman who was getting panicky. We waited about 20 minutes until firemen rescued us."

52) Moss Side Riots, 1981

On Wednesday 8 July 1981 more than 1,000 rioters besieged the police station at Moss Side, shooting an officer with a crossbow bolt through his leg. The riot lasted for 72 hours over three nights. Shops were burned and looted down the length of Princess Road, Clarendon Road, and the surrounding areas, including Rusholme. The riot

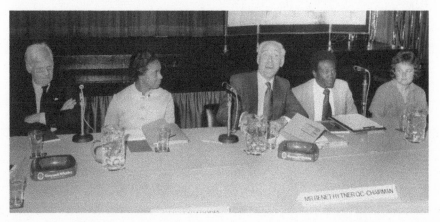

MR BENET HYTNER QC. CHAIRMAN

ended on Saturday 11 July 1981, with the use of 'police flying squads', to disperse the rioters. At the time the Manchester police forces were the only ones in Britain kitted out with full riot squad gear. On Friday 10 July 1981, Moss Side community leaders snubbed a visit by Home Secretary, William Whitelaw. Shown is the Moss Side Riots Inquiry Panel, August 1981 (Mr Benet Hytner QC, Chairman, centre).

Manchester Evening News. Friday, July 10th 1981.

Anderton nips trouble in bud, women say 'Well done!'

Police flying squads foil the riot gangs.

FLYING squad tactics by Manchester police paid off in the streets of Moss Side during the night. They acted swiftly to disperse gangs of black and white youths wherever these were seen gathering for trouble. Altogether they made 146 arrests on charges under the Public Order Act. Five policemen received "very minor" injuries.

Chief Constable Jim Anderton had announced yesterday that he would be swamping the riot zone with police to prevent a repetition of the orgies of shop burning and looting. Vans crammed with men from the Tactical Aid Group toured the area, breaking up the crowds to nip trouble in the bud.

Even reporters and photographers were moved on by the police from potential trouble spots. The tactics of stamping out the isolated outbreaks of trouble before they could escalate generally worked.

RAIN OF MISSILES.

And by the horrific standards of the previous two nights, which saw widespread looting, shops set ablaze by petrol bombers, and Moss Side police station put under siege by a mob of 1,000, it was a quiet night. Today Mr Anderton said: "Firm police action swiftly applied when necessary kept the situation under close control throughout the night.

"Trouble spots arose across a wide area of the city but were quickly contained. The right level of policing will continue to be maintained in the public interest and to uphold the rule of law." Later Mr Anderton called at Moss Side police station during a tour of the riot area with Home Secretary Mr William Whitelaw.

As they were about to enter the building, three women rushed up, saying: "Well done" and "Good on you, Mr Anderton." Mr Whitelaw said to the women "It was good last night, wasn't it? So glad you thought so."

During the night's trouble a mob of about 60 teenagers hurled bricks and bottles at police with riot shields in Moss Lane East, near its junction with Princess Road. They chanted slogans directed at Chief Constable Anderton. Dozens of baton-waving officers, wearing the new riot helmets, charged at the baying mob. Several youths were knocked to the ground and dragged into police vans.

The flare-up was over in minutes as police kept up a massive presence. A line of officers stood guard outside the police station, target of the previous night. And anticipating trouble, some Moss Side pubs closed, while taxi-drivers were reluctant to enter the area. The isolated outbreaks of trouble started early in the evening when a firebug set light to a previously-looted cycle shop in Princess Road, Moss Side, near the buildings blitzed the night before.

Firemen were quickly on the scene, but the shop was badly damaged. A firebug also broke into the Co-op store in Princess Road. But damage was confined to one chair

and a small area of flooring. Crews also dealt with three rubbish blazes, but a brigade spokesman said: "It was a lot quieter than normal for Moss Side."

LONDON was again another trouble zone. Gangs of black and white youths roamed the streets in many districts, smashing shop windows and looting. Police made 66 arrests.

Copycat hooligans also clashed with police at **CHESTER** early today. Eight arrests were made while dispersing a crowd of 40 youths who gathered outside a pub on the Blacon housing estate.

In **LIVERPOOL**, 29 people were arrested in a number of incidents in outlying areas of the city, but police said there were no major problems.

Manchester's trouble also included incidents at **WYTHENSHAWE**. Crowds of youths ran through the modern precinct last night, but there were no reports of damage there. However, the mob moved off to nearby Minsterley-Parade, smashing five plate-glass windows and looting two shops.

The gang looted beer and spirits from the Ashe and Nephew wine shop as the assistant manageress looked on helplessly.

Moss Side snub for Whitelaw.

THE RIOT-RAVAGED streets of Manchester's Moss Side area were inspected by the Home Secretary William Whitelaw.

He made one 10-minute stop at Moss Side police station, where he spoke to officers who came under siege on Wednesday night. Mr Whitelaw walked round the building and saw the smashed windows which are being covered with reinforced plastic sheets. But other leaders at Moss Side snubbed Mr Whitelaw by refusing to meet him.

The youth and community leaders, who have now formed themselves into a committee, claim they were given just one hour's notice of a proposed meeting at Manchester Town Hall. They said they should not be expected "to jump at the Home Secretary's word."

During the three-mile tour of Moss Side, in an eight-vehicle police convoy, Mr Whitelaw was accompanied by Chief Constable Jim Anderton and Chief Supt. Albert Leach. After leaving the police station the convoy travelled along Denmark Road and Wilmslow Road before turning into Claremont Road. It hurried past the wrecks of two burnt-out cars and smashed shopfronts before turning into Princess Road.

Mr Whitelaw saw the boarded-up devastated shops. Demolition men were still at work at the wrecked hardware store. Mr Whitelaw's Jaguar, flanked by police motorcycle patrolmen, kept a minimum speed of 20mph. The tour took just 12 minutes. Also in the convoy were police committee chairman John Kelly and his deputy Mrs Grace Cox.

Mr Whitelaw, who earlier visited the by-election town of Warrington, went on to Manchester Town Hall for a meeting with community leaders. **PREMIER** Mrs Thatcher was planning to visit Liverpool today. But it was not possible to arrange an alternate programme at short notice and her flight from RAF Northolt was called off. A visit to Manchester by Mrs Thatcher was not under consideration at present.

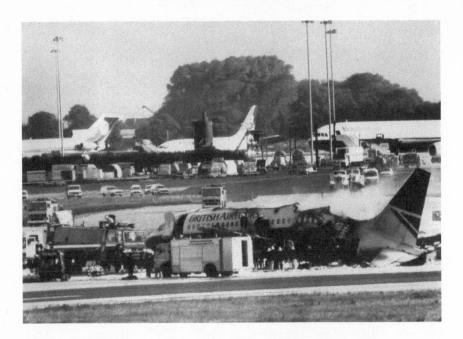

53) Manchester Air Disaster, 1985

At 07.07 a.m. on Thursday 22 August 1985, a British Airtours Boeing 737 flight carrying 131 passengers and six crew on a charter flight to Corfu was beginning its take-off from Manchester, when an engine suddenly failed. Debris punctured a wing and fuel tank, causing a fire. Captain Terrington aborted take-off, turning off the runway and towards the fire station. However, the change of direction meant flames spread quickly to the rear of the aircraft. Eighty-two people escaped, with air hostess Joanna Toff rescuing several passengers, for which she was awarded the Queen's Gallantry Medal. Fifty-five people died.

Manchester Evening News. Thursday, August 22nd 1985.
Engulfed by fire on happy jet.

Flames ripped through the British Airtours holiday jet within seconds as it turned off a runway at Manchester Airport today.

The fireball which raged through the Boeing 737, with 137 people aboard, is believed to have left about 65 dead. The toll would have been even higher if many others had not escaped down emergency chutes. Most of the dead were sitting in the rear of the plane. The heat from the fire on the wing was so powerful it burned through the fuselage within moments, producing a flame-thrower effect in the passenger compartment.

Civil Aviation Authority chief officer Mr Frank Price said he believed it would have taken only seconds for the flames to spread. Staff at British Airways, the parent company of British Airtours, said it was believed the plane's main fuel line had been severed by an

explosion in the port engine – and it was this that caused the flames to spread so rapidly through the jet.

The passengers who escaped did so through the front chutes which were rapidly deployed as soon as the airliner came to a halt. Sixty-seven people were taken to Wythenshawe Hospital, but only three detained.

The drama happened at 7.07 am when the Boeing began to take off for Corfu with a full load of happy passengers. Two babies were among those on board. Mr Gil Thompson, Manchester Airport's chief executive, said a report from the pilot said that there had been an explosion in one of the engines as he accelerated at over 100 miles an hour down the runway for take-off. He slammed on the brakes to bring the plane, flight number KT 328, to a halt.

Fleets of fire engines and more than 120 fire crew raced to the burning jet at the Bollin Valley end of the runway and started to smother it in foam. Roads around the airport were sealed off by police, who declared it a major disaster area. The plane's captain and his first officer were among those who escaped. As the flames gripped the plane, the jet broke up near the rear of the fuselage and panic gripped the passengers battling to escape the fire.

One witness, a Dan-Air worker said: "We all went to help. As soon as it stopped, the emergency doors came down and people started coming out.

"The plane was on fire but people were coming out quickly. Firemen were pouring foam on to the plane but more than half was on fire. The rear section dropped down and the main cabin up to the forward section was on fire."

It was confirmed that the pilot had reported an engine problem to air traffic controllers, who had seen flames and smoke coming from the port engine as it sped along the runway. The airport made a plea for the public to stay away from Ringway so as not to hamper the rescue operations and said that the terminal would be closed for at least four to six hours.

A fire brigade spokesman said: "The jet would have had a full load of fuel aboard. The explosion in the engine definitely took place before the fire. About 100 firemen were on the tarmac within minutes, smothering the aircraft with fire-fighting foam.

"The jet came to rest quite close to the airport fire station and firemen were on the scene very quickly with their specialised equipment."

Two thirds of the jet were engulfed in flames.

PROBE BEGINS.

A crack team of air safety experts today begin an inquiry into the cause of the Boeing disaster. They were rushed to the airport within hours of the tragedy to set up a chief inspector's investigation – the highest form of inquiry.

A spokesman for the Department of Trade's Air Accident Investigation Branch at Farnborough said: "One of them is an engineer another a flight recorder expert and the other two are highly experienced pilots.

"Of course, it is too early to say what caused the crash, but we do know the plane never got airborne." That the AIB should have sent such a strong team is an indication of how serious the department is taking the crash.

Mr Des Hetherington, general manager of British Airtours, flew from his Gatwick headquarters along with safety experts and other senior management from the company to mount their own full investigation. The pilots union BALPA will also be watching the investigation very closely.

Mr Freddie Yetman, a union technical expert, said: "Naturally, we will want to know what caused this accident." But he discounted fears that the union might be questioning the general safety of Boeing aircraft with the Ringway accident following on so closely from the Japanese Jumbo crash in which 320 people died and the Air India crash off the south coast of Ireland. Mr Yetman said: "That does not come into it at all."

HOSPITALS PUT ON FULL ALERT.
Sixty-seven patients were taken to Wythenshawe Hospital, but only three admitted.One is in the intensive care unit with severe burns. The other 64 had only superficial injuries caused by burns and inhalation of fumes. Many were also suffering from shock.

Extra doctors, nurses and reception staff were brought in under the hospital's disaster procedure to cope with the emergency. The three people detained will be transferred to Withington Hospital burns unit, which was also on full emergency alert.

Of the passengers taken to Withington, two men and a woman were treated for minor injuries and shock. The injured included a fireman who had breathed in a large quantity of fumes. Several children are known to be among the injured, but none admitted to the hospital is believed to be seriously hurt.

54) Princess Diana, 1985

Princess Diana visited a teenage survivor of the Manchester air disaster at Wythenshawe hospital, the report telling us that Lindsey Elliott opened her eyes for the first time since the tragedy. Diana (shown speaking to firemen at Manchester Airport) and Charles interrupted their holiday in Scotland to visit nine survivors of the Boeing 737 plane fire that killed fifty-five people. Lindsey lost her mother, aunt and uncle in the fire and suffered shock and smoke inhalation before escaping the blaze. She had since refused

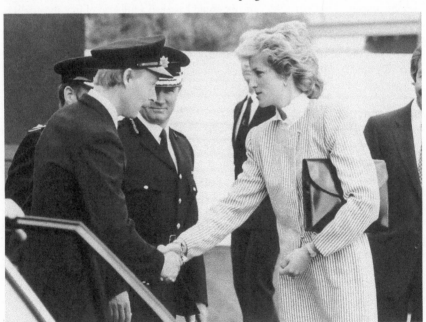

to respond but opened her eyes for the first time when the royal couple stopped at her bedside and Diana talked to her.

Manchester Evening News. Tuesday, August 27th 1985.

She's beautiful, says crash girl.

DI IS A SIGHT FOR SORE EYES.

A YOUNG victim of the Manchester air disaster responded to a Royal command today – by opening her eyes properly for the first time since the 737 horror at Ringway.

Lindsey Elliott, aged 14, gave her performance for the Prince and Princess of Wales as she temporarily forgot the pain of her injuries and the anguish of losing her mother, aunt and uncle in the accident. And after seeing Diana, Lindsey declared: "She's beautiful."

The effect of being told of the loss of so many of her family shocked Lindsey so much that she had kept her eyes firmly closed until today. Nursing staff told how she had closed her eyes as soon as she heard about her mother's death.

The pretty blonde from Heswall, Wirral, donned her best pink nightdress in excited anticipation of the Royal visit to meet the survivors now recovering at Wythenshawe hospital. Blue-eyed Lindsey is expected to make a full recovery.

The Prince and Princess of Wales sat on her bed on ward F2 for several minutes and chatted to her intently. The Prince and Princess of Wales had interrupted their summer holiday in Balmoral to fly into Manchester to comfort the injured of last week's airport disaster.

The Royal couple arrived at Ringway aboard an Andover of the Queen's flight, with the Prince at the controls as the aircraft taxied to a halt, passing just yards from the site of the inferno. Later, Prince Charles and Princess Diana were driven in an eight-limousine convoy to Wythenshawe and Withington hospitals, where nine people are still detained.

Prince Charles had arrived at Ringway with an apology. He told airport chief executive Gil Thompson that he and Princess Diana were sorry to disrupt Ringway's busy schedule.

Princess Diana, wearing a light grey and white striped two-piece suit and black shoes and handbag spent five minutes, alongside her husband, at Ringway expressing concern and sympathy for what happened last Thursday. The couple congratulated representatives of the emergency services who fought their way into the wreckage of the Boeing 737 which crashed killing 54 people.

The Princess learned at first hand from fireman Nick Loftus about the horror. He and his colleagues from Wythenshawe Fire Station were alongside the 737 within minutes – quick enough to help survivors to safety before fire swept the fuselage.

Just as they were about to walk into Withington hospital they were surprised by young Sheryl Cage who ran up the path pushing her sister Samantha in a wheelchair.

Manchester Evening News. Tuesday, August 27th 1985.

Royal tonic from Diana.

PRINCESS DIANA brought a royal tonic to air crash survivors in Manchester hospitals today.

She and Prince Charles simply ignored the clock and spent extra time with many of the injured. In fact, later the Royal couple's schedule had to be rearranged. Instead of visiting Manchester Airport fire station as planned, two dozen airport firemen crossed the tarmac aboard their emergency vehicles for a brief chat with the Prince and Princess before they left the city.

Prince Charles then boarded the Royal Andover to fly to Stuttgart, West Germany. Some 20 minutes later the Princess left to resume her holiday in Scotland aboard a small private aircraft. At Wythenshawe Hospital, Ringway disaster survivor Anna Findlay, a 20-year old medical student from Bingley, told the Prince she was planning to fly off for a skiing holiday as soon as she recovered.

Anna said: "The Royal visit did us all a world of good. We have been laughing a lot and when we laugh we cough – and that is good for you after breathing in smoke." When Prince Charles asked Mr Roy Metcalfe, 50, of Chesterfield, how he escaped from the plane, he replied: "In a great hurry."

55) Strangeways Riots, 1990

A twenty-five-day prison riot and rooftop protest began on Sunday 1 April 1990, when prisoners took control of the prison chapel. The riot quickly spread throughout most of the prison, and ended on Wednesday 25 April 1990, when the final five prisoners were removed from the rooftop, making it the longest in British penal history. One prisoner was killed during the riot and one prison officer died of a heart attack, with 147 prison officers and forty-seven prisoners injured. Much of the prison was damaged or destroyed, with the cost of repairs coming to £90 million. The prison reopened as HMP Manchester.

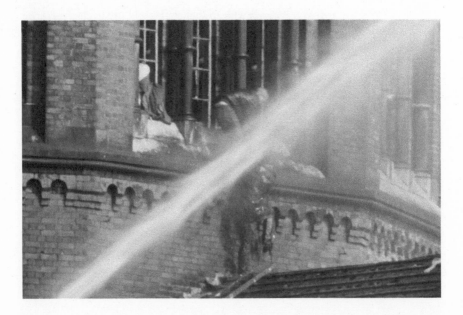

Manchester Evening News. Tuesday, April 3rd 1990.

Prisoners high on morphine mutilate victims before hurling bodies over balconies as ambulance crews send in the body bags.

The day hell broke loose in Britain's worst jail riot.

AT LEAST 20 prisoners are today feared to have been murdered in Britain's worst jail riot.

Many victims of the carnage at Manchester's Strangeways are thought to be sex offenders. Some reports say they have been hung up with their throats slashed, castrated and then hurled over balconies. A casualty nurse at North Manchester General said today a prisoner had told her of the horrific mutilations by drug-crazed prisoners. It is known some inmates have been quizzed by police about the alleged castration frenzy.

The Home Office would not confirm anyone had been murdered during the riots, but ambulance men were seen sending 20 body bags into the building. Prison chaplain Noel Proctor is believed to be acting as negotiator, trying to persuade the rioters to surrender and allow badly –injured prisoners to be treated in hospital.

When the riot broke out, in the prison chapel, there were five guards in charge of some 300 prisoners. Ambulance crews battled to treat 52 injured officers and prisoners as they were carried out. Many with slashed faces were close to tears as they were bandaged up and rushed to North Manchester General and Manchester Royal Infirmary.

DRUGS CABINETS.

As sporadic fires swept through parts of the rambling Victorian building, prisoners smashed their way into drugs cabinets in the hospital wing. High on morphine and any other drugs they could grab, they were dragged out to waiting ambulance officers. Many were screaming, totally incoherent and unable to say what they had overdosed on. A major part of the country's most overcrowded jail is now in the hands of 140 prisoners. Many of the other 1,460 inmates have been switched to other prisons. Some are still at Strangeways, waiting to be transferred.

As confusion continued to reign with new reports of more violence erupting, it was revealed that the riot began directly above the governor's office. The trouble erupted in the chapel during morning service. At the end of a corridor which used to be F wing, it is right above management's offices. Ambulance divisional officer Ken Bateman who led the mercy men throughout the night recalled. "The injured men were being brought out on stretchers or just propped up and helped out. They were in all sorts of states. But they were all dazed, frightened and very ill.

"Some had slashed faces. The ones who had taken overdoses were virtually impossible to assess. We had no way of knowing what they had taken."

There were 300 inmates in the chapel for morning service yesterday – about three times more than normal, but only five prison officers to guard them. Today police believed the swollen congregation was an indication that the riot had been carefully planned. An inmate is said to have jumped up and put a knife to the throat of one of the ministers before a prison officer was threatened and his keys snatched.

The inmates went on the loose unlocking cell doors urging others to join in and beating up those who refused. One man in for seven days for drink driving, refused and was attacked. He was in hospital today with a fractured skull and broken leg. When police got the emergency call they had always feared, they launched Operation Response, a plan which has been on ice for many years.

The helicopter was scrambled and officers from all divisions on Greater Manchester rushed to the jail. Prison officers were called in from home and many volunteered to go in fearing that colleagues had been badly injured. Today weary prison officers said it could take two years to restore the jail, but many thought it should be demolished to make way for a new complex.

Some warders reported "bodies everywhere." One helped carry a terribly injured young inmate to an ambulance and said: "I don't think he'll make it through the night."

Warders said today that trouble had been forecast by some inmates this weekend, but that had happened many times before, and no-one had any idea it would be on such a vast scale. One Bolton family was anxiously waiting news of a 18-years-old youth on the sex offenders' E wing. He is Jason Lock, of Doyle Road, Hunger Hill. He is serving 21 months, but not for a sex offence.

His sister Jacqueline said: "We don't know why he was on that wing. I have rung the prison but they can't give information about those on E wing. It's a terrible worry." Ringleaders of the riot have already been identified, it can be revealed today. They have been captured on film taken by officers in Greater Manchester Police's "eye in the sky" helicopter.

The £1m helicopter has been an invaluable aid to the police and Home Office monitoring the violent scenes. The helicopter bought in December amid some controversy has been able to maintain a watching brief on the terror without unduly inflaming the situation.

IDENTITY OF RINGLEADERS.

The photographs taken of prisoners on the rooftops and in the yards have been used by police to build up a profile of which inmates are organising the "take over." The identity of ringleaders who will face further punishment once order has been restored is vital as police work out their next move.

One policeman who was a spotter in the "aerial platform" as the helicopter is termed by police said: "I was up early on. It was like horror coming to toytown.

"It was an invaluable asset for we were able to tell officers exactly what was happening."

The helicopter was scrambled from its Openshaw base within minutes of a call being made from Strangeways by a warder.

56) *Manchester Evening News*
Editor, Michael Unger, 1990

The riot attracted an unprecedented level of media attention. There was much rumour and inaccurate reporting. Reports that twenty body bags had been sent inside the prison fuelled speculation. A *Manchester Evening News* reporter volunteered his editor to enter the jail and speak to the rioters. Michael Unger (shown opposite) persuaded about thirty prisoners to give themselves up, promising to print their demands in return. Prisoners were being locked up twenty-three hours a day in overcrowded conditions and allegedly force-fed anti-psychotic drugs to keep them calm. An inquiry, headed by Lord Woolf, concluded that 'intolerable' conditions led to the riot.

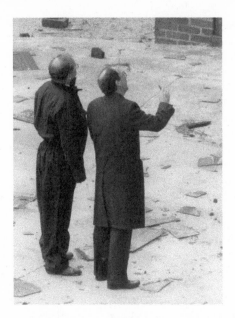

Manchester Evening News. Tuesday, April 3rd 1990.
Negotiations as crack officers stand by.

EDITOR IN TERROR JAIL.

THE STRANGEWAYS riot took a dramatic new twist today when the *Manchester Evening News* was asked to join negotiators trying to settle the jail siege.

Editor Michael Unger went to the jail after inmates unfurled a banner from the rooftops, demanding "media contact now." The *Evening News* immediately offered itself as go-between to the Home Office. Within minutes Home Secretary David Waddington ordered his officers to accept our help as long as it was the editor who entered the prison.

As Mr Unger arrived at the gates he said: "We felt it was our duty to offer our help to bring this situation to an end as quickly as possible." Three hundred crack prison officers from all over Britain were standing by as negotiations went on. The 99 defiant prisoners, still holding out after three days of mayhem, earlier today invited prison staff to come inside and see for themselves that no-one had been killed.

Then early this afternoon an ambulance pulled up at the prison gates and a man was taken away by stretcher. He is believed to be a prison officer who collapsed under stress. Another report said that just before noon another 20 prisoners had given themselves up.

Speaking from inside the jail, Mr Unger said: "I have been through some of the most damaged areas of the prison and debris is lying everywhere on the floor. There are pieces of pipe, scaffolding and broken chairs.

"I have seen a group of about six prisoners on the roof and I was only 20 yards away from them.

"There is no tension inside the jail. I have not yet been told what I am to observe but I believe my role is to watch as people give themselves up, or see the injured taken to safety."

Meanwhile the teams of prison officer snatch groups were ready for action in flame retardant-suits and crash helmets. And Prison Officers' Association chairman Ivor Serle said: "Prisoners can lie and we won't know if they are telling the truth until we go in and see for ourselves.

"We are still dreading what we might find when we go in. Let us hope this is the start of the end." Mr Serle said he believed all sex offenders – feared tortured, mutilated and killed – may now be accounted for.

He said: "The governor has set up negotiating teams. Inmates are talking to staff and the good news coming out is that they are saying there are no dead bodies in the establishment." As Mr Serle was speaking, protesting inmates on rooftops hung out a fresh banner demanding: "Media contact now."

Reports of up to 20 deaths still persisted today and it was known that a large number of body bags have been brought in by prison authorities and police. But the Home Office could not confirm any of the reports.

Rumours were still rife that sex offenders had been tortured and that two prisoners have been castrated. The prison squads, highly skilled in control and restraint and distinctive in their light brown overalls and protective clothing, have already regained four remand wings, the main prison accommodation and prison kitchens.

Manchester Evening News. Monday, April 2nd 1990.
ALL HELL BROKE LOOSE IN THE CALM OF A SUNDAY MORNING SERVICE.

TIMETABLE OF TERROR.
...By noon, hundreds of prisoners were fighting running battles with staff through corridors, workrooms and yards. Rioters' numbers were swelled after a prison officer had a knife held to his throat and his keys taken.

More fires were breaking out all over the prison. Flames from a blaze in the prison gym leapt 20 feet into the air. Outnumbered and taking casualties, the warders beat a retreat to secure the prison perimeters.

ORGY OF DESTRUCTION.
By 1pm scores of prisoners were on the roofs of the blocks that radiate like the spokes of a wheel from the centre. Many wore masks to hide their identity. Some wore captured prison officers' uniforms and wielded weapons. In an orgy of destruction they began systematically stripping the roof and raining slates down to the ground, smashing skylights and toppling coping stones.

It was apparent in the early afternoon that the rioters had two more sinister targets – the secure block housing "Rule 43" prisoners including sex offenders, and the prison pharmacy. As riot police who were drafted in to protect firefighting teams and ambulance crews began evacuating wounded prisoners, some were clearly suffering from drug overdoses.

At 2pm first reports – still persistent but yet unconfirmed – began to spread of a mounting death toll amongst prisoners.

STREAM OF CASUALTIES.
Firemen fighting blazes in the gymnasium, the chapel and in the prison's H-block claimed to have seen bodies, widely assumed to be those of "Rule 43" offenders. Throughout the

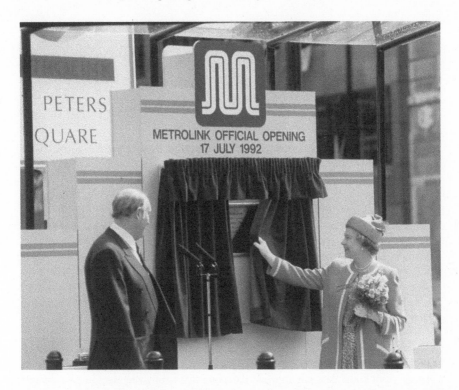

afternoon and into the evening a constant stream of casualties – up to 60 prisoners and more than a dozen staff – were taken to hospital.

And with police with riot shields and crash helmets out in large numbers, around 1,000 prisoners were evacuated through the gates and bussed to other jails. Fire lit the night sky and a pall of smoke hung over Strangeways at dawn. Though prison officers and riot police were inside the perimeter walls, much of the accommodation blocks and work areas remained in the hands of the rioters – put at around 600 strong.

Home Secretary David Waddington said it would have been "too dangerous" to have tried to retake the prison by storm during the night. By first light today, prisoners were back on the roof and fires were beginning to burn again.

57) The Queen Opening Phase One of the Metrolink, 1992

The Metrolink tram system superseded the 'Pic-Vic' scheme and opened in stages. Phase One (opened by Queen Elizabeth II) was the Altrincham to Bury, via Piccadilly, section, with the Bury to Victoria section opening on Monday 6 April 1992. The central section, between Victoria and G-Mex, opened on Monday 27 April 1992, with the G-Mex to Altrincham service beginning on Monday 15 June 1992. Trams started to operate into Piccadilly on Monday 20 July 1992, completing Phase One of the system. Other phases of Metrolink expansion include Cornbrook, through Salford Quays to Eccles; Media

City at Salford Quays; Manchester Airport; Chorlton; Didsbury; Tameside; Oldham; Rochdale, and eventually Trafford Park and the Trafford Centre.

Manchester Evening News. Friday, July 17th 1992.

City cheers on a day of royal joy.
WELCOME BACK, MA'AM.

MANCUNIANS turned out in force today as the Queen retraced her footsteps of six years ago in a city centre walkabout.

During her last visit, the Queen opened G-Mex. Today she put the royal seal on Manchester's latest multi-million pound venture, the Metrolink system. The Queen's train, the Windsor Castle, arrived at Piccadilly station exactly on time at 10.02am.

Her Majesty, wearing a mint-green, white trimmed coat and matching floral dress, looked relaxed and waved at an enthusiastic crowd. She was introduced by the Lord Lieutenant of Greater Manchester, Col John Timmins, to VIPs including Lord Mayor Bill Egerton and Chief Constable David Wilmot.

Today's programme also included the opening of the British Council's UK headquarters, a tram ride to Bury and engagements in Middleton and Oldham, where the Queen was hosting a garden party for 3,000 people. The itinerary gave well-wishers their best opportunity to see the monarch for more than 40 years.

On the tram ride from St. Peter's Square, the royal Metrolink was slowing at every station for the crowds. At the controls for the journey of a lifetime was driver John Langford. John, 42, from Droylsden, not only had the responsibility of giving the Queen a smooth ride, but was also being presented to her at journey's end. Before setting out, he said: " It is an honour and a privilege."

Along the journey, one loyal subject was missing from the crowds – despite being promised a special wave. Widow Ada Cranna, 97, was on holiday in Wales as her friends from Elms Farm sheltered housing at Whitefield watched the tram go through Whitefield station.

The development's secretary, Hilda Ashbee, wrote to Buckingham Palace mentioning Mrs Cranna, the oldest resident. An official promised the Queen would look out for her. But Mrs Ashbee admitted: "We kept it secret from her – too secret, because her family have taken her on holiday."

A WAVE OF AFFECTION FOR THE QUEEN.

MANCHESTER rolled out the red carpet for the Queen today. She thrilled crowds of well-wishers who gathered to welcome her – but two children stole the show as she arrived to open the British Council HQ in Medlock Street.

Two-year-olds Dean Roberts and Lucy Jones, whose parents work at the council, solemnly presented posies to her at the entrance – and Dean reached out to touch his monarch as she walked inside. Later the Queen rode the Metrolink to Bury before engagements in Middleton and Oldham, where she was hosting a garden party for 3,000.

She turned the super-tram timetable upside down – by boarding for Bury almost 20 minutes early.

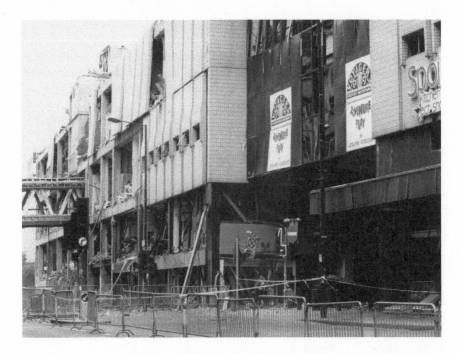

58) IRA Bomb, 1996

At about 11.20 a.m. on Saturday 15 June 1996, a massive IRA bomb devastated the busy shopping centre of Manchester. 200 people were injured in the attack, mostly by flying glass, seven seriously. The bomb exploded on Corporation Street, outside the Arndale shopping centre (shown). It was the second largest by the IRA on the British mainland. A recognised IRA codeword was used as a warning and while the police were still clearing hundreds of people from central Manchester and army bomb disposal experts were present, the bomb exploded outside Marks & Spencer. Many of those injured were beyond the police cordon.

Manchester Evening News. Saturday, June 15th 1996.
How can you do this to people?

THE chaplain at a hospital dealing with the shocked casualties had a stark message for the bombers.

The Rev Adrian Rhodes said at Manchester Royal Infirmary: "I just wish they could see the little old lady I have been talking to who is lost and very scared. I just wish they could see her and try to explain to that little old lady just why this is needed."

Mr Rhodes spoke of seeing people desperately telling him they had no idea where friends and relatives were. Hospital staff and police have been frantically ringing round other hospitals to help reunite them.

Mr Rhodes was at the MRI when the last Manchester bomb went off. "When I got the call I just thought here we go again. It was gut-wrenching. This one is much bigger and much more devastating. There are more badly shocked and injured than there were last time.

"There are some very shocked people and some very frightened people. There are old people and children talking of seeing everything suddenly disappear with glass flying all over the place.

"But despite what they have been through I am very surprised by just how well they have coped and how under control they seem to be. Many have cut legs and faces and are badly shocked and they have blood all over their clothes."

Fleets of ambulances brought in casualties to the Infirmary. Many were in floods of tears as they were helped into casualty. Two commissionaires covered in blood from head to toe came in at 12.10pm. A weeping shop worker in a wheelchair was carried in with colleagues wrapping their arms around her to comfort her.

One man appeared unconscious as he was carried in in a wheelchair. Many had head injuries with glass embedded in their faces. They all seemed eerily calm with nobody hysterical. Press officer at the MRI Richard Emmott said: "They do seem to be calm. But then often with shock it doesn't sink in for some time."

Doctors are still fighting to save the unborn child of the heavily pregnant woman in her twenties who was thrown through the air. She was seriously ill this afternoon but doctors say her unborn child is "fine" and its heart is still beating. Casualty consultant Dr Kevin Mackway Jones said: "The baby's heart is still beating but she has severe abdominal pain. She is very shocked and upset."

Four of the casualties have "potentially severe spinal injuries" after being thrown through the air. A number of children with minor cuts have been admitted. All the casualties will be given support for possible Post Traumatic Stress. MRI bosses will also keep an eye on their own staff to see how they cope with the after effects of dealing with the flood of casualties.

Dr Mackway Jones added: "We have sent our staff out to the scene to do all we can. The people I have seen here are shaking, they are crying. They have seen things they didn't expect to see when they went shopping on a Saturday.

"This is a dreadful thing to have happened in the city centre on a lovely summer's day." Three firemen were later treated at the hospital but are not thought to be seriously hurt. Doctors at the MRI are unable to keep in permanent contact with their colleagues at the scene. Dr Mackway Jones explained it was too dangerous to use mobile phones at the site of an unexploded bomb for fear of setting it off.

For more than an hour after the blast, a fleet of ambulances and police vans toured city centre streets, picking up the walking wounded and taking them to hospital. The force of the blast had shattered shop and office windows for a radius of one mile around the scene. Most of the wounded had been cut by flying or falling glass.

Philip Welland, aged 29, from Didsbury, was outside Kendal's store with his wife, Pat, when they heard the blast. He said: "We were walking away from the police cordon towards the station end of Deansgate when suddenly we heard the blast behind us. The top window from an office above us shattered and scattered glass all over us.

"Luckily, we weren't cut, but for the last half an hour I've been finding bits of glass everywhere in my hair, in my clothes and even in my pocket.

"We had come into Manchester to do some shopping and you never dream that this would happen. We are very shaken, but we just hope that all those people who were injured will be okay."

Sheila Martin, from Macclesfield, who was with her friend Marjorie Williams, had been shopping in Cross Street when the evacuation alert began. "We heard the blast but we were a good distance away by the time it went off," she said. "Thank God the evacuation system worked," she said. "The police did really well. What I can't believe is that there were people grumbling about being moved on. One man said he wanted to get back to his car before he gets a ticket. I expect he's glad he didn't now."

At North Manchester General Hospital 29 casualties were being treated, almost all suffering from flying glass injuries and shock. By early afternoon two had been admitted into the hospital's wards. In the accident department, bleeding casualties, some weeping, sat waiting for treatment.

But one woman walked about in apparent unconcern in a flowery patterned frock, her face covered in blood from wounds. Salford's Hope Hospital treated 27 casualties this afternoon mainly for injuries from flying glass. All but three – not critically hurt – were released after treatment. Hospital spokeswoman Val Michej said around 150 additional staff had reported for duty today as the hospital implemented its emergency plan.

Police Chief Supt Peter Harris said this afternoon that the investigation into the bombing was likely to take "a long time." He said two of the casualties have head injuries which were relatively serious, another five people had leg injuries caused by flying glass, and 40 to 50 other people had injuries caused by glass shards.

59) European Cup Final, 1999

In the 1998/99 season Manchester United achieved an historic 'treble' of English Premiership, F.A. Cup and UEFA Champions League. United beat Newcastle United 2–0 in the FA Cup Final, the campaign being remembered for Ryan Giggs semi-final 'wonder goal' against Arsenal. As the Champions League final entered injury time United were losing 1–0, but late goals by Teddy Sheringham and Ole Gunnar Solskjaer claimed a dramatic victory over German club Bayern Munich, in what is considered to be one of the greatest comebacks in the history of the competition. United then went on to win the Intercontinental Cup, beating Palmeiras 1–0 in Tokyo.

Manchester Evening News. Thursday, May 27th 1999.

FIGHT TO THE FINISH.

MANCHESTER United – Champions of Europe! Doesn't it just look and sound good!

The incomparable history-making Reds have written a fantasy finish to their glorious treble success that was beyond belief even by their own outrageously dramatic standards. Where do you begin with the plaudits for such a phenomenal side and such an exceptional achievement?

Start with A for Amazing and work your way through the dictionary. There are plenty of worthwhile words to describe United. But only those five words at the start really matter. The Reds are the European Champions and this is the dawn of an era of potential Continental dominance by Alex Ferguson's team.

Barcelona 99 will go down in the Old Trafford annals as the most astonishing chapter ever in the history of the club. Wembley 68 won't be forgotten. That was the

ground-breaker and it was a courageous and emotional triumph for Sir Matt Busby's European Cup winners.

But for sheer drama the Nou Camp theatrics will forever be imprinted on the memory. I said it after the epic Arsenal FA Cup replay and I'll say it again, keep all your memorabilia from this legendary victory because you are going to want to say: "I was there."

It seemed that half of Manchester WAS there as United once again whipped their emotionally drained followers into new frenzied heights. The thrill-seeking team that love to take you to the limits of endurance did it again. And even as Peter Schmeichel lifted that huge silver trophy into the Spanish night sky and a million flash bulbs popped you still had to pinch yourself to believe it had really happened.

Had United really turned certain defeat into a staggering victory in injury time? Had the team who seem to revel in rescuing lost causes really pulled off the ultimate comeback? This was the revival to end all revivals. Even these super resilient Reds can't dream up an ending to eclipse this one. I can't honestly say I blame the presumptuous UEFA official who pinned Bayern Munich ribbons on the European Cup as the Nou Camp clock ticked on to the 90-minute mark.

I doubt if even the most hopeful and ardent United fan had dared entertain the fanciful notion that he'd be hastily untying those colours from the handles little over three minutes later and fixing red and white ones to the glittering prize.

There had been a numbing and helpless feeling in the stomach that this was going to be a night when it wasn't going to happen for United. It was the story you didn't want to write. The team who had blazed a goal-scoring trail across Europe for ten months were tragically going to find the well had dried up on their last visit.

That gnawing suspicion didn't immediately surface when Mario Basler put the Germans ahead after five minutes. Following Ronny Johnsen's questionable foul on the juggernaut Jancker, United's wall seemed to fold at the very point that Basler aimed his shot for.

Schmeichel never moved and the colossal Red Army comforted themselves with the knowledge that this was a mere molehill for a side who climbed a mountain in Turin. The Germans are masters of protecting their spoils and they withdrew and invited the challenge.

United had plenty of possession but little punch as the night wore on. A Yorke flick at the near post was pushed away by keeper Oliver Kahn in the 22nd minute. Cole swiped one over in the 38th Beckham sent a free kick hurtling wide on 41 and Giggs sent in a weak header right on half time as United barely flickered.

Bayern picked their moments to break out and Zickler had a header saved by Schmeichel and hit a drive wide before Matthaus defied his 38 years to burst from his sweeper role to run the length of the field and crash a shot over from 25 yards.

The sight of Stam slicing a clearance into Schmeichel's arms just after the break and the Dane almost being beaten to an Irwin back pass by Jancker didn't help to ease the feeling that the treble was going to be one challenge too many. A 40-yard audacious attempt from Basler to catch Schmeichel off his line heralded the arrival of Teddy Sheringham at Ferguson's side on the touchline as the pair mulled over substitute strategy.

With the United crowd calling for the FA Cup final hero he remained at the end of the leash for a further four minutes before Jesper Blomqvist made way. While one of his first Wembley touches opened the scoring against Newcastle this time the Londoner's opening gambit almost finished off United completely.

Sheringham and Beckham failed to read each other's minds on the right flank deep into Bayern territory and the Cup Final scorer gave away the ball and the Germans broke swiftly. The counter ended with Effenburg trying to lob over Schmeichel. The keeper hadn't

had too many opportunities to end his career in a blaze of glory but he stretched every sinew in his giant frame to keep the midfielder's chip out and leave the Reds in the hunt.

Schmeichel was unable to draw himself up enough to keep out substitute Scholl in the 79th minute, but this time the post kept United in with a shout. Maybe, just maybe, luck was going to help out here.

A comeback was growing even more remote, though, when Jancker's overhead kick struck the Red's bar with five minutes of normal time to go. But that second woodwork intervention gave you some hope to grasp on to. Maybe someone was guiding United towards their goal from above. But they were certainly going to leave it late.

Fortune favours the brave, however, and while the Germans were counting down to the moment when they would mount the winner's rostrum, United's bravehearts launched their unbelievable late, late blitz.

The Nou Camp clock had just showed 90 minutes and the fourth UEFA official was parading the three minutes to go on the time board, as the Reds won a corner. Some 50,000-plus United fans screamed encouragement, and Schmeichel had his own ideas for an improbable storyline, as he bounded up the field to try to meet Beckham's corner.

He didn't make it but in the ensuing panic the Germans sliced a clearance, Giggs helped the ball goal-wards and Sheringham swept in an astonishing equaliser. Bayern were crushed and you just felt they wouldn't survive the Golden Goal in extra time. Never-say-die United, however, had an even better climax on their minds. They smelled blood and went for the deflated Germans.

Another corner was forced, and, with terror and turmoil leaving Bayern's defence in disarray, Beckham's set-piece was headed on by the inspirational Sheringham. And United's second super-sub Ole Solskjaer reacted to stick out his leg and plant the ball in the roof of the net. Fergie reckoned that Sir Matt Busby, on what would have been his 90th birthday, had helped that one home from above, and spookily, it made you wonder.

The Nou Camp erupted and five Germans slumped to the floor as their defensive resilience lay in tatters. Italian referee Pierluigi Collina even had to try to pull members of the distraught and vanquished Munich side to their feet among the human debris in their box to finish the game.

You couldn't have scripted a more fitting finale for a treble-winning season of so many epic and dramatic finishes. It was all over and United had achieved the impossible in the most incredible and inconceivable way. Thanks for the memories, lads.

60) Millennium Celebrations, 2000

Emergency services across the United Kingdom coped with a massive rise in 999 calls with no significant difficulty. The Greater Manchester Ambulance Service had its busiest night on record, with 1,200 calls. Feared 'Millenium Bug' disruption, which was widely predicted at the time, failed to materialise, as businesses, banks, airlines and the government reported no significant computer problems in the first few hours of 2000. There were no further problems as the year progressed. At noon across the United Kingdom, thousands of church bells pealed in unison as 2,000 churches rang in the third millennium.

Manchester Evening News. Monday, January 3rd 2000.

IT'S THE PARTY OF OUR LIFETIME.

Thousands join the fun.

SOAKED to the skin and dancing for joy, Manchester celebrated the Millenium as only the city knows how.

More than 17,000 revellers crammed into Castlefield to witness a spectacular firework display at the end of a free council-organised extravaganza. It was the proud centre-piece of the city's New Year celebrations as more than 30,000 people flocked onto Manchester's streets.

Live pictures of Big Ben striking midnight were beamed into the main arena, prompting uninhibited celebrations, hugging and kissing. Then it was ten minutes of spectacular pyrotechnics, so amazing at one point it looked as if fire was raining from the skies.

Revellers at the ticket-only event, and a further 1,500 who gathered outside the perimeter fence, then belted out The Beatles Hey Jude as it was blasted across Castlefield. The feel-good factor was tangible and tears of joy flowed.

"I was crying," admitted drama student Naomi Jones, "We stood up on the bridge with a bottle of champagne. The fireworks were beautiful." Her friend Emily Webster, 19, said: "It was absolutely fantastic. It was raining but it was proper Manchester. It was the best way to sum up Manchester this Millenium – with rain."

Former Stone Roses frontman Ian Brown kick-started the party when he arrived on one of Castlefield's three stages just before 10pm. It started raining mid-way through his first number and Brown declared: "Who would have thought it would be raining?"

A sea of hands appeared in the crowd – but no-one cared it was a little wet. One fan even jumped into the water feature at the front of the stage. As the merriment rolled on, 6,000 revellers packed into Albert Square for an unofficial celebration which exploded as the town hall clock struck midnight.

Champagne corks flew and congas formed around statues as balloons, streamers and fireworks filled the square. Three-year-old Rachael Baker, of Hulme, sat on her dad Charlie's shoulders and said: "This is like magic." Chaz Singh, 33, of Rochdale, cradling three-year-old son Nishaan, added: "We've had a great night – Manchester can be proud."

The revellers earned praise from the event organisers and the police. By 1am there had not been any arrests in the city centre. By 4am less than 100 people were arrested throughout Greater Manchester – normal for any Friday or Saturday night.

"We are proud of Manchester," said city centre supremo Coun Pat Karney. "People will look back on it and say Manchester put on its best face. I want to thank everyone who gave up their New Year's Eve and stayed away from their families so that Manchester could have a good time."

Chief Insp Garry Shewman said: "The good-natured spirit made the role of policing Manchester such a joy. It's been a wonderful atmosphere."

GREATER Manchester and Cheshire celebrated in style as thousands flocked to pubs, clubs and events.

But many preferred to stay at home, attend church services or take to their streets for parties for the countdown to 2000. Salford and Trafford hosted a joint celebration with a waterfront party at Salford Quays. Giant screens in marquees relayed millennium news from across the globe.

Then a Viking battle and white lantern procession was followed by a wharf-side pageant. It set sail to join the fun at Castlefield.

In Bolton, families arrived in the Town Hall Square for a Victorian fun fair with strolling musicians, helter skelter and firework finale. But in Rochdale and Stockport, civic leaders chose not to host an official event. Oldham and Middleton also decided against organised celebration.

Officials preferred to let off a series of midnight fireworks from hills above both towns. In Cheshire, Knutsford town crier Julie Mitchell took to the streets for two hours to herald the new century. Macclesfield hosted a party outside the town hall while Alderley Edge enjoyed a 12-hour party in the village park.

In Ramsbottom, near Bury, residents formed a torchlight procession up Holcombe Hill, while in Bollington, near Macclesfield, villagers held a lantern parade. Thousands also attended hundreds of church services, including a major civic celebration at Salford Cathedral.

Churches in Knutsford, determined that the religious meaning of the millennium would get through, issued a gold-covered edition of St. Luke's Gospel to 6,000 homes. Huge beacons were also lit at Castlefield, Salford Quays, Bromley Cross in Bolton, and the Peak District's Cat and Fiddle pub, near Buxton.

Holmes Chapel in Cheshire spent two years planning the village celebration – but the event was scrapped due to fears over the millennium bug and lack of insurance cover.

A TIME TO LOOK AHEAD.

Almost 20,000 people flocked into Manchester city centre yesterday to mark the arrival of the third millennium. The last time the streets were lined with such happy crowds was last century when United won the treble.

Coming almost two days after the main event, it was a private affair for the north-west – and a towering success. The crowds gasped in amazement as the magnificent floats – the most spectacular from Manchester's ethnic communities – passed by.

On New Year's Eve the eyes of the world were naturally on the home of time... encouraged by the Prime Minister himself, who had urged Britain to become a "beacon" for the 21st century. Sadly, the bonfire burned only dimly.

With would-be riders banned for safety reasons, the London Eye wheel was no more than a very expensive sculpture, Concorde was hidden by low cloud, and they are still arguing whether or not the promised "River of Fire" pyrotechnics actually went off or not.

But the biggest scandal was the Dome itself. However much the Queen and Tony Blair enjoyed themselves, thousands of other guests were left in an undignified queue just to get in. M.E.N. readers who won the chance to join the great and the good ended up beside them outside.

Some of the guests had to pick up their tickets at the last minute and, despite assurances from the organisers, it took nearly three hours before they were packed like sardines on to a train to take them to the Dome.

BRIGHT FUTURE.

But now is no time to crow about London's shortcomings – at least the Millenium bug didn't strike. Today, before the big return to work tomorrow, after one of the longest festive lay-offs of recent years, we ought to reflect on the bright future awaiting Greater Manchester and the north west.

Though by no means everyone has jobs, unemployment is at its lowest for some time and the approaching Commonwealth Games will offer opportunities to many. We begin the new century with a brand new city centre, itself a beacon to the rest of the country of how to triumph over adversity. And the cause of that adversity, the troubles of Northern

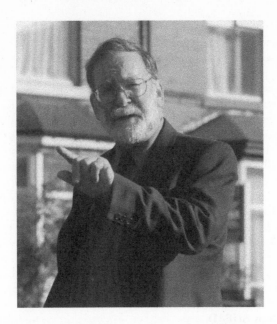

Ireland – which spawned the mainland bombing campaign and ripped the heart out of Manchester in 1996 – also move into the year 2000 with hope at last of peace.

Today, Manchester United are in Brazil in the hope of becoming the very best football club in the world. For the last decade, the city has led the field of popular music. The Archbishop of Canterbury and his fellow church leaders yesterday urged the nation to adopt a more spiritual outlook on life. They want a return to more Christian values and a cooling of the adoration of fame and wealth.

They are right to aspire to that. It is their job. But the famous and wealthy are usually talented in some way, too. What is important is that the talented use their gift from God as a beacon to the rest of us.

61) Doctor Harold Shipman, *c.* 1998

Shipman practiced as a GP in Hyde and was initially arrested on Monday 7 September 1998, being charged with the murder of Kathleen Grundy. As the investigation developed, evidence of further murders was uncovered. During interviews Shipman was highly confident and arrogant, belittling those who interviewed him and believing he had a superior intellect. Shipman was given fifteen life sentences for murder but police believe he may have killed up to 215 patients. He never expressed any remorse for the murders. On Tuesday 13 January 2004 Harold Shipman was found hanged in his cell at Wakefield High Security Prison in West Yorkshire.

Manchester Evening News. Monday, January 31st 2000.

SHIPMAN TO SPEND REST OF LIFE IN JAIL.

GUILTY!

Family GP Harold Shipman was tonight given 15 life sentences after being convicted of murdering 15 women patients for pleasure.

The jury's verdict made the unremarkable, softly-spoken doctor – Dr Death – the most prolific convicted serial killer in British criminal history. And now the *Manchester Evening News* can reveal police are expected to charge Shipman – who was convicted 20 years ago for forging prescriptions to feed a drug habit – with the murder of another 23 patients next month.

Detectives have now investigated 136 deaths in Hyde and believe the doctor may have been responsible for killing 90. But Tameside Coroner John Pollard believes the death toll is much higher – possibly as many as 1,000.

Tonight the jury of seven men and five women returned their verdicts on the 50th day of his trial at Preston Crown Court. Mr Justice Forbes told Shipman: "The crimes of which you stand convicted are so heinous that life must mean life. I recommend that you should spend the remainder of your days in prison."

As well as the life sentences, Shipman was given four years for forging a will. Shipman – described by a colleague as "brilliant with a needle" – poisoned unsuspecting patients by injections of morphine. It is believed he had lured them into believing he was carrying out blood tests and then watched them slowly die.

Soon after, he altered their computer patient records to fit his false causes of death. But 54-year-old Shipman has taken the secret of why he was addicted to murder to jail with him. Police believe he had "a taste for killing" but only he knows the motive for the massive betrayal of his patients' trust

He was caught through sheer greed trying to forge a patient's will. But apart from that one attempt to enrich himself, Shipman never appears to have had a penny from any of his victims. *Had he not clinically forged the will of his victim Kathleen Grundy he would still be murdering by stealth today.*

The 23 new charges – which are expected to be formally laid on February 28th – involve mainly elderly women patients from Hyde where Shipman practised alone at his surgery in Market Street…

The incredible murder addiction of the man some have given the macabre nickname "Dr Jekyll of Hyde" has resulted in a government inquiry. Shipman got away with murder for a decade because he practised alone and his patients had implicit trust in him.

But he also exploited limitations in the system – such as the lack of a system to cross-check GP patient death times. It has since been learned that Shipman's women patients aged around 65 were twice more likely to die than those with a neighbouring practice.

It has also emerged that the local health authority had no idea that Shipman had a 20-year-old conviction for forging prescriptions for himself. It happened at Todmorden, West Yorkshire, when as a GP in a group practice, he became addicted to painkiller pethidine. He had to quit his job before he was fined in court and then spent a year in rehabilitation before returning to practice in Hyde.

The Department of Health plans new curbs such as health authorities being given access to any criminal convictions of would-be GPs. The *Manchester Evening News* has established that Dr Shipman was reported to police as a potential killer five months before he was finally caught.

But it is understood detectives did not check if Shipman had a criminal record – which the doctor did – and the investigation was dropped for lack of evidence in the spring of 1996. Following this the GP murdered three more patients, including his last victim,

Kathleen Grundy. Police chiefs have reviewed that first inquiry, which was triggered by a suspicious GP, and have suggested the reasons for aborting it.

Tonight, police officers who exhumed the first of nine bodies on August 1st 1998, were still staggered by the scale of Shipman's crimes. When the post-mortem on Kathleen Grundy was ordered, detectives did not expect that anything would be found. They were amazed when morphine was discovered in tissue samples, not least because a doctor should have known it was a traceable opiate.

If Shipman had injected his victims with insulin, which is produced naturally in the body, he would not have been charged with any murders – just with trying to forge Mrs Grundy's will. None of Shipman's patients were terminally ill and the jury were told that mercy killing was not a consideration.

"If Shipman was expressing the ultimate power of control over life and death and repeated it so often he could have found the drama of taking life to his taste," said the prosecution. One of the biggest unanswered questions today was when did Shipman really start killing patients?

One psychologist consulted by police, said it was possible he had been killing since he qualified in the 1960s. Police did not bring in evidence dating further back than 1996 because of the decomposition of bodies...

Tonight staff at Dr Shipman's Market Street surgery refused to talk about the guilty verdict. A receptionist told the MEN: "We are saying nothing. Contact the health authority." Elsewhere in Hyde residents said they had expected today's court decision.

Harvey Cope, 74, of Vincents Street, Gee Cross said: "Its shocking that the town will always be tarred by this.

"It is such a simple thing to expect to go to your doctor and get first class treatment. It makes you think twice about the very basics of life."

Local MP Tom Pendry today said Shipman had dealt a body blow to the town of Hyde and called for greater openness from the authorities following the killer doctor's conviction. Mr Pendry said: "This dreadful case has dealt a body blow to the town of Hyde and its people that will take us a long time to recover from. My thoughts are with my constituents who have had their lives shattered by the cruel actions of Dr Shipman.

"The trust between doctors and patients is one of the most important bonds between two people in our society. The bereaved families should be told all they can be by the relevant authorities, the health authority, the police and the medical bodies who supervise and regulate GPs.

"Nothing short of that will offer any assurances that they will get the answers they want to questions that have been gnawing away at all of them throughout this traumatic investigation and trial.

"All of those who knew Dr Shipman will be examining their memories of him and asking the question, how could he get away with this appalling catalogue of crimes."

62) Commonwealth Games, 2002

The Commonwealth Games brought life back to deprived districts of Manchester and regenerated large areas of the city. Manchester now has a legacy as one of the world's leading cities for sport. The games were the largest multi-sport event the United Kingdom had seen since the 1948 Olympic Games – making it a popular tourist attraction. The slogan used to publicise the event was 'Count Yourself In'. New world-class sporting

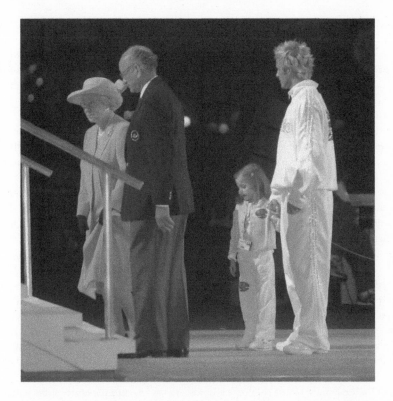

venues were also constructed as part of the games' legacy. Shown above are the queen and Duke of Windsor, with David Beckham and Kirsty Howard, at the opening ceremony.

Manchester Evening News. Thursday, July 25th 2002.

THE WORLD WATCHES AS GREATER MANCHESTER'S SPORTING DREAM BECOMES STUNNING REALITY.

On with the great event.
It's ready, set, go as Queen prepares to launch the show.
THE big day has dawned.

After years of effort and millions pounds of investment, the brave dream to bring the XVII Commonwealth Games to Greater Manchester today became a reality. Manchester has managed to turn the failure of an Olympic bid into a magnificent success, bringing home the biggest sporting event ever staged in the UK and a legacy of facilities and regeneration right across the region.

Everything is ready, everywhere is set – so let the Games begin! Tonight, the eyes of the world will be on the new stadium as the Queen receives the Jubilee Baton she sent on its historic 59,000-mile journey five months ago and reads her message to the Commonwealth.

Her words will come at the end of an opening ceremony promised to be "stunning" and signal the start of 10 days of sporting brilliance. Out on the streets, the party has already started. Exchange Square, at the heart of the rebuilt city centre, erupted in a riot

of cheering and flag-waving when the Queen, accompanied by Prince Philip, arrived yesterday evening ahead of a service of thanksgiving in the Cathedral.

The royal couple immediately moved to the throng of well-wishers, many of whom had been waiting patiently since early morning for the chance to catch a glimpse of the monarch. Greeted by Manchester City Council leader Richard Leese, chief executive Howard Bernstein and the Lord Lieutenant of Greater Manchester, Colonel Sir John Timmins, the Queen collected flowers and shook hands with young and old.

As she began her walkabout towards the cathedral in the beautifully rebuilt heart of the city, the horrors of the IRA bomb blast of six years ago seemed little more than a distant memory. And the royal party later joined in giving thanks for the restoration of the city centre in the special Cathedral service which was the culmination of a day of celebration.

The first person the Queen spoke to during her walkabout was 69-year-old Frank Jenner, from Salford, who had been out since early morning to reserve his spot. Film extra Frank, who had travelled to the capital for the past two years to celebrate the Queen Mother's 100th and 101st birthdays, presented the Queen with 50 golden roses in the shape of the figure 50 to mark her Jubilee year.

"Are those for me?" she beamed and took the flowers before moving on. The Queen chatted informally to Coun Leese as the party made it way past the Marks and Spencer store and down the steps onto the Shambles before moving to the Cathedral.

The walkabout followed an afternoon tour of Greater Manchester which began when the royal jet touched down at Manchester Airport soon after midday. And tonight, the Queen will take centre stage in the Games' opening ceremony when she will finally be reunited with the Jubilee Baton, handed to her by six-year-old Kirsty Howard from Wythenshawe.

Little Kirsty, who is seriously ill after being born with her heart back to front, is the mascot for the Francis House children's hospice and has touched the hearts of the nation – particularly David and Victoria Beckham – with her determination to help raise £5m.

Thousands of people crammed into Albert Square yesterday to greet the Baton Relay as it arrived in the city centre towards the end of its tour of 23 countries. Manchester United's Ryan Giggs and Manchester City' Stuart Pearce received a warm welcome as they carried the hi-tech beacon together up Brazennose Street and on to a stage in front of the town hall.

The huge crowd cheered and clapped as the two football stars held the baton aloft and carried it on to a stage in front of the town hall. The baton was due to begin its final journey today from the city centre, travelling through Didsbury, Cheadle, Trafford and Salford before making its way via canal boat back to the city centre.

It will eventually be carried to the City of Manchester Stadium in time for tonight's opening ceremony, where local sprinter Darren Campbell will be England's flag bearer.